Praise for "The Box Must Be Empty"

"This profoundly moving memoir leads with vulnerability, communicates with grace, and delivers the kind of hard-earned wisdom that only comes with time. An intensely personal story of recovery, its lessons apply to any soul with unhealed wounds."

—**Daryl Potter,** author of "Even the Monsters" and "Bitter for Sweet"

"Marilyn Kriete states her reason for writing this book on its final page: There was none like it. Well, I agree. I know of no one who captures the referred pain of an unmourned relationship like she does. I know of no one who captures the beauty and confusion and love and trauma of an unhealthy church like she does. And she does it with moxie and grace and clarity and wisdom and, above all, realness. It's a candidness you can feel in your bones. She was right: This is a one-of-a-kind book."

—**Ken Guidroz,** author of "Letters to My Son in Prison: A Memoir"

"Marilyn is an insightful storyteller who provides language for the most damaged parts of ourselves. She connects with the culturally specific ways that many people in churches experience grief. I recommend this book for anyone working through delayed and complicated grief and/or spiritual trauma."

—**Kyle Spears,** mental health practitioner,
The Attachment and Trauma Center of Nebraska

"Do not make the mistake of thinking that Marilyn Kriete's book is a straightforward memoir; it is not. Rather, Marilyn mixes autobiography, ethnography, and testimony in a raw and candid manner that both captivates and illuminates. She gifts us the privilege of peering into her often-tortured

inner world, unfurling her personal grief before us. Yet this suffering is intermingled with the travails of her controversial faith group. Her grief is constantly overshadowed by the multi-tentacled demands of ministry work and one imagines how she survived to write this book at all. A worthy read for anyone seeking the wisdom to understand how egregious losses emerge from a human soul while in the midst of a tight-knit God fearing community, I can't recommend this book highly enough.

—**Sean St. Jean, PhD, MSW, RSW**, director of field education at King's University, Tennessee

"...a compelling and heartfelt memoir that paints a vivid picture of the grieving process and the impact unresolved grief can have on a person's life and those around them. The raw emotions and moving journey the author showcases will resonate with readers long after the book ends."

—**Anthony Alvina**, book blogger and author

"Few writers can escort the reader through the tough stumbling blocks of crises—death of loved one, a flawed marriage, dysfunctional families, depression, and even loss of faith in a ministry—with the skill of this insightful author. The words flow, the emotions surge, and the empathy soars as she closes with the proverbial light at the end of the tunnel. Brilliantly written and consummately interesting, this little book is a valuable assist to everyone who faces crises—and isn't that all of us? Highly recommended."

—**Grady Harp**, Top 100 Amazon Reviewer

follow church directives to relocate without exception or question. Naturally, the highest-level ICOC administrators or leaders were not expected to frequently relocate or shop in thrift stores to make ends meet. The couple's life seemed to improve after leaving the church, though the need to continue moving was evident in this rare and unusual story."

—**Michelle**

"Beautifully written… what a compelling story. I read it in two days… couldn't put it down, because I felt drawn in by the author's very real sharing of her deep pain over both her past and more present griefs. You will ache along with her… her descriptions of the depth of her hurt brought me to tears more than once. I had read Ms. Kriete's fascinating and vulnerable first book, which introduced me to her childhood and the beginnings of her story: it is what drew me to her second memoir. I loved learning how she and God worked together through her pain and great losses; and seeing how much strength she gained from her honest, deep relationship with God, and from her love of the Bible. I came away feeling much hope, and courage, seeing that even deep and complicated grief can be faced, and that there can be true peace on the other side."

—**Beth Westbrook**

"I fell in love with Marilyn Kriete's writing when I read her first book, 'Paradise Road,' and this second book does not disappoint. It's full of the same kind of brutal honesty, passion, humor, colorful narrative, and poetic writing that kept me riveted in the first book. I actually had to stop myself after a few hours of uninterrupted reading, so that I could savour it over a few days instead of devouring it in one sitting. Marilyn's journey of grief is long and complicated, and it seems at times as if her life is doomed to sorrow, abandonment, loneliness and disillusionment, but she is a fighter.

She fights for healing, and she finds it, not in one simple solution, which would not be realistic, because her grief is not simple. The solution comes slowly, wholistically, as she engages body, soul, spirit, and mind. Everyone's story of grief is slightly different, but there is so much for all of us to learn from Marilyn's journey that I wouldn't hesitate to recommend it to anyone who is struggling with grief, or anyone who works with those who grieve. Not only is the content valuable, but the writing is beautiful, evocative, and easy to read. Her descriptions of some of the characters who cross her path paint such a vivid picture that you feel as though you know them."

—Gwen Bodie

"Anyone with unresolved grief, usually hidden down deep in their box of inner memories, will find it arises, as old and new tears, on the pages of this very stirring memoir! I highly recommend this follow-up to Kriete's first book, 'Paradise Road.'"

—Laura Fizelle

"There is no question in my mind that I will be purchasing this for one or more gifts. A moving personal story of understanding complex lingering grief of a love suddenly lost (read Marilyn's first book, 'Paradise Road' for more on that), made worse by many hurts from a worldly heavy handed and legalistic church culture driven by the one she calls 'top leader.' Marilyn's experience is intense as she wrestles through her grief to reach a good place. A moving book that led me to read it not once but twice!"

—Carolyn Stanfield

"I read Marilyn Kriete's first memoir 'Paradise Road' and loved it so much that I could not wait for her second memoir. I was not disappointed. Marilyn is a gifted and evocative writer. Though I could not relate to the kind of

long delayed and immense grief she suffered over a lost love, her story taught me how faith can sustain us through any trial. Her time with her husband, Henry, the Church of Christ and the heartbreak it led to while they were raising their two children and living all over the world made for a one-of-a-kind story that was hard to put down."

—**Monique Maitre**

"Inherently, ministry life is lonely; add repressed grief to the situation and it produces a tale of gut-wrenching isolation and all neuroticism that ensues. If you thought it's tough to be a leader in a church setting, 'The Box Must Be Empty' dispels such silly notions: it is downright brutal. Kriete invites the reader to share in her messy experience of catharsis while she skillfully cradles the shock in humor and wit. This author will not disappoint. It's not just her authenticity you'll connect with, her epigrammatic elegance is left on every page."

—**June Foreman**

"As I traveled with Marilyn through her grief journey, I watched her struggle with overwhelming sadness over her losses and unwelcome changes to her ministry responsibilities, discover the *Grief Recovery Method* and come to peace with everything. It led me to procure the 'Grief Recovery Handbook' for myself to process the things in my life that I wish were 'different, better, more.'"

—**Emily Taylor**

A Memoir of Complicated Grief,
Spiritual Despair, and Ultimate Healing

THE BOX

MUST

BE EMPTY

MARILYN KRIETE

LU(ID
HOUSE
PUBLISHING

LU◖ID
HOUSE
PUBLISHING

Published by Lucid House Publishing, LLC in Marietta, Georgia, United States of America
www.LucidHousePublishing.com
© 2023 by Marilyn Kriete
All rights reserved. First Edition.
This title is also available as an e-book via Lucid House Publishing, LLC
It is also available as an audiobook narrated by the author and distributed by
Blackstone Publishing.
Cover design: Troy King Interior: Jan Sharrow
Author photo: Wendy McAlpine
Note: This memoir is written in U.K. English.

The events depicted in this memoir are true, according to the author's (imperfect) recollection. Names of many individuals have been changed to protect their privacy. Ideas and suggestions from the author's personal journey are not intended as a substitute for seeking professional guidance.

Library of Congress Cataloging-in-Publication Data:
Kriete, Marilyn, 1956-
The box must be empty: a memoir of complicated grief, spiritual despair,
and ultimate healing/ by Marilyn Kriete—1st ed.
Library of Congress Control Number: 2023933472
Print ISBN: 978-1950495313
E-book ISBN: 978-1950495320
1. Spiritual trauma 2. Family dysfunction 3. Grief and loss 4. Infertility 5. Adoption
6. Discipleship 7. Spiritual healing 8. International Churches of Christ
9. Death and bereavement 10. Bipolar disorder
BIO026000, FAM014000, PSY022050

For Henry, with profound gratitude.

Through many dangers, toils and snares we have already come…

Thank you for loving me through this whole crazy ride.

A lesser man would've run for the hills.

Contents

It is good to be merry and wise;

It is good to be honest and true;

It is good to be off with the old love

Before you are on with the new.

From *Songs of England and Scotland Volume II*
edited by Peter Cunningham
(published by James Cochrane, London, 1835)

PROLOGUE

Some of us feast on memoirs like foodies at a twelve-course Chinese banquet. I'm one of those readers. For me, getting an inside peek at the lives of others, told from their unique perspective, is endlessly fascinating. *What happened to you, and how did you feel? How did your troubles resolve? What did you learn, and what can I learn from you? Where did life take you next?* These are the questions that keep me coming back.

Coming of age tales abound in memoir, and I've written mine in an earlier book, called *Paradise Road*. I invite you to read that memoir as a fuller introduction to the older Marilyn you'll meet in these pages.

Grief memoirs fill a deep need among the bereaved to connect with fellow survivors, and so I add this to the fine selection on offer. The story you hold in your hands is about grief—complicated, catastrophic, cumulative grief—and my journey through it and beyond. It's a long, hard journey, but it has a happy ending, a genuine one, so don't despair as we travel back in time. Perhaps you'll find comfort and healing in your own sorrows by swimming with me through mine. Near the end, I find answers I hope will resonate, if they are meant to help you.

This is also a journey of faith, lost and recovered. Many seekers join intense spiritual communities, only to leave later in heartbreak and disillusionment. Whether we walk away or find ourselves abandoned, losing our place in a vital community and having to start over can be as devastating as a sudden, premature death. It certainly was for me.

I've also read scores of dysfunctional family and addiction memoirs, including many where faith is ascribed as a key to the writer's recovery. My addiction has been to constant motion, keeping me from facing my inner ghosts and demons till I was forced, by utter breakdown, to do so. My family of birth and my family of choice have also imparted their share of dysfunction, as many families do. I share these aspects only as they relate to my burgeoning griefs—never to throw stones or blame others for the trials I needed to face.

I've read many memoirs that document leaving one's religion, of walking (or running) away from a faith community the writer no longer believes in. These stories fascinate me in all their variations. But not many document this: the wholesale loss of self-worth, hope, and confidence when a person of faith is pummelled by betrayals and disappointments they are powerless to change. And what if these hits come from lingering ghosts? What happens when the hits are unrelenting, and no one can guide the woeful pilgrim home? Where are the answers, the comfort, the glue, when a grief-riddled life feels unbearably broken, and everything a person once trusted seems hollow and void?

This is that book.

Come swim with me to the welcoming shore.

CHAPTER

OLD LADY ROSE

Theres a new movie playing. It's called *Titanic*. My husband, Henry, a film lover who can't resist early buzz, goes on opening night, along with our nine-year-old son, Daniel, but I stay home. We've recently adopted Tassja, our almost two-year-old daughter, and I'm happy to hang out with her. After a rough, emotionally starved infancy, she's attached to me, hard, and I'm equally besotted. We'll get a full review when the men come home.

They love it, of course. It's thrilling and action-packed; the special effects are *awesome*. In terms of plot, there's passing reference to a love story, but it's almost tangential. The *Titanic* they've just seen is a glorious spectacle of stupendous sound effects and visuals. An epic, heart-stopping adventure on an overwhelming scale: everything you want from a December blockbuster.

Two weeks later I take Daniel for a second viewing, but it's a different movie with Mom. Within the first hour, I'm weeping to the point of meltdown, and Daniel, pulled out of the story by my tears, is perplexed. Nobody's died yet; in fact, Jack and Rose, gallivanting aboard the massive

ship, are living the life of Riley. But I know where this plot's headed, and I know the lovers are doomed. By the time Rose watches Jack slip into the sea, I'm a quivering wreck, and when old-lady Rose, still dreaming of Jack in her dotage, imagines their reunion in the ship's ballroom, I'm beyond recovery. As the credits roll and the theatre empties, I'm weeping convulsively, unable to leave my seat or stop crying. Daniel panics. This was supposed to be a fun matinee with Mom. What's happened to his steady-Eddie mother?

What's happened is a cataclysm. She's been swallowed by a volcano that's been simmering, underground and undetected, for half her life: a grief volcano, with a man named Jack still living in its core. The simple trajectory of Jack and Rose's relationship—Jack rescues Rose, Rose rescues Jack, Rose loses Jack, forever and irrevocably—mirrors her brief and intense relationship with her own lost-forever Jack, and it's as if this semblance has tripped a magma-erupting switch.

And Rose never forgets Jack: that's the final twist of the knife. In the darkness of the theatre, newly awakened grief shakes its hoary head, and a chilling realization fills my heart. As much as I've tried to repress all conscious thoughts of Jack, to move on and live my post-Jack life, to leave the distant past where it belongs, to play the hand that's dealt me, to inhabit the here and now—he's never left. He's simply been hiding, waiting in ambush, until now, January 1998, two full decades after his apparent death.

I manage to drive in the midst of my deluge, but the tears won't stop, and when I get home, I leave Daniel to play with his little sister and close myself in the upstairs office with Henry. He's the man I married two years after Jack died. Our union was celebrated in a tiny, intimate outdoor wedding with seven souls in attendance. Maybe eight, now that I think of it.

Henry has many fine qualities—passion, zeal, intelligence, and originality among them—but it's his compassion that first drew me, and now that compassion enfolds me. I weep it all out, Jack and Rose, Jack and Marilyn, the massive eruption that's still exploding in my heart. He listens and holds me. It's a tender, perfect response to despair, deep calling deep.

The next day, or maybe the same night, he writes a poem, "I Love the Man Who Loved my Wife." Every five or ten years, when something huge grips his soul, Henry writes a poem. This is a good and noble one. As the words pour out of him, he means every word. He reads it aloud and we both cry. It's a lovely, heart-breaking sentiment. A few months later, he's going to loathe the poem, loathe the eruption, and loathe the aftermath, understandably so, because this tragedy is not going away.

But for a while, I think it has. The hot magma cools, and floating ash becomes the new sky. I won't go to that place of pain again, not willingly. But now I'm crying a lot, in secrecy and confusion, over everything and nothing. Mostly over nothing. The tears come unbidden, and life seems hopeless, even though I have a fulfilling ministry, a loving husband, a best-buddy son, and, at long last, the daughter I've longed and prayed for. I have good friends, almost too many, and a cozy, beautiful five-bedroom house on a little azalea-and-bamboo-fringed lake which we share with two friends, sisters in Christ. I'm healthy, fit, and energetic. After years of moving from one country to another, we have a place in Virginia Beach, a place we dare call *home*. Yet I'm utterly unmoored.

I don't talk about my crying jags with anyone. They baffle me; they don't reflect the outer contours of my life, and I don't connect them with Jack or the *Titanic* episode. Perhaps they're a symptom of post-partum depression; adoptive mothers, I later learn, are prone to the same post-joy despair.* This adoption has been far more challenging than our first.

Daniel came to us in Bombay (now called Mumbai), on Father's Day, his birth day, and that same day we carried him home from a hill station hospital by train, taxi, and rickshaw. From the moment we held him, we flooded his senses with love, buttressing him from his first loss. Apart from nightly colic, he was a cooing, happy baby who made us feel like parenting experts, experience be damned.

> *There are hidden losses entwined in every adoption, which may include the following: grieving the infertility which led to adoption; grieving past mistakes which may have led to the infertility; grieving the biological children who will never be; grieving the missed days or years between the adopted child's birth and her adoption; grieving the loss experienced by the adoptee; grieving the damage done in the family (or orphanage) of origin, and wrestling with fears that even the greatest adoptive parenting will never be enough to mend this little stranger's heart.*

Adopting our daughter was different. She joined us as a toddler, surrendered at 14 months by a troubled young mother who'd struggled with three unplanned babies born within 32 months. Whatever had or hadn't happened during those early months lay thick on her psyche. She needed love—maternal love, paternal love, remedial love, miraculous love—by the truckload, and her invisible wounds made her hyperactive and insatiable. I was pouring all I had—plus all I *hadn't* had, all the maternal love I'd missed as a child—into loving her, hoping it would fill the cracks and holes. In many ways, she was finally thriving. She'd come to us woefully undersized, without teeth and practically non-verbal, and now I was filling notebooks with her burgeoning vocabulary while her teeth emerged and

her body caught up. She never stopped moving. Our beautiful, busy child enthralled and exhausted me.

Now I was being urged by church leaders to leave her with babysitters, to put her in day care, to leave her for days while we traveled, so I could immerse myself back in the ministry and function like the mother of a 'normal' toddler. She'd been with us for barely six months, and the ministry expectations were tearing me up. She needed more of my time. I knew that.

But the International Churches of Christ (ICOC), the fellowship we belonged to and had served faithfully as ministry leaders over the past 20 years, was an organization with intense, daily mentoring, called 'discipling,' and a frenzied mandate to saturate the world with Christ's message in our generation. Every hour of every day was held to account. We'd been trained to put the church and the mission first, back in those days when few of us had children or knew what a baby needed, especially an adopted one. Now every forced separation triggered tears and desperation in her, and as a mother I was chided for having a clingy child. Perhaps this was the source of my constant cycle of tears, springing from a deep well of frustration and conflict. I try to do what I'm told, but it's the opposite of what my heart says.

I don't talk about any of this. I know I should be grateful to finally have a second child after seven years of thwarted adoptions and disappointments, and I am. But there's a thorn. Is there room, amid gratitude, for fear and anxiety? My mentors, the senior evangelists' wives who advise and supervise my life, admonish me to be grateful for the ministry, regardless of the emotional toll our frequent moves (four intercontinental moves and nine cities so far)—are taking. None of them has moved as much as we have, at the beck and call of church leadership.

The toll of constant moves goes largely unrecognized. With every move we're expected to be all-in, excited, forward-looking, embracing each new location as if it's to be our permanent homeland, though it never is. Looking backwards is a sin—remember Lot's wife!—and the chain of losses, though deeply felt, is never acknowledged. We've taken up the challenge to go anywhere, do anything for Jesus—our organization's mantra. At first, the commitment and rapid growth of the church is thrilling, but the cost keeps building. In every place, I need to be an exemplary church leader, a role model for the church members in my marriage, motherhood, and ministry, and a highly evangelistic multitasker. This is crucial. The health of the entire congregation depends on how Henry and I are doing, or so we're told. So I strive to be grateful, to look forward, to bury my sorrows.

I'm the queen of holding it together, or at least I used to be.

In our new neighborhood in Virginia Beach I find hidden pockets, little coves and parks where I can secretly go and cry. When the tears push through, I slip on my New Balance running shoes, grab my daughter, and run for cover. While my child sleeps in her baby jogger or plays on the ground beside me, I water the sand and wind tossed bramble with longing and regrets before running us back home. I'm keeping it together, at least outwardly, with this frequent emotional purging. I'm grateful for these tiny wildernesses, and for my two-year-old's quiet complicity. She already knows her own grief, and is probably absorbing my secret sorrows, too.

Henry and I have moved 16 times in the 17 years we've been married. I know how to pare, purge, pack, and unpack a house in days, how to dive fresh into a new city and culture, and how to make new friends in record time. In every place, I've given my heart completely before scraping out what's left to start over. But the shards are getting smaller with every move, and the residuals darker.

The moves have been erratic and unpredictable. Many blindsided me. Shortly after Daniel's birth, we left Bombay for Canada to get a new visa, only to be blocked en route from ever going back. Instead of returning to India, we found ourselves marooned in London, which became home for the next six months. In Africa, our next stop, we'd been asked to switch countries for four to six months, with the promise of returning to the place we called home, only to be informed later that the move was permanent and there'd be no going back for goodbyes. Even that "permanent" move had ended abruptly, with a sudden decision to move us back across the ocean.

Now, after several more moves, we'd been promised a long stay in Virginia Beach and encouraged to buy a house and put down roots—in fact, the church even gifted us with money to make the down payment. My relief at this gesture towards permanence was profound. We bought the first house we looked at, a suburban waterfront property on a tiny lake. The prospect of settling in, of hanging pictures that would gather dust and watching seasons change through the same windows, seemed a gift from heaven. I looked at children in the church and thought, "I get to watch these kids grow up!"

The thought was dazzling. Until now, I'd passed through countless lives like a speeding train, never knowing where the next station lay. After less than four years in any place—more often, two years or less—this was a novel concept. I let myself exhale and imagine the promise unfolding.

I refuse to acknowledge that permanency will always be an illusion, especially in our kind of ministry.

CHAPTER

THE THIRD CIRCLE OF HELL

One year into our Virginia Beach mortgage, we were summoned to a roadside diner by a pair of junior leaders acting on behalf of our region's top leader. We liked this couple. We'd known them during our two years in Washington, D.C. and had mentored them for a time.

Mentoring, or 'discipling', as we called it, was far more intensive than the word normally implies. Discipling someone, especially someone in leadership, meant assessing every aspect of their lives at all times and offering ongoing correction, instruction, and advice. Nothing was off limits. How one dressed, talked, spent time or money, interacted with others, parented, lived out their faith, chose to spend holidays, behaved romantically, or selected their closest friends—all this and more was up for correction and counsel.

Seeking advice was lauded; following advice was mandatory. Ministry couples were expected to have an exemplary marriage and be phenomenally productive. We all complied with the program, but when genuine friendship graced these relationships, we tried to back off on the correction

model and simply enjoy each other's company. After running through some requisite questions, reverting to lighthearted friendship and laughter was easy to do. This was the kind of relationship we'd shared with Tom and Stacey.

Now, however, the tables were turned. Tom and Stacey had risen in leadership and they were now discipling us. Our meeting spot was a country diner featuring pulled pork sandwiches and southern sweet tea, halfway between our two cities. I could tell by Tom's subdued demeanor that this meeting had an agenda beyond friendship.

Before we'd swallowed our first mouthfuls, Tom cut to the chase. "We need you to move to Indianapolis, guys. The church there is in a rough spot and you're the best couple to lead it. Sam wants you there in two months. You'll love Indy—it's a great city!"

He quickly listed the city's attractions: a large, established congregation, a vibrant sports culture, and, of course, home to the Indy 500. The sports features enticed me as much as moving to the third circle of hell. And I knew Tom well. I could tell he was following a prepackaged script, and that *he'd* rather be in the third circle of hell than have to relay this message to us, his burnt-out colleagues. Tom and Stacey knew our history. They knew how often we'd moved, how we'd struggled over leaving Africa, how much we craved stability, and how much we loved our current home.

We were stunned.

My lunch grew cold as we pled our case. We'd just bought a house! We were promised! We'd just adopted a toddler! Our son had new friends and loved his teacher! The ministry was thriving! The church loved us! We loved them! And there was nothing, *nothing* about Indy that was remotely alluring.

In the midst of our objections, we asked who was slated to take our place.

Tom and Stacey looked down, then at each other. We'd hit the ditch on our bumpy ride.

"We are," said Stacey. "Sam wants us to oversee the region from Virginia Beach."

The plot had thickened; there was more strategy behind this move than the needs in Indianapolis. Sam—the overseer of a huge swath of churches in the USA, the UK, India, Australia and beyond—was one of the grand masters in our movement. These men often shuffled junior leaders like pawns to meet a larger agenda, one that didn't necessarily have the pawns' best interests in mind. We'd had glimpses of these strategies before, had been behind the scenes when other shuffles and moves were discussed and lives were upended for the "greater good." We'd been victims *and* beneficiaries of similar schemes. Leaders in our churches were moved for doing well or not doing well enough. There was typically no advance warning. We always joked that the only way to stay put was finding an elusive happy balance where we couldn't be moved for either reason.

Apparently, Henry and I never found it.

The awkwardness Tom and Stacey felt over this disclosure was palpable. In sending this couple as messengers, Sam had essentially asked them to pillage our castle, send us into exile, and feast on the spoils. Oh, and then move in and redecorate the castle as their own. This was a worldly way to view it, but I was in a worldly way.

Within minutes, I was weeping with anger and despair. How would Daniel react, being pulled from all his new friends and forced to start over in his sixth school? How would I extricate my heart from the close friends I'd expected to grow older with? How would I explain to my parents the

insanity of buying our first home—which I'd gushed about at length—and moving 14 months later to a destination with no obvious appeal? How could our leaders expect this of us, after all our other moves and sacrifices?

We didn't have cell phones back then, but Tom needed backup. "Let's call Sam, tell him how you're feeling. Where's the nearest church member's house? We'll call from there."

I wept as we drove to the nearest house, where Tom dialed Sam. "The Krietes aren't very happy," he announced. "Do you want to talk to them?"

Of course, he didn't. That's why he'd sent Tom and Stacey in his stead. Henry took the phone and talked—or rather, listened—as Sam admonished him. Our case to stay was compelling, but it was meaningless in view of the big picture. I continued to weep, as I would for the next several hours. Twenty minutes later, I was summoned to the phone, expecting to hear Sam's booming voice.

Instead, a higher voice, that of Sam's wife, Toni, a woman generally overshadowed by her husband's outsized personality, waited to ream me out.

I sobbed and snivelled as she spoke. "Are you being like Jesus on the cross right now? Are you being sacrificial in your life, like He was? Are you thinking spiritually about the kingdom or just thinking about yourself?"

This was a bit rich, coming from a woman who'd only moved three times in the 16 years I'd known her. Who lived in one of the most affluent suburbs in the United States of America. Who came to our mandatory staff meetings only when she felt perfectly well, which wasn't often. Who'd *never* been asked to move, unless she and Sam made a joint, personal decision that would benefit their family.

I was speechless, partly because she'd gone straight for the jugular, but mostly because I couldn't speak for crying. By now I had a raging headache,

the killer kind you get from hours of non-stop weeping. Tom and Stacey looked at their watches and made motions to leave. What was there to say? We all knew how these things worked.

"But they *asked* us," I reminded Henry as we drove the two hours back. "If it's a question, we can say no. We're not doing it. We can't do it. I can't do this again."

We were hitting rush hour traffic. The entire day had been spent in one long, agonizing conversation, and I was still crying. It was a Wednesday. There was barely enough time to get home, pick up our babysat kids from home, and drive another half hour across town for our church midweek service.

Tassja threw herself at me when I got home, refusing to let go. "Hurry, hurry..." The usual refrain in our hectic schedule. I was struggling to put the lid on my own tears so I could attend to hers. That night, I was scheduled to introduce a visiting ministry couple from Indonesia who'd be speaking to the church.

Tassja wasn't having it. As soon as I brought her to the children's class, ready to drop her off, she clung to my legs and howled. This was typical behavior when I dropped her off most places, but tonight seemed worse than usual. No amount of cajoling from the teachers could wrench her away from me. I wanted to keep her with me, let her sit on my lap and cuddle, or wander near the back of the auditorium with my eye on her movements. But I knew what was expected of me. I couldn't let her 'win' a single battle, which meant a spanking was in order, maybe two or three, whatever it took to get her cooperation.

We'd spanked our son a few times, rarely, since he usually repented at the threat of a spanking and was generally compliant. But to spank my little girl for wanting to be with me, when she'd been with a series of

caregivers and hadn't seen me all day? I wrestled with these thoughts, and, to my shame, took her to the ladies' room and spanked her. And took her back to class, where I was met with the same resistance, and spanked again. No change.

Knowing my absence would be noted, I gave in and carried her into the auditorium, where I knew I'd be challenged for not keeping her in class. I handed her to someone she liked, and introduced the visiting couple, who gave a stirring account of their third world ministry. Unlike most of tonight's listeners who were well-fed Americans who'd never traveled to the third world, I envied them. They lived in Jakarta. They were FROM Jakarta. They were exactly where they wanted to be, with little risk of being sent across the globe to a place they'd never considered.

I'd been in Jakarta once, on a scouting trip with Henry years prior. The city was hot, sunny, high-energy, and exciting. Like Bombay had been. Like Lagos and Pretoria had been, the places I missed and had never wanted to leave. I ranked living in North America much lower than living on these exotic continents and wished we could trade places.

The final duty of my day was to engage our Indonesian visitors in meaningful, spiritual conversation while covertly evaluating both their presentation and demeanor—how they interacted with us, the members, and each other. They'd be doing the same. Somebody, in the next few days, would ask for a full report from both ends. This was Discipling. This is what disciplers did: evaluate, discern, compare, correct, look for weaknesses to report, and areas to work on. Whatever had happened in my world that day—the utter upending of our recently constructed life— couldn't be mentioned. I needed to be giving, joyful, gracious, and spiritual. I knew, from the condition of my heart, that even a whisper of my current struggles would be tainted with resentment and self-pity.

I thought I'd done well but got a failing grade. "You weren't very giving with the Indonesian leaders," my local discipler told me a few days later. "She said you seemed a bit distracted. She said your daughter seemed fussy and clingy. Why didn't you have her in class?"

I could list my reasons in a talk like this, but they'd be shot down. Defending oneself was usually viewed as being prideful. I was out of step, resisting the move to Indy, crying over my situation, coddling my daughter, who didn't behave like other two-year-olds fortunate enough to have had love and stability from birth. A day or two later, we'd dared to give our answer, a firm no, the first time (to my knowledge) anyone had refused such a request to move. The shock waves must have reverberated throughout the global reaches of our movement.

But our superiors were relentless. For weeks we got calls from other leaders, urging us to move to Indy and affirming we were the best couple, the only couple, suited to the task. The church had experienced a painful split. There were wounded disciples and families at odds with each other. Only the Krietes (they said) had the experience and people skills to foster healing and help the church grow. I knew if we continued to say no, we'd never hear the end of it. Worn down by flattery and persuasion, we reluctantly said yes. The two-month moving date was getting close.

I expected huge blessings to follow our sacrifice. God knew—from my prayers, from my tears, from eavesdropping on my inner, imaginary conversations—that my longing to stay in Virginia Beach was as strong as my aversion to moving. Surely, knowing all we were giving up, how anguished we were to leave our cozy house and friends, our new spiritual family, surely He was waiting to mightily bless us! This was the hope to which I clung, the salve for my wounded heart. But the reality would be different.

CHAPTER

CRASHES

The move was scheduled for August, but before we flew to Indy and searched for a rental, we had other plans. I wanted to introduce my parents to their new granddaughter, so we headed to their cabin in British Columbia for a short visit. More loss: My mother refused to touch or pick up Tassja, regarding her like a strange, possibly contagious pet I'd dragged home from my travels.

It was hard to admit my mother was racist. Tassja was beautiful and obviously mixed-race, attracting compliments and attention wherever we went. Strangers often asked to hold and talk to her. But not this granny. Years later, my mother said she thought our tiny toddler was depressed. And perhaps she was. After all, her new grandmother withheld smiles and human touch the entire visit.

I waited until our last evening to mention the move, hoping I could sound casual and at peace with our decision. My parents asked the predictable questions—"What about your house?" "Weren't you finally settled there?" "Why Indiana, of all places?" Outwardly, they accepted my lame

answers. Inwardly, I knew they suspected we were in a cult. The church was a topic we silently agreed to avoid. They never asked about our work or ambitions or why we were sent all over the globe.

On our final morning, Henry took Daniel for a two-hour horse trail ride at a nearby ranch, which seemed the perfect way to end our holiday. I took Tassja in the baby jogger for a long hike, packed our luggage, and waited for their return. And waited. Morning slipped into afternoon, and three anxious hours later, a strange man wearing a cowboy hat delivered the riders—and the bad news—in a dusty pickup truck. There'd been a stampede as the horses headed back to the barns, and several riders were thrown. Henry was one of them. He lay now in the back seat, white with pain, his denim shirt in tatters, gravel and dried blood embedded in his back. He'd broken several ribs (we'd later find out), but for now there was nowhere to take him but the local doctor-in-a-cabin, 30 minutes away. Off we went.

The doctor in a cabin was exactly that, an ill-equipped doctor in a remote log cabin. He tossed Henry's shirt, handpicked the gravel from his wounds, and probed for broken bones, but for pain he had nothing but Tylenol with codeine. Near midnight, I drove our little family back to Vancouver while Henry writhed in the back seat for seven hours. Our flight was that morning. His injuries meant the imminent move—packing, house-hunting, divesting, arranging—would all be on me, and we faced a tight deadline. We didn't know yet that his broken ribs would never heal properly, gifting him with a lifetime of pain.

Still, we made it work. We flew to Indiana, and I house hunted while Henry rested. On moving day, we flew again instead of driving 15 hours to Indianapolis, sending our belongings by U-Haul and asking another friend to drive our car, loaded with glass-covered paintings and our two pets. Our driver, eager to make good time, drove flawlessly until the last hour, when he

fell asleep and totalled the car. The paintings, swaddled in blankets, sustained no injuries, nor did the cat, the dog, or the driver. But in the last 24 hours our rental house had fallen through, and now we were homeless *and* carless.

Henry, having re-cracked his ribs in a sudden movement, was in even worse agony than before, and Daniel was despondent and angry over leaving his best friends. I was exhausted from travel, from house-hunting and packing up a five-bedroom house without Henry's help. Far from a blessed transition, this was a rocky beginning. Still, I reasoned, we were doing the right thing, the sacrificial thing, and reward must be at hand.

The shower of compensatory blessings failed to console me. While there were great aspects to our new life—the church was warm and welcoming, Daniel found new friends, Henry was flourishing with a new staff and responsibilities—for me, something was missing. I felt like an outsider, struggling to relate to the upbeat Midwestern women who were now my closest friends. Everything felt generic.

For weeks, we got to know families in the church by having them over for dinner, and after the first half-dozen suppers, a horrifying realization dawned: *almost every couple's story was the same.* They'd been raised in the Midwest, gone to university (Purdue, Ball State, Butler, Indiana University) where they'd become Christians and married their handsome counterpart straight out of college. They had three or four well-rounded, athletic children who'd follow in their footsteps. They loved basketball, football, Jazzercise, and tailgate parties. Although we never talked politics, they were probably solid Republicans. They were on track to have oodles of athletic, all-American grandchildren with similar interests, hobbies, and trajectories.

I liked these women, loved them, as sisters in Christ. They were kind and warm, but I couldn't relate to their wholesome cheer and settled lives.

I'd felt far more at home in Nigeria, where millions of short-changed Africans scrambled and pushed for survival in the packed streets of Lagos. We'd lived with them, among them (at one point, sharing our tiny three-bedroom bungalow with eight African women and children), vying with everyone else for electricity, clean water, transportation, and the remote chance of getting a home telephone, while shunning the sheltered expat community.

I'd fallen in love with the persistent, expressive Nigerians and their feverish lifestyle, with their humorous take on the chronic, corrupt, and exasperating conditions of daily life, and with the fierce zeal they transferred to their faith. We came from opposite worlds, yet somehow my heart clicked with theirs. Maybe it was the survivor in me.

But I was in Hoosier Land now, and I tried to adapt, painfully enduring Thanksgiving celebrations that focused on football, but drawing a line at attending the Indy 500. Strangely, some aspects of Midwestern life were rubbing off on me. I found myself crying at school assemblies while singing American anthems in a room full of patriots, and Jazzercise was actually kind of fun. I threw myself into the ministry and started a neighborhood women's group that grew weekly. We put on some incredible women's events. I found some country roads to explore, edged by ubiquitous corn fields, and bought a second-hand bicycle.

Tassja was adjusting to her fourth preschool and driving her teacher crazy. In my first and only parent-teacher conference with her, she got straight to the point. "Mrs. Kriete," she said, "I've been teaching preschool for over 20 years. In all my classes, I like to have flow. I'm *good* at flow." She paused for dramatic effect. "With Tassja in my class, there IS no flow."

I had to laugh. This was an apt description of life with Tassja as I knew it, too.

Even if the abundant blessings I'd been expecting weren't evident, at least life seemed settled again. We'd begun to make peace with our new circumstances and sold the Virginia Beach house at great loss. *No turning back* was our second church mantra. For the first year, I was too busy to make room for grief.

But the following summer, my grief was activated when we flew to Victoria for a family wedding and, for the first time in 20 years, I reconnected with some of Jack's closest friends. Six of them lived on Vancouver Island, and they threw me a small party, bearing photo albums and newspaper clippings from our days with Jack. One friend had kept all the articles Jack and I had written during our unfinished cycling trip to South America. Other friends shared forgotten details of past group adventures. We'd undertaken all kinds of trips together: hiking, white-water canoeing, cross-country skiing, and cycling.

I hadn't retained a single memento or photo of Jack—not deliberately, but because of my constant moves—and it was strange and powerful to suddenly have physical evidence of his existence and to be with others who'd known and loved him. By moving away right after Jack died, I'd lost all ties to him beyond his spectre in my heart.

Reminiscing stirred up ghosts—happily, I thought at the time, but I was oblivious to what these remembrances were doing. A tempest was brewing, triggered first by the *Titanic* story of Jack-and-Rose and fuelled now with fresh memories of the passionate man who'd stolen my heart and then died when my back was turned, leaving me empty.

Back in Indianapolis, I wasn't paying attention. Part of me was always busy, chasing my schedule from morning till night, but my shadow side was ailing. In almost every conversation, I felt a strange detachment, as if I were watching a puppet playing my part. At church, I'd wander through

the congregation, giving and getting hugs and wondering how I could feel so lonely amid so much affection. I didn't have the nearby crying spots I'd watered in Virginia Beach, so instead of finding release, my trapped tears gathered force, waiting to erupt like an overstuffed pressure cooker. A nudge or a jiggle would make it explode.

The nudge came in the guise of another's tragedy. A single mother in our church crashed her car one night, killing her own mother and her three-year-old daughter. I keened like a banshee when I heard, not for hours but for days, unable to stop or think of anything else. I knew the young woman, though not well, and had little in common with her except for her three-year-old daughter. Our girls were the same age and had been friends. The details of her accident disturbed me. She'd neglected to buckle in her daughter and she and her mother had just had an argument. But it was probably her age that gutted me most. She was 22, the same age I'd been when Jack died. I didn't make a conscious connection at the time, but I believe I wept for her more than she did for herself, certain she wouldn't have the faith, maturity, or emotional strength to cope with her crushing loss and guilt. I pictured her entire life collapsing in protracted, unbearable grief, a vision that undid me.

It took years before I realized why her loss affected me so deeply. I was weeping for 22-year-old Marilyn, freshly bereaved (Jack was my fiancé, my future), lashed by guilt for not being the perfect companion through his life and death and all that came after, and frozen in raw, unprocessed grief. Triggered by my young friend's tragedy, *that* Marilyn was suddenly alive and present, not doing well, and taking over my 43-year-old body. She'd just woken up from a long, strange dream, and there was hell to pay.

BREAKING POINT

After the grief nudge, I found myself sitting on our tiny back porch, furtively crying in stolen moments. Nobody knew. It was early September, and we were scheduled to join a large group trip to Israel. Henry and I had explored the Holy Land years before, enroute to our new life in Bombay, and the 10 days we spent hopping buses from Dan to Beersheba had been magical. This time we'd be with a group of a hundred—colleagues and friends from around the world—touring and talking from morning till night: an extrovert's dream. The prospect dismayed me. Among such friends, I was hopeless at hiding myself. Indeed, I usually relished the intimacy of sharing feelings, struggles, and confessions over the hours we'd spend together. This time was different.

I knew exactly how these ministry trips went. For days on end, we sat, walked, talked, and ate with the same friends, all with shared history and church culture, and everything came out. I've always loved long, open-ended conversations. Around the three-hour mark in a conversation, it's said, people start getting deeper and more honest. But now I dreaded such

conversations. Inside, I was 22 again, fresh grief flooding my heart, and *this* Marilyn didn't want to be surrounded by her future ministry friends, let alone talk to them. *This* Marilyn didn't even *know* them yet.

My body, always more attuned to my true condition than my conscious mind, conspired to protect me. I developed a double ear infection, with both ears so profoundly blocked that flying was out of the question. (All my life, severe middle ear infections have been my Achilles' heel, inflicting months of pain and impaired hearing.) Surely, I'd get a pass… but no, I wouldn't. It was nearly impossible to use illness to get out of traveling. Group discipling events, like pretty much every meeting or activity in our churches, were mandatory.

Instead, I was told, I'd miss the scheduled flight and schedule a tympanostomy, the fancy name for getting your eardrums popped, drained, and fitted with ear tubes. Thus doctored, I'd fly alone to Israel and catch up with the tour a few days late. If all went according to plan, I'd be around my inquisitive friends for six full days of probing talks.

The procedure, conducted without anesthesia in the specialist's office (*This will only take a few minutes,* said the doctor, confusing pain duration with intensity), sent me through the roof with searing pain. A day later, I began my 30-hour journey of flights, lay-overs, and transfers to reach Israel. In Rome, the Israeli officials questioned my last-minute ticket purchase and detained me for seven additional hours, asking the same questions 40 different ways before deciding I wasn't a terrorist disguised as a frazzled church lady. Along the way, my luggage was lost. I arrived in Jerusalem like a bereft refugee, not happy in the least to have made it.

I cried the whole way. By now, my grief had returned to its roots, and I felt as if Jack had just died. But this time, instead of stuffing my pain into an impenetrable bubble and riding away on my bicycle, as I had at 22, I

was forced to live it and *feel* it, in all its searing anguish. The excruciating ear surgery paled by comparison. If it's true we grieve in proportion to our love—and it must be—I was doomed to drown in an endless tsunami of grief. After all, I hadn't, I *couldn't* stop loving him.

I'd never heard of such regressions. Old lady Rose, still dreaming of Jack in her dotage, had confirmed my suspicion that time doesn't, in fact, heal the deepest wounds (as long as the heart goes on, so does the pain), but I'd never heard of delayed grieving or complicated grief. I'd never heard of anyone reliving their greatest loss decades later, or of a griever reverting to the emotional age they were when the loss occurred. I only knew that something overwhelming and inescapable had flooded my being and I felt like an absolute freak, ambushed by grief that was stuck in time, a sleeper gathering strength for two decades while I seemingly went on with my life.

My week in Israel passed in a blur. I was jet-lagged, desolate, and drained, wearing borrowed clothes too hot and baggy for the climate (my suitcase turned up on the last day), traipsing through ruins and listening to lectures that pinged off my heart like ancient pebbles on stone. I was living a parallel life, walking around in a friend's clothes, wearing my ministry face, yet awash in my private tsunami. I was afraid to tell Henry—my bereft state scared me, how could it not terrify him?—and shared only slivers of my turmoil with two friends. But what I hinted at was bizarre, and my friends' bewildered responses made me feel even more freakish. "Every landscape is a condition of the spirit," wrote the philosopher Henri Frederic Amiel, and on this trip, only the dusty, impoverished towns of Palestine spoke to my spirit. All I wanted was to return to my children and then hide myself in a closet where I could secretly weep.

How had I lived through the past 20 years, unaware of such vast, buried pain? I'd stuffed my grief in a locker and forgotten both locker and contents existed. The only way I could explain it, to myself or to others, was to say I'd been *busy*. From the day Jack received his final prognosis, 21 days before he died, until now, I hadn't stopped moving, running from death while it burrowed inside me.

Jack was a nomad, a born traveler, and he'd pulled me into his world when we set off on our great adventure: a bicycling trip from Canada to South America, where we planned to one day return and live. During that trip, his cancer returned, and within months of aborting our trip, he was gone.

I embarked on my own cycling trip within days of his death, filling my blank, widowed slate with a constant flow of people and places before unexpectedly becoming a Christian at the end of my wanderings. I'd undertaken the solo trip as a tribute to Jack and a test of my own spirit, but all I'd really done was postpone the mourning I wasn't able or ready to endure. Soon after, I met Henry and dove into the ministry, marrying within a year and working at his side. We celebrated our first anniversary in Boston where we'd moved for three and a half years of training before planting a church in Toronto. The years were busy, fruitful, and full. We barely had time to feed our marriage. From Toronto we moved to Bombay, immersing ourselves in a new culture and adopting our Indian son. Our years in India were followed by a six-month stint in London, and from there we'd flown to Lagos for a supposed six-month assignment that turned into four years.

Our next location was Pretoria, on the cusp of Nelson Mandela's election, where we grieved Nigeria but fell in love with broken South Africa. We were comforted in Pretoria by the promise of staying on the continent for the long haul. Two years later, we were suddenly transferred to Washington, D.C. Leaving the continent was a huge blow, the snuffing of

our African dreams. I was gutted and felt utterly betrayed by the sudden change of plans.

I started crashing in the nation's capitol. After sunny, vibrant Africa, I abhorred the cold sterility of our new neighborhood, aptly named Foggy Bottom, where we lived just blocks from the infamous Watergate Hotel.

My serial losses were catching up. I battled insomnia, crying alone at night, too immersed in grief to see its origins, and attributed all of it to losing our African dreams and relationships. In Washington, as everywhere, we had responsibilities that kept us running from early morning to nearly midnight, six days a week. We were given 'holy Mondays,' a single day off, to recover from the ministry, but it was never enough. Mondays were also couple time and family time, leaving little space to check in with myself.

Washington, D.C., was the low point in our wanderings. Our subsequent move to Virginia Beach seemed a reprieve, only to be pulled out from under us with the summons to Indy. If I'd been charting myself, keeping track of my losses and gains, I could've predicted the inevitable meltdown awaiting me. But I hadn't. I'd been busy and didn't yet know the tenacious, cumulative nature of grief.

The funnel sucked me deeper when I returned to Indy from Israel. Now I truly felt like an actor, wearing my ministry face around everyone and hiding my true face of despair.

And all this Jack sorrow! Despite what Henry assumed, after my grief first erupted, I *hadn't* been conscious of Jack throughout our married life, lurking inside like a gothic family secret. Sure, there were two anniversaries I never forgot, his birthday and his death-day, but apart from brief imaginings and calculating how old he'd be without the second date, I tried not to dwell on these reminders or linger too long in memory-land.

He was gone; I'd always love him; it would always be the most tragic chapter of my life. I'd never love someone as deeply, or rather, *let* myself *depend* on someone as deeply, as I had with Jack. I couldn't. That decision had come swiftly, before I'd even picked up his ashes from the crematorium. As for his part in my marriage, I guess he *had* been a shadowy third, but hidden so well in the dark that I'd not seen him.

Now I was trapped in 1978, the year of Jack's death, remembering his illness and his exit in excruciating detail, weeping as I should have wept then. The sense of having fallen back in time was constant. Forty-three-year-old Marilyn had vanished, and a younger, shattered Marilyn took the stage—an empty stage where she wept alone, anguished and confused. Nothing in my 1978 life corresponded with the life I was living now, and vice versa. How could I explain this sudden fall down the rabbit hole to everyone around me, especially those who were used to the competent Marilyn who spent her days teaching and nurturing others? I couldn't. As insistent and real as my fall into this time-warp felt, I knew it would sound insane to anyone unless they'd experienced something similar.

And nowhere could I find anyone who had, even in books.

Henry was still sympathetic at this point, though I didn't share how immersed and trapped I felt. I was drowning. He agreed I needed help, some holy and skillful intervention, preferably from a professional with a similar faith background. An experienced therapist in our church fit the bill and I rushed off to see her. She was warm, sympathetic, and maternal, and though younger than 43-year-old Marilyn, she was senior to Marilyn-in-the-chair. I viewed her as my only hope.

She kept huge boxes of tissue on her desk, essential as I poured out my story and cried out for a rope, a light, any kind of rescue, and begged for help to make sense of the tsunami. Our one-hour session stretched

into three. All the tissues in the world couldn't absorb the ocean of pain that flooded her office. At the three-hour mark, she pointed to the clock. It was near midnight, and she was a working mom with early morning appointments. I had to swim myself to the car and go home. When could I see her again?

"Next week around the same time," she told me. "My schedule is full, but I can make time for a weekly appointment. But only for one hour, two hours max. That's the best I can do."

I couldn't last a week. I wasn't sure I'd survive the night. Now that I'd opened the floodgates—or *started* to, there were oceans to come—I couldn't imagine having another 'normal' day. Ashamed of my neediness, I told her I'd see her in a week, knowing I'd never make it, and drove home in a panic. If I were to identify the tipping point, this session, and the overwhelming feelings that followed, is where my nervous breakdown took hold.

The next morning I called her office, begging to be patched through, and told her that waiting a week between appointments was impossible. I was bleeding out, even as we spoke, and needed immediate, intensive care. But she already knew that. And she'd already made a call to Theo, her mentor, to seek advice. He was a therapist I'd seen back in our Washington days, when I'd had four sessions to talk about my grief over leaving Africa. Those appointments were five years prior. My Indy therapist was astonished by his response. As soon as she mentioned my name, and before sharing any details, he asked, "Is she ready to deal with that loss from 20 years ago?"

I couldn't remember mentioning Jack to Theo, but I must have said something, and he'd glimpsed the enormity of what lay hidden. It was as if he'd been expecting this call, someday, whenever the sleeping giant awoke. *Knowing* the giant would waken.

He'd be happy to see me, he told her. He'd clear out his schedule and see me every day for two weeks, as much as I needed. Philadelphia was his new home. I should come right away. He was ready and waiting.

CHAPTER

MY PORTION AND CUP

Theo had been a lifesaver when I worked with him in the past, though I'd swept away memories of our sessions as part of the painful baggage I'd carried in Washington and wanted to forget. Our first year there had been dark and heavy. Along with our shared grief over leaving Africa, Henry was belatedly mourning the death of his father, who'd died suddenly when we lived in Lagos. He'd flown back for the funeral in a daze and returned days later in an even greater daze. Like me, Henry had buried his huge, complicated grief, only to be inundated later.

When the delayed emotions hit, six years later, he was bulldozed with grief and regret. This led to several weekend sessions with Theo, a fellow church member and therapist who specialized in working with ICOC staff members. At that time, Theo was living in Boston, and the leaders had flown Henry there for a series of weekend sessions. At some point, he asked Henry how his wife was doing.

Henry, mired in his own pain, was a bit out of touch with mine. "OK, I guess. Better than I'm doing...but she *has* been spending a lot of nights crying in the study."

(It's amazing how prolonged misery distorts our perception of what's normal.)

"Bring her with you next time," Theo said. "She needs help, too."

And so I came. We traveled the day the O.J. Simpson verdict broke and watched the stunning outcome in the airport, waiting for our flight to Boston.

Henry had prepared me for Theo's physical appearance. On his first visit, he told me, he'd sat in the waiting room, envisioning a thin, bespectacled, pin-suited intellectual stepping out of his office and calling his name. As he waited, a short, black, woolly-headed gnome dressed in faded flannel and corduroy and floppy white sneakers passed in and out of a closed room several times. *Hmm*, thought Henry. *Dr. Ackerman must be counselling some homeless clients. Good for him!* A few minutes later, the homeless man opened the door.

"Henry," he said, extending a broad hand. "I'm Theo. Pleased to meet you!"

I knew to expect the unexpected (he did look homeless!), but didn't expect to be instantly charmed by the grinning leprechaun who greeted me, wearing a plaid vest over an adorable round belly with his aforementioned floppy sneakers. He looked like a compact Black Santa Claus (and for Christmas, years later, I gave him a ten-inch Santa that looked just like him, down to the afro, the wire-rim glasses, and the twinkle in his eyes), though he hailed from the Deep South, not the North Pole. His honeyed accent made him even more disarming.

Theo believed in long appointments for long-distance clients, allowing time to go deep if they were ready. Perhaps he was privy to the

three-hour-conversation tip, too. He'd cleared out entire days to meet with us, separately and individually, and we dove in, hungry to be heard in a place of non-judgement. We could bare our souls with our ministry mentors, if we chose to, but we'd inevitably be brought back to what was best for the ministry: unquestioning commitment to the mission and to those who determined where we'd live and what we'd do. If we got too raw, repercussions would follow, and intense emotional attachments, to which I was prone, were seen as a liability. But in Theo's office, all expectations were left at the door and we were free to be ourselves: weak, wailing, and ready to dive into gut-level honesty and full disclosure.

In these Boston sessions, I spilled my insecurities with him, having fallen from pinnacles of faith in Lagos to the pit of a messy ministry in Washington. We'd inherited a 500-member region built on hasty conversions and shoddy follow-ups. In the ICOC, every member was expected to attend three services a week: Sunday morning, midweek, and a small-group Bible study. Only extreme circumstances exempted full attendance. We modelled and expected dedication, with a few stragglers in every large group. But when we inherited our new region, a full quarter of the members were struggling or nowhere to be found, and we were held responsible for all of them. We hadn't ever met many of them! In many cases, their identities and whereabouts were a mystery, or, if they were traceable, they had no interest in coming back. How were we expected to bring these ghosts back to the fold?

Every Tuesday in Washington, we spent most of the day in disheartening staff meetings, where each region's statistics (attendance, conversions, visitors, Bible studies, financial contributions, etc.) were publicly shared, analysed, shamed (or praised), and used as a marker of how well each ministry couple was, or wasn't, doing. Our statistics defined us, and

no allowances were made for mitigating circumstances, like inheriting an unholy mess as leaders were shifted around, or struggling with personal issues that affected productivity. We were doing our best, but as Henry put it, it often felt like we were trying to run a race with a broken leg.

We were mourning lost dreams and relationships in Africa after our sudden and unwelcome move. In particular, we mourned two orphaned Liberian girls who'd lost their parents and home in Liberia's civil war, soon landing in an empty Nigerian warehouse where we met and unofficially adopted them. In the course of two years, they'd become like daughters, but we were forced to leave them behind when we were asked to move to South Africa. After our departure, they'd vanished into the vast pool of refugees housed in rough camps outside the cities. I not only mourned them, but felt incredibly guilty for breaking promises we'd made, promises we were powerless to keep. Many other deep relationships ended when we left Nigeria and then South Africa, never to return. The finality of these endings broke my heart. With every move, I wasn't getting better at moving on, but markedly worse.

I shared all this with Theo, who listened, and made me laugh. Being with him felt as comfortable as hanging out with Santa on his time off.

No one except Theo understood how Africa's dirt was still under our nails, how we pined for hot African days and evening strolls around our bustling neighborhood, dropping in on friends and making new ones in the streets. Our home had been filled with friends and visitors. We'd plunged headfirst into third-world hospitality and spontaneity, and now, thrust into Washington's *call-first-and-book-an-appointment* culture, we felt lonely and displaced. We missed the food, the roasted corn and plantain in the markets, the bartering with street vendors for tomatoes, yams, and eggs. We missed feeling *alive*. In Washington, I felt heavy and burdened.

As much as I knew it wasn't helpful, I couldn't stop comparing our days in Africa with those I was plodding through in America.

I also felt very guilty. As a Christian, I knew I was called to be joyful in all circumstances. I felt guilty for not being my usual, spirited self and for feeling faithless and betrayed. Not many outsiders choose to live in Africa, but we'd fallen in love with Nigeria and South Africa, and hoped in both countries to stay for the long haul. Now we were flailing in a city that failed to capture our hearts or inspire any loyalty.

I had a favourite scripture from Psalm 16 that I loved to share and proclaim:

"Lord, you have assigned me my portion and my cup;
You have made my lot secure.
The boundary lines have fallen for me in pleasant places;
Surely I have a delightful inheritance."

For years I'd connected with its message: God chooses the times and places of our lives, and He always knows best. With places come boundaries—all the places we can't also be, all the other lives we aren't living—but these boundaries are *good*, part of our spiritual journey enroute to our ultimate inheritance: heaven. But now my boundaries no longer felt pleasant. I didn't like where He'd assigned me, and I struggled with who was to blame. To hold a faithful view of my life meant holding God responsible, and that felt scary. How could I be angry with my Creator, the One who knows best? The other, worldly view was to blame the leaders who'd called us out of Lagos, then Pretoria, and sent us to Washington. Nothing about our new home felt right, so whose fault was it? I didn't belong in Washington, D.C., any more than my white, Canadian husband was a good choice to lead the

large campus ministry at Howard University. Yet that's what they'd asked him to do—based on our African experience, which was hardly the same.

My faith struggles were huge. How could I joyfully proclaim Christ in this world when I didn't trust the world He'd given me?

I spent three days in Boston discussing these things with Theo. We talked about my insomnia and midnight crying. He pointed out the obvious: yes, I had reasons to cry, but I was also clinically depressed. Was I open to seeing if an anti-depressant would help? I was. For a short time, I tried Zoloft, and the medication might have helped a little, though I think the arrival of spring helped more.

The Boston sessions didn't fix me, but I was grateful for Theo's witness. Nor was Henry completely fixed. We were like swollen, infected wounds, and Theo had drained the upper layers. There were indications of a deeper mental illness in Henry—intense mood and energy swings—that no one noted or addressed, including us. In another swift move, we were relieved of leading the 500-member region and sent across the Potomac River to lead a 12-member family group. This was a stunning demotion, in terms of ministry and prestige, yet an unexpected act of grace. Our 'exile' led to a time of great fruitfulness as our group of 12 tripled in size in the course of a year. God has a sense of humor.

Somewhere in my sobbing narrative to Theo, I must've mentioned Jack. But in those early sessions, he was simply an ancient thread in my unravelling life, a closed-off corner of my distant past, an unfinished story I rarely mentioned. Jack represented another lifetime, joined to a different Marilyn, and surely not connected to my grief over Africa and all our other losses.

Or so I thought.

CHAPTER

RED FLAGS

Within days of my therapist's phone call, I flew to Philadelphia for two weeks of sessions with Theo. Once again, he'd cleared his schedule to focus primarily on me. When I was all better, I'd fly back with my new, mended heart, ready to reengage with my current life. The intervention would be a short but necessary blip on our marriage-and-family continuum.

I started journaling in preparation for our sessions, most of it anguished letters to Jack in which I struggled to say what I'd failed to say in life. This seemed like a good starting point; after all, wasn't being stuck in grief all about unfinished business? Long past caring what strangers might think, I scribbled and wept in the departure lounge till the last boarding was called.

Theo had arranged our first session for the morning I arrived, and I felt like I was delivering a tray of raw eggs, each ready to roll and crack if I didn't reach him in time. But when one of the Philadelphia church elders picked me up from the airport, he told me Theo was suddenly "missing in action." What did that even mean? The elder said that he'd try to track

Theo down and see if he and I could meet the next day, a Saturday. He shed no light on possible reasons for Theo's disappearance.

One missed day shouldn't have been a big deal, but for me it was huge. The lone life raft I'd spotted had disappeared, and I was bobbing and panicked in churning waters. My mental state was that precarious.

Theo's unexplained absence was a red flag, one I felt but refused to see. Based on his intuitive question—*Is she ready to deal with that loss of 20 years ago?*—I was convinced he was the only person on earth who could save me, but now I grappled with intense feelings of abandonment. *How could he not be here for me, knowing I'm disintegrating, desperate, dying?* Instead of driving to Theo's office, the elder took me to the inner city apartment where I'd be staying with two young interns in the church. I could rest up, he said, and he'd call when he found Theo.

But I couldn't rest. The apartment was narrow, high-ceilinged and almost windowless, dim and claustrophobic. The women who lived there each had a tiny bedroom, but I'd be sleeping in the cramped, cluttered living room that doubled as their office space. I was grateful for free lodging, but this was all wrong. I needed air, light, and privacy. I needed a secret place to cry the tears that wouldn't stop and somewhere to walk or run when I needed the numbing power of exercise to clear my head. The streets outside weren't safe; the warehouse-turned-apartment-building sat in the heart of a ghetto, with dealers, used needles, and addicts just outside the front door.

"Don't go outside," my hosts advised me. "No one walks safely out here." They jumped in their safety-alarmed cars and drove to tonier parts of the city to run their ministries. I sat on their scratchy old couch and cried, feeling like the shadowy room and my dark thoughts would crush me.

Theo was found. The next afternoon, the elder delivered me to another ghetto where Theo kept his office and helped run an addiction recovery

program. I was trembling as I climbed the worn linoleum stairs to the second floor. Theo hadn't changed. He was wearing another of his signature knit vests and his eyes still twinkled. His tummy was still round and comforting. But he looked a bit green in the gills. He was hungover, in fact, though I didn't know this yet. Neither of us mentioned the missed appointment. As sunshine hit the grimy windows, we grinned and hugged like long-lost friends. I'd come to the right place.

I had brought pictures of my children to show him, the remaining lights of my blighted life. Daniel, now 11, was the exact age of Theo's adopted son, Aaron. In a striking coincidence, both boys were born and adopted on the same June day in 1988: Father's Day. We'd all become parents at the same time, an ocean apart, and Theo and his wife had later adopted a little girl, just as we had, though she was three years older than Tassja. Theo proposed I stay a bit longer, into Thanksgiving, and suggested our families spend the holiday together so the kids could meet. He was eager to see Henry again and thought it might be helpful if Henry could participate in a session or two. His wife Cheryl worked in the office downstairs. I'd meet her on Monday, if not at church the following morning. We were already blurring the professional boundaries between therapist and client, falling into a friendship of shared intimacies and connections outside our office sessions.

But this was inevitable in our church culture. Theo and his wife were also disciples, converted as singles in different locations and married in the church, part of the same overlapping relationships and alliances. This was how we lived, beginning with the one-on-one Bible studies everyone undertook to become a member. A profound level of honesty was fostered from the earliest studies and conversations. We spoke openly about our sins, our yearnings, our struggles, the embarrassing and telling details of

our lives. Nothing was off-limits, and openness was expected. We needed to know what our pitfalls might be, how Satan could tempt us through past and present weaknesses. If I'd struggled with romantic entanglements as a non-Christian, for example, was it not likely I'd be tempted in those areas as a believer?

After the initial Bible studies, every member was discipled in weekly, one-on-one sessions, and with maturity came responsibility to disciple others. Church leaders had multiple discipling relationships (part of the reason for our insanely packed schedules) and were likewise discipled by other leaders. We all knew the ins and outs of each other's lives, our spouses, children, work lives, habits, predilections, and plans. This connectedness was both the strength of our fellowship and our weakness. We shared incredible friendships, but our extreme co-dependence was subject to human pride, failure, and neuroses.

Theo was part of all this and more. He was a counsellor who specialized in helping distressed ministry leaders, a friend and therapist of my husband, a lapsed alcoholic with a mountain of unresolved trauma he'd shortly be sharing with me, and a soon-to-be close family friend. He was also the one basket where I placed all my raw and vulnerable eggs, hoping they would hatch, not rot, in his care.

Viewed from this perspective, it seems foolish that I'd entrust so much to him. But Theo was all heart, as endearing and soft as a teddy bear. He had a quirky sense of humor and wasn't intimidated by the church leaders. After years of counseling, he had a perceptive take on the casualties of being in the fulltime ministry. He understood how we thought, how we were trained to think in the ICOC, and how that affected our mental health.

I sunk into the corner of his leather sofa and pulled out Exhibit A.

CHAPTER

A HOLLOW VORTEX

Theo read slowly, as if each word were a stair to be climbed. Then he looked at me, puzzled.

"But this is a love letter," he said.

I blinked back. "Of course, it is. What did you expect?"

The paper he held was my latest letter to Jack, penned in the airport while I waited for my flight, words blotted with dried tears.

He paused, about to explain, and changed his mind. "Doesn't matter. Tell me more about Jack."

I started from the day we met. I was 15, out on a weekend pass from the Girls' Home where I'd been sent after running away a year before. That year I spent most Friday and Saturday evenings in a dark basement apartment, waiting for my best friend and her boyfriend to emerge from the bedroom. I passed the time swigging cheap gin, being romanced by random visitors, or simply talking to whomever dropped by. Jack was 23, a philosophy grad student living next door in a communal house. He was always looking for kindred spirits, people who loved long, deep talks, and

that night he found me. There were no come-ons or romantic gestures. I was so much younger; it wouldn't have occurred to me. But we talked for hours that night, the first sparks of a profound friendship.

I told Theo how five years later our friendship burst into passion for two intense, wonderful years until he died of cancer. Theo listened, never taking his eyes off me. Seven years of my life had been lit by Jack, first as a cherished friend and then as the most breathtaking love I'd ever known. His love had healed me from parental wounds, awakened me to love myself, and ultimately hollowed me with grief and longing.

Theo's leather sofa was a wise choice. At least the drenched tissues I stacked in a pile beside me wouldn't leak through. But Jack had leaked through every layer of my heart, leaving a geyser the size of Old Faithful, and now that I'd lifted the lid, the eruption wouldn't stop.

As the November sky grew dark, I mentioned my current accommodations to Theo.

"It's awful," I told him. "I'm in such a dark place, and the apartment makes me feel trapped, even worse than I felt before. I don't want to sleep in their living room, crying all night where they'll hear me. There's no place to escape or get away—I can't even step outside for a walk!"

Theo understood. As gracious as my hosts might be, their tiny quarters weren't conducive to healing. He suggested I stay at the elder's four-story house, in the safe, tree-lined streets of the suburbs, where there was ample room to journal and emote in private. The elder lived close to Theo's neighborhood and Theo could pick me up on his way to work. We'd drive in with Cheryl, chatting about everything but Jack until we were safe in the counseling room. In fact, the elder and his wife were scheduled to travel out of town, which meant I'd have the whole place to myself.

Within days, another red flag popped up. Theo and I intended to have daily sessions over the next two weeks, but he was scheduled to attend a weekend seminar in New York and couldn't miss it. Could I travel with him, he wondered? We could fit in sessions around his other commitments. We'd be driving down with a group and I'd share a room with a female attendee, so it wasn't a question of propriety, but it did seem strange for a therapist to take a patient with him. Theo ran his idea past the elder, who quickly squashed it. I'd have to wait for his return, free to cry in any or all of the of unused rooms in the elder's house. Again, I struggled with ridiculous feelings of abandonment, not sure I'd make it through the howling, insomniac nights now that my grief was uncorked.

Nights were the worst. In daylight, there were outlets: talking to Theo (once he returned), journaling in a sunny room, or running miles of circles around a park near the elder's house. At night, I lay captive and awake as the ghosts showed up. I never slept more than a few broken hours, broken and pierced with loneliness and despair. My mind dragged me back to earlier pain, the undealt-with issues around my mother's rejection and my father's passivity. As a teen, I'd smothered these feelings with drugs, alcohol, long walks, and anorexia. Now the shadows were turning into inescapable wraiths, tearing at my newly opened heart.

Old memories surfaced with renewed power. An episode I'd forgotten—the year my father had almost left the family for another woman, a widow with four young children—flattened me, along with the primal pain I'd felt as a 13-year-old, burdened with this dreadful secret. Now the memory pinned me to the bed as I relived the fear and devastation I'd felt, listening to my mother weep and beseech him to stay. In the end, he hadn't left, but his year-long struggle shredded my heart, and I'd never, until that night, let myself fully experience the life-altering pain.

The words of an old hymn played endlessly in my head, a contrast to my exact opposite feelings about God as I wrestled with grief and abandonment:

"Great is thy faithfulness, O God my Father,
There is no shadow of turning with thee.
Thou changest not, thy compassions they fail not:
Great is thy faithfulness, Lord, unto me."

I felt the full weight of my father's emotional abandonment, a father who hadn't cherished or fought for me, whose love felt distant and impersonal and was unreliable and never enough, and I realized I'd transferred these same qualities to God. Yes, I believed God knew me and watched over me. He'd been a power and a strength in my life, had given my life meaning and purpose, had led me around the world and brought a good husband and two beautiful children into my life. But was He perfectly faithful? Was He with me like a loving father, anticipating and meeting my greatest, most crucial needs—my emotional ones? Another line from the hymn taunted me:

"All I have needed, thy hands have provided;
Great is thy faithfulness, Lord, unto me."

Instead of filling me with love and security, it seemed God had taken and taken. He'd birthed me to parents who pushed me away. He'd taken Jack, the most compatible and loving person I'd ever known, the one who knew me better and loved me more unconditionally than anyone ever had, who'd found treasure in a broken girl and made her feel special. God had

allowed infertility, marriage struggles, constant moves, and immeasurable losses to plow through my life. He'd known the state of my heart—empty and hurt—yet tested and tried me with wave upon wave of giving followed by endless taking.

With similar despair, I wrestled with another scripture:

"God is faithful; he will not let you be tempted beyond what you can bear. But when you are tempted, he will also provide a way out so that you can stand up under it." (1 Cor. 10:23)

This verse gutted me. It intimated that the fault was mine, not God's, that I'd lost sight of the way out, and that all my troubles were my fault. Still, I blamed Him. He'd overestimated what I could handle. I couldn't bear the grief He'd heaped on my head, and now the dire state of my heart and my faith were exposed. Clearly, I couldn't trust God to meet my emotional needs. Look where He'd brought me! I was a hollow vortex of need, and no one, except Theo in his small, imperfect way, was doing anything to fill it. No one could. I craved the physical and emotional comfort I'd found in Jack, the high point of joy and security in my tumultuous life, and even though 20 years had passed, my heart had not forgotten and insisted on feeling that way again.

I knew my husband loved me, and I loved him. But in many ways, we were miles apart. My heart craved a different love, with someone who consistently brought out the best in me. In the beginning, it seemed Henry did, but time and conflict had eroded that purity, and now we were often at odds, or on different wavelengths. The love I shared with him was based on our shared passion for teaching the gospel and serving others and our spiritual roots had given purpose to our marriage. In this way, he'd brought

out a different 'best' in me. But we'd let years of over-scheduling crowd out the time we needed to nurture our relationship. We ran our ministry like a non-stop clinic, devoting hours to other people's lives and marriages but mere minutes to our own. And there were underlying tensions between us, hot spots that surfaced early in our marriage and were never resolved.

In our sixth year of marriage, we were summoned from Toronto to Boston for two weeks of intensive counseling sessions, an excruciating ordeal that exposed our resentments and rifts but left us unhealed. We were in the hands of amateur counselors, leaders in the church who meant well but lacked the skills to guide us to recovery. Since then, our marriage had been peppered with disruptive landmines, hazards we learned to avoid until new triggers sparked the same old explosions. What kept us together was love: love for our children, love for God and His people, love for the adventurous life He'd given us. And commitment: We'd promised at the start of our marriage that the word 'divorce' would never cross our lips. We believed God had brought us together. We still do. We were in this for life, no matter what.

And now we were being tested by fire. Neither of us expected the intrusion of my Jack grief, and we were already vulnerable from years of ongoing change and uncertainty. Henry was a bewildered soldier, trying to support his shattered, sobbing wife and struggling with his own justified resentment and griefs, while Satan's arrows zinged past my heart into his.

CHAPTER

THE BOX MUST BE EMPTY

Once Theo returned from New York, our sessions resumed. Each morning, Cheryl and Theo picked me up from the elder's house and drove us over the Schuylkill River into the city. My heart would beat wildly from the moment I entered the car, anticipating and dreading the emotional flood that would start as soon as Theo closed the office door and handed me a box of tissues. We began each session with wisecracks and jokes—he knew how to make me laugh—but it wasn't long before his simple questions had me in tears. All it took was "How are you doing?" Or, "How was your night?" Sometimes I could only howl. The grief felt bottomless, inexhaustible, and bound to every fibre of my being.

He wasn't guiding so much as listening, bearing witness as I accessed deeper and deeper pools of pain. I felt free to bare my soul with him, more than I'd felt with anyone since Jack. Usually, I withdrew and cried in secret, and felt intense shame if I broke down in front of friends or mentors. With Theo, I felt far less shame. His compassion and patience brought me to tears—as did almost everything in my canyon of sorrow.

Fortunately, I wasn't paying by the hour for his time, or we would have quickly gone broke. The church was covering all of it. But Theo didn't seem to have a road map, and the more I unearthed my bottomless grief and pain, the more there seemed to be. After our morning sessions, Theo usually saw a client or two in the afternoons and I'd creep into a tiny, unused office on the third floor and journal the memories and associations flooding my mind. Then, if time permitted, we'd have another session downstairs before joining Cheryl for the homeward drive. It was always dark when we drove home, heavy curtains shuttering the close of another harrowing day.

One morning, Theo watched me walk from the elder's back door to the car, and when we sat in his office, ready to talk, he shared what he'd seen.

"I had this strong sense of you, as if I could see and feel the pain you carry. It was so tangible and intense. On a scale of one to 10, I saw your pain at eight or possibly nine."

At least I wasn't a 10; surely 10s were the suicides. Perhaps these weren't the wisest words to share with me. But his words validated my sorrows; I wasn't an emotional hypochondriac, but a bona fide mourner, flattened by life's vicissitudes, and safely (I thought) in the hands of someone who could guide me through my grief to solid ground.

Still, I needed some markers of progress, some indications that Theo had a method to lead me into wellness. Henry, too, needed hope that my grief could be put to rest. He and I talked briefly by phone in the evenings and I couldn't report what he wanted to hear. He and the kids were due to arrive for Thanksgiving in a few days. Time was running out, and I was still in stage one, drowning in despair.

Theo hatched a plan, something he'd done with other clients. "We'll have a memorial," he said. "Together, we'll create a ceremony to say

goodbye to Jack. Henry should be part of it, too. It will help both of you move forward."

My heart seized with immediate aversion. The gesture felt trite and premature. But he was the therapist.

"Find yourself a little box to bury in the ground. It will represent Jack and putting him to rest and the funeral you never had for him."

That oversight had been at Jack's insistence: he wanted no funeral, no ceremony to mark his life or death. I hadn't questioned the wisdom of this directive, the only thing he'd asked me to do once he was gone, along with his cremation.

"Can I write a letter," I asked," to put inside the box? To tell Jack how I feel about him?"

Only an enormous box and reams of paper could accommodate my regrets and my gratitude, my longing and my sorrow, my questions and my desperation, and everything else swirling in my heart.

"No letter," said Theo. "Not even a note. The box must be empty. Maybe a photograph, if you have one, but that's it."

I didn't have a single photo of Jack. That was part of the problem. I'd dispersed his few belongings, cut him out of my conscious mind, and buried my memories in a deep, but not permanent, grave. To my present dismay, I'd moved on in haste and desperation. Now Jack was back and my heart was heaped with unfinished grief, and Theo was asking me to bury him again?

But he was the therapist.

"Okay," I said. "No letter. Just an empty box."

I ignored my inner howl and thought about where I could find a suitable box. Maybe a little carved one, from an import store. Shaped like a coffin, I imagined, like the one Jack never had. The little box memorial felt

all wrong, but Theo was the expert, and apparently this pseudo-funeral might work.

Later that night, I phoned Henry and told him the plan. He was pleased. Here was an easy solution, after all, and we could all go back to Indianapolis after Thanksgiving and forget this breakdown had ever happened. I'd get my two-week miracle cure.

The night before Thanksgiving, I couldn't sleep, anxious about Henry's arrival and the challenge of trying to act normal around the kids. I felt far from the finish line. If anything, I was deeper than ever in grief and confusion, and distressed over the ritual we'd planned. Still, I was excited about introducing our children to Theo's kids. They were hosting us for a Thanksgiving feast and I could hardly wait to see how the kids got along. Imagine having a friend who was born and adopted on the same day as you! Tassja, too, would be thrilled to have an older friend like Crystal, Theo's daughter.

The 650-mile trip took longer than Henry anticipated, and when they didn't show up when I expected, I spent several frantic hours convinced they'd crashed and died, all because of my toxic grief and inherent selfishness. By the time they pulled up, I was beside myself with guilt and fear. But it was time to be Mom again, not 22-year-old Marilyn. I climbed in the front seat, and we drove to Theo's house, visions of turkey and sweet potato pie dancing in our heads.

I hadn't been to their house before, and the paint-starved, three-story saltbox was not what I had pictured. Dead leaves and torn papers clung to a chain-metal fence around a decrepit brown lawn, and the front door was dusty and looked unused. In the back, the kitchen door was open, and we climbed a few rickety stairs and hollered inside.

"Hello! Anyone home? It's us! Sorry we're late!"

No answer. We stepped inside.

The kitchen was an indoor version of the backyard. A blustery November wind had blown more leaves and papers onto the unwashed floor, and the stove stood cold, covered with empty pots and pans. Were we at the right house? A dark blue roaster sat near the kitchen sink, and I lifted the lid. Turkey, already cooked. And a pile of potatoes in the sink, waiting to be peeled. And yes, over on the table were the sweet potato pies Theo had promised to bake. We hollered some more and eventually Cheryl came down to the kitchen. She'd been upstairs, she said, taking a little nap. The kids must be in their rooms and Theo must be in the basement, where he kept his home office. She seemed happy to see us.

More red flags. I noted and dismissed the evidence. Cheryl looked drained, and Theo's basement retreat was a little room where he drank himself to sleep on rough nights. They were fighting their own secret battles. But we all needed a happy Thanksgiving, so I borrowed an apron from Cheryl and peeled potatoes in the sink while the kids ran upstairs to meet their new friends. Theo shuffled in, and there was awkwardness while we shifted from our therapeutic mode to something less intense. I knew Theo was carefully watching my interactions with Henry, just as I was observing his with Cheryl and his children.

One thing was obvious: there was no embarrassment on their part at being mostly unprepared for our arrival. In their place, I would have been mortified at the dirty kitchen floor, the unset table, and the general disorder. Two hours later, we collected chairs from around the house to circle the table, now topped with reheated turkey and a few side dishes. There was no cranberry sauce, but the pies were delicious. It wasn't the Thanksgiving dinner I'd envisioned and something felt off. I wondered if this was how the Ackermans always did Thanksgiving, or if we were all having a

bad year. At least no one turned on the TV to watch football, an American tradition I was happy to skip.

I knew Henry was desperate to learn what progress I'd made so far. We hadn't spoken deeply by phone, and we'd driven to Theo's without discussing the current state of my heart. The unspoken questions and unsatisfactory answers I would have given contributed to the awkwardness of our shared meal. Theo and I were thick as thieves, yet lost in the waters of my grief. The true things each of us wanted to say were suppressed, covered with the thin veneer of pretending that having dinner with your family and the therapist who'd watched you cry for two weeks was perfectly normal.

There would be no fake funeral, no tiny-box memorial for Jack. Weeping as usual at my next appointment, I broke the news to Theo. A trite, belated ritual would not bring closure, I was sure. Saying goodbye to Jack now would be like rescuing him from a dungeon, only to throw him back into a deeper one, tossing the keys into the sea. I was roiling in guilt, convinced I'd turned my back on him when I bicycled into a new life, falling into new relationships that happened too soon. As I excavated the past with Theo, I was seeing my old life, especially the months following Jack's death, from a new and appalling perspective.

Two resurrections—Jack's and mine—had taken place, and my 22-year-old self was scrutinizing every decision she'd made in the weeks following her lover's death, beginning with the dispassionate dumping of his ashes under an unmarked tree. I'd felt no connection to the gravelly dust, but rather revulsion at the thought that these grisly residuals now constituted his final link to the earth. Days later, I'd set off on a quest to complete an unfinished bicycle trip Jack had undertaken years earlier,

riding the remaining miles from Alberta to Colorado. But within weeks, even this quest got sidetracked as I headed west instead to pursue a possible relationship with a man I barely knew. This rebound relationship, the first of several in swift succession, fizzled quickly as I cycled from one blue-eyed disappointment to the next. Even though these events lay deep in the past and were enacted by a lost, lonely version of myself, I was finding it increasingly hard to forgive myself for seemingly moving on so quickly. I should've worn black; I should've stayed in one place and mourned my loss for at least a full year. I should have insisted on having some kind of memorial service. Above all, I should've refrained from pursuing any romantic interests, regardless of the pull or my loneliness.

Ironically, I was also grasping that the same misguided decisions I made might have been Jack's response, too, had the roles been reversed. Neither of us were good at being alone, and after the fullness of our love, its sudden absence howled for consolation, even by strangers. Yet this realization brought no comfort. Jack might have done the same, but he'd also have felt weak and guilty when his grief caught up with him.

The journey and my unsatisfactory rebounds ultimately led me to Christ, the true source of love and wholeness, but even this fact, once the fount of great joy, brought no relief. Plunged back into grief I'd failed to process when the time was right, I felt more lost than ever. Jesus felt very far away, probably because my 22-year-old self didn't know him yet. For that woman, Jack had just died, taking her heart along with him. My lack of joy and consolation in God was another source of deep guilt and shame. I wasn't living up to the gospel I'd proclaimed for many years. I felt like a failure on both ends of my jagged grief journey.

The rest of my life—my marriage, my service in the ministry, even my two children—felt as if it belonged to someone else. I hadn't completed my

grief work, bridging the wide gulf between then and now, and I couldn't complete it until every emotion I'd buried and denied found its way out.

Theo agreed to forego the memorial. It was a terrible idea now that he thought about it. My grief, still raw and tangled, needed processing. As my tear-stained journals indicated, I had mountains of unfinished business to traverse, each step important. My belated, post-death conversation with Jack had barely begun, and planting an empty box in the ground, hoping the gesture would substitute for grief work, would be futile. In fact, it would only make things worse.

This sudden reversal was a sucker-punch to Henry, who'd latched onto the memorial like a drowning man, desperate to get his wife back, ghost-free, and hopefully cured of her spiralling depression. From the tender and ironic day he'd written "I Love the Man who Loved my Wife," his patience was wearing thin. I couldn't blame him. I couldn't stand being with me, either. He was married to a woman who literally couldn't stop crying, hung up on events from 20 years past. We shared leadership of a large ministry, and I'd abdicated to wallow in guilt and old memories. I'd been granted three weeks with a professional to shore up the past and move forward. And now, instead of cooperating with a suggested ritual that might have accomplished something, I was refusing. Henry had every reason to be angry and scared, even if I believed the memorial would bring more harm than good.

I was angry and scared, too: I was angry at his anger and afraid my grief was incurable. The thought of driving back to Indianapolis in my present state was terrifying. I needed more time with Theo, a lot more time, and Theo agreed. He consulted the leaders who oversaw our ministry, breaking client confidentiality with enough information to plead my

case. I imagined the phone calls and meetings taking place—big moves like ours involved many leaders and opinions—and how it would yield gossip about my strange affliction and our troubled marriage. I imagined—and this was not a stretch—the head-scratching conversations and speculations encircling the globe. We were minor celebrities in the ICOC, known to congregations around the world, and our business was notable.

My stepping out of the ministry for longer therapy, which would mean temporarily moving to Philadelphia to be near Theo, would affect and involve many others. We were team players in a complex organization, leading a large church that would require another experienced couple to take our place. Theo was proposing a six-month sabbatical, a break giving me time to tackle my grief and heal. Another move was imminent if Theo could convince our leaders that such an interval was crucial to my recovery.

CHAPTER

ENTANGLED

To someone who's never been part of ICOC culture, it's hard to describe the intensity and extent of our interwoven relationships. I sometimes meet Christians who listen to my story and say, *Oh yes, my church was like that, too.*

But it wasn't. There isn't another church I know of that fosters the intoxicating bonds of love, transparency, and emotional intimacy we experienced. For most of us, being in the church graced us with a depth and breadth of relationships we'd only dreamed of. We shared daily, profound friendships that were stronger than blood. Unfortunately, sin, pride, and weakness could and did contaminate the purity of our fellowship, leading to undesirable (and officially unacknowledged) side effects: control, co-dependence, blurred boundaries, blind obedience to leadership, and the tendency and expectation to follow advice that wasn't always wise or balanced.

When Henry and I first visited the Boston church in 1981, we were stunned by the love and unity we witnessed among the members. To my

delight, we'd finally found a thriving, fast-growing, relationship-based fellowship like the church described in the New Testament. Within weeks of our weeklong visit, we packed up our lives in Toronto, moved to Boston, and never looked back, at least not until later, when my heart was shattered by too many moves and broken promises.

Still, even with my shattered heart, I was convinced there was no church truer to the Scriptures, no better place to serve God, and nowhere else I'd want to be. Leaving the ICOC was unthinkable. This was God's family, warts and all, and we were devoted and loyal, even when we secretly joked about our 'cultishness.'

Here was a culture where our best friends, mentors, employers, and nearly all our family relationships were interconnected; where spiritual maturity was constantly being evaluated, based on compliance, attitude, and performance; where we regularly attended retreats and conferences with our colleagues and spent days in intimate talks, knowingly at risk of having those confessions used against us in later sessions or decisions; and where every aspect of our lives was subject to correction and inquiry, even as we preached salvation by grace and learning to love like Jesus. Talented new members could rise quickly to leadership, giving them a dangerous measure of authority over other immature believers. Premises for discipling were backed by Scripture, especially the dozens of *one another* New Testament verses that proscribe confessing and confronting sin and carrying each other's burdens. Other frequently referenced passages came from the Proverbs, verses on seeking advice, hungering for wisdom, and leaning not on our own understanding. We camped on verses that described the inherent deceitfulness of the heart, and thus the need for transparency and counsel.

A close—and closed—culture like this, tainted with spiritual immaturity, impatience, and worldly ambition, lends itself to deeper problems.

Like many members, both in and out of leadership, I struggled with chronic guilt and insecurity. My salvation, once firmly grounded in God's grace, became precariously linked to works. I learned to stifle the inner voice that bristled at misguided advice and whispered *maybe not*. In this culture, questioning the advice or wisdom of leaders was labelled as pride and was soundly rebuked. And in our results-driven culture, little time remained for self-reflection. The group and its mission—preaching the gospel to every creature under heaven—was everything.

After swimming in this culture for years, grateful for my friends and all the new companions joining our ranks, delighted by our shared purpose and history, I had lost sight of what's healthy, what's nurturing, what's invasive, and what's weird. The good that I felt and witnessed—genuine love, saved souls, reconstructed lives—outweighed the bad effects I tried to ignore. Of all the sins we preached against, pride and disloyalty were regarded as seriously as the big ones: sexual immorality and idolatry.

All these interwoven relationships were my *life*, shaping what I thought and did. And as wonderful as it felt to be so interconnected, being so entwined with others made me lose touch with myself. For years, when anyone asked how I was doing, probing beyond the surface of *what* I was doing, I couldn't really say. I knew how everyone *else* was doing, based on the hours I spent asking questions, dispensing advice, and keeping track of everyone under my care. But until my breakdown, I was woefully out of touch with my own heart. I frequently had crying spells and migraine headaches, low intervals, and waves of unexplained sadness. I dealt with these moments by working harder, connecting more, and praying for strength. Something unseen lurked inside me, but I didn't have time or perspective to investigate its roots. And when I did, when my heart finally forced me to stop and look, all I could see were pain and loneliness.

Before making a decision about whether I needed more time with Theo, the leaders wanted a meeting. I was terrified. For three weeks, my limited interactions had been with Theo and the pages of my journal. My grief was uncorked and my tears unstoppable. I had history with these leaders, and it wasn't all good. At times I'd been a hero in their eyes, exhibiting great faithfulness and fruitfulness, but they'd also heard me say *no* to Indianapolis, and witnessed struggles in our marriage. They'd chastised us for mourning over Africa, downplaying the trauma of broken promises and dreams. I could readily imagine what they must be thinking now. *Hadn't we already had our share of breakdowns? Didn't we have a history of marriage issues they'd already tried to fix? Weren't we grateful for all the moves and opportunities they'd given us?* Now we were struggling again, or at least I was, and my breakdown was breaking down Henry. The Indy church was doing well under our leadership, but if we pulled up stakes for long-term counseling, who would take our place?

Mired in fear, shame, and the impossibility of explaining myself, I wept through most of the meeting, wishing Theo could be there to support me. He'd given his report, but the leaders wanted to hear it from me. I was a blubbering mess, facing an inquisition by six baffled interrogators. How could I expect them to understand this weeping girl, scrunched in her chair with a wet stack of tissues as she wailed over her life in 1978?

I couldn't.

I sensed their exasperation and hoped it wasn't mixed with contempt. They'd seen me in weakness before, but never this shattered, and now it was obvious I was in no shape to return to Indy. Theo's proposal was radical yet straightforward: A six-month break from the all-consuming ministry. Weekly sessions with Theo. Acknowledgement that these cracks had developed over 20 years and warranted at least six months to be addressed and healed.

My brokenness spoke volumes. I was everything these leaders didn't want in leadership: weak, weepy, and inwardly focused. I'm not sure how they would have handled me alone, but the Krietes as a team were valuable, and worth the investment.

For me, the most difficult aspect of the plan was accepting the impact of this six-month hiatus on others' lives. To cover for our absence, a ministry couple with two young children would leave their church in West Virginia and move into our newly rented house. Another family would move to West Virginia to fill their shoes. And both these families planned to bring others with them: interns, nannies, assistants. A lot of people would suddenly be moving house, changing schools, and crossing state lines—on very short notice, in a few weeks, right after Christmas—to accommodate this weeping woman. This ripple effect put great pressure on my healing schedule. If I didn't get better, would I be resented for all the upheaval my grief had caused? Would I be resented either way? I tried not to dwell on this.

Because the move was meant to be temporary, our kids weren't distressed by the news. In fact, Daniel was thrilled the day Henry picked him up from school and told him they were leaving for the Thanksgiving trip to Philly. He'd been minutes away from a dreaded English test and disliked his teacher, who'd embarrassed him in class. Now he could leave the teacher and her class for good, and he already had a new friend waiting in Philly. Tassja was always up for adventure. For her, new schools meant meeting new favorite people. Even Henry welcomed a break. He'd been pining for a sabbatical (something we didn't get in our church), though the circumstances were hardly ideal. As for me, I was relieved to continue my grief work in a place where I wouldn't have to pretend to be happy and strong. That ship had sailed.

CHAPTER

LEADING THE BLIND

We drove back to Indy and awaited the big transition. It was the cusp of 2000, and we celebrated New Year's Eve like everyone else that year, watching TV and waiting for the Y2K bug to bamboozle the world's computers, one time zone after another.

The next morning, we drove to Philadelphia in two cars. Instead of a computer-less apocalypse, we faced a blinding snowstorm, worsening as we inched our way to Pennsylvania. Our pets and the kids huddled in my car, while Henry drove separately, surrounded by the luggage we were taking. Both vehicles spun out several times. As the storm intensified, I was terrified my oceans of grief would sweep my family to a snowy highway death.

I drove through the blizzard in an anxious crawl, unable to see the road or other vehicles. The Y2K bug had spared us, but portents of doom lingered. Everything, especially the blinding snow, felt heavy, heavy, heavy, though I tried to hide my fear from the kids. In the darkness of the car, encased by swirling snow, I felt completely cut off from both worlds, the one we'd left and the unknown life ahead. Perhaps we should have

sought shelter in a motel, but we pressed on, compelled and protected by invisible forces.

The couple leading the Philadelphia church were good friends, and they welcomed us with a tour of the three-story duplex they'd rented for us, ten minutes from their home. Bright sun sparkled on mounds of snow left by the storm, and I was relieved they'd situated us not in a rough neighborhood of Philadelphia, as I'd pictured, but in the elegant Mainline, nestled among rolling hills and pockets of pasture and stables. The house was old, tall and narrow, with a tiny living room and kitchen on the main floor, three bedrooms on the second floor, and a third-floor garret, sunny and freshly painted.

Within days, we configured the single attic room into recreational space for all of us: an artist's studio for Tassja, a gaming studio for Daniel, an office studio for Henry, and an exercise studio for me. We'd have friends and visitors dropping by, but far fewer. For once, our home wouldn't be streaming from morning till night with guests, group meetings, Bible studies, and other appointments. Of our many homes up to that point—twelve for Daniel, four for Tassja—this would be their favorite. We'd spend more family time in this home than in any other place.

My appointments with Theo resumed the next week. This time, they wouldn't be daily sessions, but weekly, two-hour meetings. This time, I'd drive myself to the city to see him, getting lost almost every time and leaving early to cover the panicked hours I'd spend backtracking on the interstates, certain I'd be late for my coveted 120 minutes. My fear of not being able to see him from one desperate week to the next seemed to cancel my ability to navigate as soon as I got behind the wheel, and I kept taking the same wrong turns on the complicated route. Between appointments, I wrote in

my journal, walked or ran through the quiet hills in Chester County, and spent hours at the local library in Berwyn, trying to diagnose myself.

Theo wouldn't give any labels to my breakdown. He listened—too much, I was starting to think—and when he spoke, it was often to share his own struggles. Not current ones, or at least not much. He knew better than that. But he also carried a huge, inconsolable loss from his earlier life, and he brought it out of hiding to share with me. Perhaps he thought his disclosure would encourage me, knowing others carried immense grief into their present and completely altered lives, where it didn't belong and wouldn't go away. But it didn't. Instead, his confession scared me: My rescuer was as haunted by his past as I was. Maybe he wanted to share his story with someone who could relate. Whatever his reasons, we bonded in our grief; his, a devastating family abandonment, and mine, an abandonment through death.

Every week, I arrived at his office in a state of heightened anxiety, trembling over my wrong turns and the fear of missing valuable minutes of therapy by getting lost. So much hinged on what transpired when we met, and the seven-day gap from one session to the next felt like walking a tightrope. Once seated, I released whichever Marilyn was ruling that day: hopeless Marilyn, angry Marilyn, yearning Marilyn, conflicted Marilyn, cynical Marilyn. Theo liked some of the Marilyns better than others, though each version was welcome to emote.

But his lack of direction was infuriating. I had questions for him and wanted answers. Why I was in so much pain, so many years later? Why had I emotionally regressed to my early twenties and had he ever seen this happen with other clients? How was I supposed to recover my scattered pieces and reconsolidate? Would I always feel this way? Was something

inherently wrong with me? Was it possible to negotiate with a ghost and heal the past? Was this a case of being haunted from beyond the grave?

But Theo had no solid answers. Instead, we wandered in a sandstorm of pain, stumbling after vague suggestions that changed from week to week. "Find a private space at home and make a grief closet," he advised. "You can enter it for one hour a day and weep your heart out. But after one hour, the grieving stops." Compartmentalization. This suggestion stumped me, because the only private space in our home was an unfinished cold cellar, damp and full of cobwebs, hardly conducive to healing or release. And one hour a day seemed stingy, given my sole focus on resolving my grief within six months.

But when I returned the next week to report my noncompliance, my unwillingness to venture to the basement and cry among the spiders, he'd already forgotten his advice. Instead, he proposed the exact opposite. "Give yourself over to the grief! Weep and journal all day, every day, till the kids come home from school." This was more in line with what I'd been doing anyway, but even this suggestion left me struggling without guideposts, doomed to cry till I'd run out of tears.

One week he'd commiserate on how hard it was to be married and feel connected to a spouse while swamped by memories of an earlier love. These words alleviated my guilt over the distance I felt from Henry and seemed to suggest our marriage could wait till I was in a better space and had something to offer the relationship.

A week later, he'd focus on ideas for fixing our fractured partnership. "Buy yourself a nice container with a lid, big enough to hold a bunch of written questions and bonding exercises. Make time with Henry every day to pull one paper from the pot and do whatever it says."

The first part of this assignment was easy. I found a beautiful peacock-colored teapot and filled it with prescriptions: questions to generate deep discussions, and activities to share. But the filled teapot was as far as we got. By this point, our marriage was so fraught that we could barely converse unless it was about the children.

Sometimes Theo would suggest my grief would subside over time. Other days, he framed it as a constant ache I'd just have to live with. When I pointed out his inconsistencies, he'd deny ever having suggested the opposite, or argue that both ways of dealing with my pain could be right. If I'd been with a younger therapist, I would have suspected he was winging it, dealing with his first case of complicated grief and in over his head. But Theo had been counseling for decades—he was in his fifties.

His moods were as mercurial as mine. Some days he was the loving, engaged therapist I'd first met, full of gentle jokes and affection. Other days, he seemed distant, prickly, or impatient with me. I understood that—even I was getting impatient with myself—but I desperately needed consistency and some kind of strategy to move forward. We seemed to be tumbling down a long, dimly lit tunnel, hoping something helpful would stick. As time went on, I inwardly blamed him for my lack of progress. He was, after all, the reason we'd moved to Philadelphia, displacing other families and putting my fate in his hands. But he seemed increasingly scattered and distracted, lacking the focus of our early sessions.

So, I did what I usually do to figure myself out. I ran to the nearest library.

CHAPTER

SEARCHING THE STACKS

Books are my lifeline in times of confusion. I read to explore feelings, to understand myself and others by finding strangers with similar tales and yearnings, and to seek answers for the inexplicable. Libraries are my sanctuaries, offering all this for free. This was the year 2000; we didn't have a computer in Philly, and I wouldn't have known how to use one if we had. Perhaps, if the times had been different, I'd have found online others like me, struggling with similar, intransigent grief, and, through them, found a road map much sooner.

Instead, I trekked to the nearest branch library and scoured its shelves for books about grief, loss, mourning, and depression. I stacked books on tables and scanned their contents, schlepping the most promising volumes home and devouring them for clues. What was happening to me? Had anything like this ever happened to anyone else, anywhere, ever? If so, was there a name for my condition? Was it a recognized, documented thing to suddenly wake up after 20 years in an alternate life and find yourself back in the head and heart of your younger, exiled self, feeling as if the death had

just happened and your emotions were fresh? And if it was a *thing*, was it something treatable, or would I be locked in this split, capsized, double life forever?

So far, no one I'd met could relate to my condition. When I told people I was mourning the death of a lover *from 1978* and that it felt like he'd just died, no one ever nodded and said, "Yes, I've been through that too! And so has my sister/friend/cousin/grandfather! And here's what I did..."

Instead, I was met with expressions of fear, dismay, or bafflement, reinforcing my freakishness. In fact, one of Theo's scattershot suggestions had been to join a grief recovery group, and I'd found one at a nearby hospital. Now I could commune with others in the throes of grief and find comfort in sharing my journey. At the first meeting we sat in a circle and introduced ourselves, along with the loss we were grieving.

"I'm Mary, and I lost my mother four months ago." "I'm Betty. My husband of 40 years just died last month." "My name is Ralph. I'm here because my brother died in this hospital back in December." I noted that none of the deaths went back further than 10 months.

When my turn came, I sat up straight and returned their gazes. "My name is Marilyn. I'm here because I lost my fiancé to cancer, back in 1978. I haven't been able to get over his death. So, I'm here to see if this will help."

If I'd hoped for sympathy from this band of mourners, I'd come to the wrong place. Their sad little smiles vanished, replaced by a ring of mouths held in horrified O's. It was as if I'd walked into a sanitarium with a writhing sack of deadly contaminated vipers and let them loose. *Still mourning the death of someone 22 years later? Run for your lives!!*

They didn't run; I did. My presence was clearly a blight on this otherwise homogenous group, and midway through the meeting I got up to

pour myself a cup of coffee, changed my mind, and slipped out the door with my shame.

Another inane and disappointing suggestion from Theo. How did he think I, with my freakish, oversized grief, could find consolation in such a group? With every failed attempt at finding answers or even connection, I felt more alien, a toxic blob leaking misery onto everything I touched.

Back at the library, I searched for conditions that matched my malady. I'd never heard of delayed grief, complicated grief, or disenfranchised grief, all aberrations of whatever normal grief is supposed to be. Each of these maladaptations seemed to fit, framing my struggle as an amalgam of everything that can go wrong with grieving. But I found no examples of emotional regression like I was experiencing, and no mention of anyone waiting over 20 years to feel or face the scope of their grief. When I compared myself to the examples given in grief books, I seemed to be suffering a heightened version of all three aberrations.

And none of the books described these conditions in enough detail to satisfy me. In fact, everything about the science of grief seemed vague, and understandably so. How do you measure the severity of anyone's sorrows, or compare them with others', when the mourner's pain transcends language? How do you determine when grief crosses the line from understandably intense and life-altering, to pathological? Like describing what constitutes an actual nervous breakdown—something I'd wondered about since childhood, until recently collapsing into my own—it seemed impossible to put clear markers around the stages and conditions of grief.

After all, even Elizabeth Kübler-Ross's five stages of grief, accepted at face value at the time, had been constructed around the experiences of dying patients, not the grievers left behind, and it was dawning on clinicians and mourners that these stages weren't linear so much as circular

and overlapping. Grief came in waves; every mourner knew that. How individuals deal with grief, the deepest pits of human experience, seemed beyond science's ability to quantify and qualify, but of course clinicians had to try, inventing labels to describe the shock, numbness, pain, anger, yearning, and despair that rush in to fill the permanent loss of love, security, and imagined future, as well as the torment that lingers over unfinished business and unfixable, hindsight regrets.

I took notes as I studied, scribbling quotes from the grief books, interspersed with lines of poetry and harsh self-reflection (achingly, overwhelmingly negative jabs at myself), excited to share my gleanings with Theo and see if any of it could be used to build a ladder out of the pit.

Most of what I wrote seemed to float past Theo's head. We connected emotionally, but not always intellectually, and rarely over literature. Theo worked intuitively, and as much as I valued intuition, I was hungry for logic and concrete directions. I needed a roadmap, as well as a powerful magnet to pull my shattered pieces together again. Instead, I found myself searching for a map and a magnet among the stacks at the Berwyn Public Library, while my therapist frustrated me with reliably contradictory advice and exasperating mood swings.

I wish I'd kept those journals so I could remember the quotes that spoke to my pain. Most of the best lines came from poetry, others from song lyrics remembered or discovered. Somehow, the poetry seemed truer than the scientific research about grief, more rooted in actual human experience than the tabulations of after-the-fact, generically worded questionnaires administered to invisible study populations. But instead of keeping the journals, anticipating a book that needed to be written someday, I'd purged them, imagining their discovery in the event of my sudden death.

If my husband were to find them, he'd be devastated at having to relive my circular preoccupation with Jack. I couldn't bear the thought of breaking his heart again, or of him reading my painful assessment of our marriage, as seen through my devastated eyes. With prescience, I would have culled the quotes for future reference, but as always when it came to Jack's death and his impact on my life, I wasn't thinking clearly. I have a vague memory of rifling through the tear-stained pages of my notebooks before dousing them with bleach and consigning the dripping pulp to the trash.

Or so I thought.

But no. As I write these words, I'm prompted to search again through an old pile of notebooks, and there, tucked between the pages of a tattered green cover, are some torn out pages my prescient self squirreled away for future reference. Not everything is there. But like a personal version of the Dead Sea Scrolls, an intact slice of the past falls into the present, mostly pages I wrote during my first visits to Theo, with updates recorded as I stumbled, howled, and complained through six months of counseling. Twenty years on, the words are here, confirming what I remember and jostling my reservoir to release even more.

It's true: I was utterly falling apart. And even worse than I remembered.

A great deal of my despair fed off our distressed marriage and the yawning, uncrossable canyon that lay between us. There were minefields in that canyon, planted by both sides (with prodding from the devil), seemingly unsweepable. I'd forgotten that Henry, struggling with our two-way impasse, was having his own sessions with Theo during that time. But he skipped and cancelled more and more appointments as the months passed, overwhelmed with emotions and perhaps resentful of the closeness I shared with Theo. At the time, his non-compliance seemed passive-aggressive, but we never discussed his motives or ambivalence. It was difficult to address

anything related to our crisis when we were in the thick of it, especially how we felt the other was falling short. Meanwhile, Theo kept postponing a meeting with both of us, knowing how destructive a three-way session could be with our hearts so savaged and raw.

In many journal entries I wrestled with faith and trust, specifically the *lack* of both in my relationship with God, and how much shame I felt over my spiritual weakness. I was appalled at myself for doubting God's goodness and wisdom, for questioning all the twists and turns my life had taken, and my mind was at odds with my heart, wanting to trust in the Scriptures but knowing my heart was steeped in hopelessness. I also wrote about my children, my fear of hurting them through my visible pain and brokenness, and the joy they brought me, even in mourning. Every page was a lament.

Now I pore through the salvaged pages, lifting sections to share as I write through the eyes of the past with new sight, almost two decades later. The snippets of poetry and quotes I remember writing are missing, except for the lyrics to "Desperado," and the words to an old folk song, "The River is Wide," and a section of prose, copied from a novel I must have been reading at the time:

He'd gone and done it; he'd captured the paradox of loss, at least what Hannah knew of it. No one was ever gone completely, just enough to make you ache. Hannah's mother would always be with her, a shadowy presence she could neither claim nor relinquish, neither quite remember or ever quite forget.

"What do you think?" he asked.
She stepped forward and took it from him.
"It breaks my heart," she said.

From *Deep in the Heart*, I'd written beneath it. I Google the title, hoping to find the author and book that sent me those words. But there's no record of the novel I'd been reading in 1998, only a list of romance novels I've never heard of, bearing the same overused title. I read the lines again, remembering my own struggle to claim or relinquish Jack. Neither felt right, and that was the crux of it.

There are two gems of poetry I remember finding back then. The first, from Robert Browning:

If two lives join, there is oft a scar,
They are one and one, with a shadowy third;
One near one is too far.

And the second, by Emily Dickinson:
I could not die with you,
For one must wait
To shut the other's gaze down—
I could not.

These words spoke to the core of what I felt. But poetry is merely recognition, a shared lament amid the pangs of yearning, and I kept searching for the atlas that could guide me home.

■ ■ ■

As my sessions with Theo staggered on, I yoyoed between anger and attachment. Entrenched in transference and counter-transference, I ricocheted back and forth, longing for each meeting to arrive and then being devastated when we seemed to be spinning in circles or sliding downhill,

backwards. Theo took on more clients, and he squeezed me in between longer sessions with other ministry people in crisis. I was no longer his star patient. Somehow, I'd been bumped from first-class to coach, and I didn't like the demotion.

On the other hand, I saw more of Theo outside his office than in it. He always sought me out at church to share a hug and chat about how I was doing, all things considered. He liked to sit near the back, where he could observe his clients from behind. If he noticed Henry and me sharing a chuckle or whispering together, he was quick to point out signs that our marriage was viable. I was also getting close to Cheryl, meeting for coffee and movies while our kids played together. One night we watched the art house movie *Chocolat* and left the theater in search of the perfect cup of hot chocolate, impossible to find, as elusive as our hopes for a perfect marriage. I witnessed gruff Theo at home, where he shuffled around in sweatpants and disappeared into mind-numbing television, alternately joking and complaining about the mess he and his overstretched wife were too tired to clean. He was gentler with the children than with her, but not blameless.

One day, upon hearing his daughter wanted him to meet to our family cat, he invited me to bring the feline over for an afternoon. When I did, he was furious, wondering whose idea it was to bring that damn cat into the house and ordering it to leave. (He clearly wasn't a cat person.) The incident crushed me—and his seven-year-old daughter— adding to the growing pile of mixed messages he sent. I struggled with the impact of his inconsistencies on his children. Most of his erratic behavior was likely the outcome of late-night drinking combined with advanced diabetes—and possibly some encroaching dementia—but at that point I hadn't connected

the dots. I loved him and resented him and hated feeling so dependent on someone I couldn't predict or detach from.

Inevitably, afraid to confront my sole rescuer, I turned the anger back on myself, feeling like I'd failed everyone on earth, including my therapist.

Still, if I'd been noticing, there were subtle signs of progress. During one maddening session, I bolted from Theo's office before the clock timed out, threatening never to return and furious at his inability to point me in a distinct direction. *I'd show him!* But it was me being shown, more alone than ever, weeping as I navigated the busy highways home. (Strangely, I never got lost on the way back.) The trip took over an hour, but I was still crying as I neared the first townships in the Mainline.

Now I was panicking, wondering how I'd pull myself together in time to pick up the kids from school, or if Henry got them, in time to greet them at home with any composure. I considered finding a hiding spot where I could cry myself to empty, however long it took. But instead of searching for a hideout, I did something I'd never done before: I drove to a friend's house, prepared to do my crying in front of another person (besides Theo and the first counselor). This was huge. Rather than closeting myself when grieving, as I'd done all my life, I was reaching out— not afterwards, but during the worst of it.

Of course, I'd cried in front of others before—like my breakdown in front of our circle of advisors in Washington—but not willingly. This time, I chose to be seen. I cried with my friend, and she didn't pull away. She didn't seem appalled by my wailing or question why I was still so fragile after months of therapy. She simply stopped what she was doing, led me to a quiet room, listened, hugged me, and let her tears join mine. She did everything I needed, and I left feeling comforted and less alone.

Back home, the tenderness was shaky. Henry was watching for signs of improvement, indications we'd be able to return to Indiana and carry on, and the signs weren't there. The empty hours weighed on him. This wasn't the sabbatical he'd dreamed of, a self-structured time free of distractions and outside responsibilities, freeing his mind for fresh pursuits. It was more like a long, anxious wait in the intensive care unit.

The onus for change was on me, but the burden to love, support, and forgive his ailing wife was on him. I wasn't the devoted woman he'd married, but a weepy, morose stranger who kept him at arm's length. He couldn't share in my grief fest, so he languished in his own. What was it like to have a wife mourning the death of a long-deceased lover? Humiliating. Especially as her grief kept unspooling and everyone in our far-flung, tightly knit fellowship heard about it. Who knew what our friends thought, what people said or imagined in the absence of salacious details?

I completely understood his resentment towards me, and I resented him for it. Being in his shoes must have been a nightmare. But I hadn't *chosen* this nightmare for either of us. Like him, I longed to return to earlier days, when the mission had been our singular, unifying focus. I longed to go back to Africa, to the much lighter struggles of third world living, when our battles with malaria, typhoid, cholera, power outages, water shortages, military coups, corruption, roadside robberies, pollution-induced migraines, and insects that laid eggs under our son's tender skin seemed the worst the world could offer. Those long-lost days seemed carefree and radiant compared to our present darkness. Indeed, we were the saddest of specimens: a house divided, a couple at odds with each other, torn apart by unshared history and unwelcome ghosts. Far from being closer to a cure, I didn't believe we could ever be happy again.

CHAPTER

FLIRTING WITH ANGER

Despite the red flags, my earliest sessions with Theo had flickered with hope, like a brave birthday candle in a blackened house.

"*I'm glad Theo knows what he's doing,*" I'd written in my first week, "*because I sure don't.*"

But as the weeks progressed, my journal entries grew bleak and more critical. I was frantic over the passing of time, disturbed by Theo's rambling mind and method, and terrified at the thought of being unfixed at the end of my treatment. At first, I was gracious, giving him the benefit of the doubt and attributing my frustration to a difference in approach.

"*I think my nature is to want to go after each area of my life systematically—room by room, not running all over the house with one item from here, one from there. I'd like to get some rooms straightened out, be able to close the door, and move on to the next one, to feel like I'm making measurable progress, not just stirring up dirt. If I can get a handle on even one room, it will give me confidence that I can complete the whole house. Maybe I'm just impatient...or unrealistic about what this will take.*"

And again, a few weeks later, I wrote, "*Maybe it's just the way I operate, but I feel such a need to understand everything I've felt and talked about with Theo in a LOGICAL way: to understand, step-by-step, how I got to the edge, how to get back to the centre, and how to keep this from happening again. If I miss a step, I might fall again. I'm assuming that by reaching understanding I can transcend and control my emotions. If I'd been around Jesus when he preached, I probably would've asked for some practical applications after each parable—just to make sure.*"

Like the guilty, tortured person I'd become, I initially blamed myself for the lack of direction coming from Theo. But my emotions were out of control, and I desperately needed logic and wisdom to reign me in. I turned to the grief books, tagging my sorrow and despair with possible labels, unsure if they described me or if I was far worse than the cases they depicted, drowning in uncharted waters. "Delayed grieving," for example, occurred when grief resurfaced several months or a few years after the loss, not 22 years later. And I hadn't found any accounts of people being yanked back into their younger, freshly bereaved selves, unable to connect with their current lives and circumstances. Yet Theo resisted labels or even a tentative diagnosis.

This bothered me.

I wrote: "*I want to have a name and a prognosis for whatever my condition is… It's obvious I have the symptoms of depression, but that seems like such a catch-all descriptor for many manifestations. If I have to battle with these feelings for the rest of my life, does that mean I'm chronically depressed? When and if I'm healed, will I feel mostly happy?*"

Eventually his contradictory advice and almost comical reversals made me furious. Was he purposely trying to drive me insane? Intentional or not, it seemed to be working. I wrote:

"*I hear too many contradictions in things he's said along the way. One day, the 'projected possible outcome' of what my relationship with Jack might have been is not a real factor: the relationship was what it was (nearly perfect) and never got sour. The next day (literally!), it becomes an essential way to measure the value of what I think I've lost.*" (This was in reference to discussions about the short duration of our relationship: with less than two years as a couple, we hadn't passed beyond the honeymoon phase. Would the apparent 'perfection' have worn off? And did this unknown factor change anything about my perception of what I'd experienced with him?) Either way, I noted his frequent and profound inconsistencies:

"*At some stage, a fake burial was essential. Then it wasn't.*"

"*One day, I needed to "let go" of the relationship. Then, later, he says I can "keep it"—only compartmentalized.*"

"*I need to build my life independently of Henry; next session, I need to consider 'giving myself completely' to him.*"

"*First he says: I will never truly get out of this pain; I need to learn to live with it and use it to help others. Next session: I need to 'believe' I can overcome this, and eventually I will.*"

"*One week: I shouldn't try medication; I need to address and deal with my issues head-on. Next week: "No, I do need medication to start dealing with my avalanche of emotions.*"

"*Satan has orchestrated these things in my life to destroy me.' Later: 'No, I've chosen and dug this pit for myself—and I LIKE it! It's 'comfortable!'*"

This last one, I clearly refuted: "*I hate it here, it's miserable.*"

The see-sawing advice he dispensed threw me into greater distress and confusion: "*I don't know what to believe, what to keep, what to throw away. Do we need to agree on an assessment of my 'stuff' in order for me to make progress? If so, I'm doomed.*"

I'd skipped the next appointment with Theo after bolting from his office, hoping he'd seek me out, perhaps apologize, and woo me back. Of course, he did none of those things. He knew I'd be back, having nowhere else to turn and clinging to the insane hope that somehow things would change. In an effort to stimulate his thinking, I was bringing him books I'd found, hoping he'd read the short sections I'd marked, and listen to the song that best described the Marilyn left behind by Jack—a Jackson Browne song called "Fountain of Sorrows"— but even these cognitive aids weren't helping; he ignored them. The journal records my growing frustration:

"I'm angry that Theo hasn't taken five minutes to play the song I gave him. I feel like I'm putting my heart on the table, saying, 'This is the song that's defined me—since 1978.' Is it unreasonable to expect that he'd listen to it by now? Same thing with the book section I gave him: it should take only 10 minutes to read. I don't want to be demanding or too blunt. But when I bring it up each time I see him, is that not saying, 'This is important to me?'"

He never explained why he hadn't listened or read, or why he balked at being definitive. He'd promise to do it by next week… and then he'd "forget." I knew he liked to go home after long days of appointments and lose himself in escapist TV. Perhaps he didn't do homework anymore; he'd been counseling for many years, and the books on his shelves were gathering dust. Or perhaps other clients, similarly frustrated, were also hounding him with suggested readings, and it was all too much. Unlikely, but still, I gave him slack and slack and slack. I loved him; I'd entrusted him with my splintered heart, and he was all I had.

I had a goal in mind, captured in this entry: *"I want to bring 22-year-old Marilyn back, and make sure she gets the comfort and healing she needs. I want*

her to learn to share what's most painful. I can't let go of that whole time period because I'll be abandoning her if I do."

I wouldn't quit, I couldn't quit, but I liked to imagine it:

"I feel like writing a resignation letter to Theo and telling him I quit. I've spent so many hours walking around my sadness, assessing the extent of the damage, marvelling and despairing at how huge it is, how unfixable. It's been there all along, and now I've finally seen it, the extent of it, and there doesn't seem to be any advantage in doing so. In fact, now it has a life of its own, and I can't recover my stable and functioning self."

Perhaps Theo was being deliberate in his obfuscations, trying to get me in touch with my anger by frustrating me at every turn. After all, depression is said to be anger turned inwards on oneself instead of the people we're afraid to confront. If that was his intention, he was hitting the nail right on its spinning, exasperated head.

Anger is a tricky beast. Some people live in it, raging through life and yelling at everyone who gets in the way of their elusive happiness. Others let anger smolder till it blows up, then apologize and promise to do better. The lucky among us, blessed with good role models, have learned the proper time and place for anger and manage it well. But I belong to the fourth group, the chronic anger stuffers. Flattened and terrified as a child by my mother's anger, I had no place for it in my adult life. Anger scared me; it destroyed relationships and gutted tender hearts. I kept mine under heavy wraps, invisible even to myself.

Early in my Theo sessions, awakened one night by ghosts, I'd written this:

"Thoughts about Anger:

If I get angry at God, how can I ask or expect Him to help me? If I reject Him, He'll reject me. If He rejects me, I really have no one.

If I get angry at Jack, I'm pushing away the saving love he gave me.

If I express the extent of my anger to Henry, he'll turn it back on me, and our marriage will be destroyed. His anger feels dangerous.

If I get angry at my parents, it will reactivate all the old feelings, and they will reject me again. I want to be closer to them.

If I get angry at 'the Movement' (or those who have made major life decisions for me), I'll be in big trouble, will have to undergo more (pointless) confrontations, and will be called to show 'repentance'—or be rejected. I might be resentful rather than grateful for all the opportunities and blessings in each move we had to make. And I might have to move again.

I guess I'm having a hard time reconciling anger with anything good. Anger = Destruction. And why should I be angry when everybody tried their best?"

With my history, anger was not an option, not a tool for change, and not my friend. I was beginning to see its broad shadow swimming in the murky depths of my pain but could see no acceptable outlet. Instead, I'd turned it on myself, and it was starting to surface:

"How do I feel: Very sad. Life feels 98% painful… even what brings joy will somehow turn sorrowful. Too sad for words, only tears. Starting to feel some anger (!) that life is so SAD."

Contrary to what my exclamation point indicated, this shouldn't have been a surprise. My anger was as potent and real as the blood coursing my veins. And one of Theo's repeated comments to me, that Marilyn sure didn't love Marilyn much these days, was evidently true, popping up all over my journal like stab wounds:

"I really hate the person I've let myself become."

"I hate my life—or at least the way I'm living it. Yet I feel so powerless to change even one thing."

"I remember turning to Jesus because I feared the person I could see myself becoming by the age of 40. Now I've crossed that line, and I'm not the dreaded burn-out that I'd pictured, but a different kind of burn-out: a spiritual shipwreck. Even worse than what I imagined…"

"I don't like being told that I look unhappy most of the time, although I'm sure it's true. It's obvious I've failed to live up to one of my favorite scriptures: 'All the days of the afflicted are bad, but a cheerful heart has a continual feast.' I'd really prefer to live in the land of the feasting if I only knew how."

"Henry has a really hard time with my sadness. He told me the other day that he's mostly attracted to happy, cheerful, funny women (opposite of me)."

The implications of my condition terrified me:

"Everything seems to be at stake here: my marriage, our children, the ministry, my heart and soul, the future. I'm afraid, but there's no turning back now. I can't keep living this way: at odds with myself, divided, uncertain, sick of pretending—most of all to myself. This is the price I pay for ignoring my true feelings, my night dreams, all the symptoms of my mal-or-dis-or-non-functioning that have been shouting for my attention across the years."

Feelings of failure and self-loathing oozed onto the journal. This was larger than grief; it was a complete and utter collapse of self. No wonder I dreaded reaching the end of my six-month stint unchanged or even worse than when I'd started. No wonder I craved a rescuer and wouldn't let go, even if the savior I'd chosen was mired in his own despair and numbing the pain with wine.

I should've found a way to vent, even if it meant flirting with anger. But it seemed easier to focus on my failures and blame my whole life on everything I'd done wrong.

"I'm seeing more clearly every day how my confidence has been stolen. Like someone who won a gold medal for running, and now can't believe they can even jog anymore. My 'legs' feel weak and broken. I have no confidence in being able to teach, inspire, or lead anymore: my cup is empty."

I was angriest at myself for failing to mourn Jack thoroughly, to completion, in a reasonable time frame, the way I assumed normal people grieved. The grief books said the first year of bereavement is the worst, initially bad but steadily improving as the months passed. By the second and third year, they warned, you might take a dip on the anniversaries, but you should be reengaged with life and looking forward. None of the books talked about falling into greater grief decades later. I knew Queen Victoria had mourned her dear Albert in seclusion for 10 years, and publicly for the rest of her life, but she was the only real life example of wildly protracted grief I knew of, and her grief seemed pathological. She'd never recovered, as I imagined I never would, and though she was rumoured to have had a later relationship with a Mr. Brown, she never set aside her widow's black. Yet even in grief she'd managed to rule the British Empire—in other words, pathological or not, she'd done much better in her grief than I was doing with mine.

I envied Queen Victoria. I envied her circle of enablers, letting her get away with it— wearing black every day and looking as glum as she pleased, impervious to whatever they might have whispered behind her back. Her grief had been franchised; it *became* a franchise, as she filled England with monuments and memorials to her lost paramour. No one would stop remembering her loss, even if they tried. My grief, on the other hand, was begging for franchise, after half a lifetime of anything but.

CHAPTER

DISENFRANCHISED

During the gap between finishing by first memoir and beginning this one, my brother Doug died. He was one of four brothers, not quite nearest to me in age, but perhaps nearest in temperament and with much shared history. I loved—I love—him deeply. He'd been diagnosed with a rare form of cancer, Stage four at discovery, nearly six years ago: a slow-growing demon that resisted both chemo and radiation. Thinking he had weeks, maybe months, to live, he'd scrambled to get his affairs in order, and we all rushed in to express the love we'd taken for granted.

I was blessed, after 30 years in different locations, to live only five minutes away from him when he was diagnosed, and we drank in his remaining time, which turned out to be six agonizing years of pain and steady decline. At the three-year mark, Henry and I moved across the mountains, five hours away, and my sibling relationship became weekly phone calls as his life shrank to the size of his tiny apartment, his pointless doctor's appointments, and the rare hours he could rise above excruciating pain and other incapacitating symptoms. His voice weakened and my hearing

was getting worse and some weeks I wouldn't call because I didn't want to keep guessing at what he was saying, or keep asking him to repeat himself, knowing I still wouldn't catch it.

In winter, it was dangerous to make the five-hour trip to see him; two treacherous mountain passes lay between us and he always begged me not to take the risk. I felt myself letting go of him, month by month, knowing any moment could be his last. I didn't want to be hit by a tsunami of grief when his time came; it seemed wiser to let him go in stages and gradually get used to the hole his departure would rip through my heart.

Most of all, I feared learning he'd died alone, unable to reach the phone for help. He was falling a lot, his legs buckling unexpectedly, or losing his balance. And he insisted on living independently.

But when the last days came, it wasn't like that. His kidneys gave out, and he went to the last of many hospitals. There was time to call everyone and summon us back for final goodbyes. With his typical tenacity, he held on for almost three weeks, giving us to time to gather as family: joking, crying, reminiscing, and holding hands around his bed. He slept through much of it, but then he'd wake up, open his eyes, and chuckle at another bad pun or wisecrack pinging across his hearing. Humor got us through much of it and to the end he loved a good joke. He let me read the first four chapters of my first memoir to him, smiling and crying as he remembered the family scenes I described, affirming their truth. We took turns sitting in groups around his bed, talking to and about and around him, letting him know we were there.

He held on till the day I dreaded: my birthday, which was also the day of his first wedding anniversary. He'd married the love of his life a year before, after 30 years of being her ardent boyfriend. I knew he hadn't held on for my birthday, but for her. Still, I was a little miffed at the thought of

associating every future birthday with his death. Perhaps he was getting back at me for pushing him off a pier when I was four and he was two, though even then he'd done the unexpected, opening his eyes and looking for fish, thrilled at the marine world he'd suddenly discovered, and disappointed when my father scooped him up to land. This was his earliest memory—a good one.

His death, like many deaths, was tragic. He was too young to die, preceding both parents and robbed of his own golden years. Until cancer struck, he'd been an active, healthy vegan, in love with music, nature, and his lovely girlfriend, Valerie. His final years, especially the last three, were mostly a nightmare. But as far as tragic deaths go, it was a good one. He wasn't alone when he died; he wasn't taken before saying goodbye to nearly everyone he loved, and in his last hours, he was finally pain-free, and surrounded by love.

A week from the day I'm writing this, we'll be gathered in a big stone church to remember his life. His widow, because she really *is* a widow, will be carried and loved by those he left behind. The world would perceive her differently if they hadn't been married, if they hadn't legally and publicly demonstrated the depth of their commitment, even after 30 years of devotion. My brother left her with legitimacy: a wedding ring, a marriage certificate, a shared last name. He left her a legacy: She was his wife, and is now his widow, in the eyes of everyone.

She was robbed of her husband and left with a grief the world recognizes. Had he died without their wedding vows, she would always be 'the girlfriend'—someone with less permission to grieve deeply, to claim ownership. The grief would be the same, but not the world's perception of it. As devastated as she is—and will be, perhaps for the rest of her life—her pain is validated by the duration and definition of their relationship. Her

grief, in the eyes of all, is legitimate, even though the world will still expect her to process her loss far sooner than she probably will. Her grief, if you will, is what I call enfranchised grief, distinct from its lonely opposite: that which the experts call 'disenfranchised.'

The term *disenfranchised grief* was coined by psychiatrist Kenneth Doka in the 1980s to describe "a loss that cannot be socially sanctioned, openly acknowledged, or publicly mourned." The definition encompasses any number of losses that society may minimize or even overlook: the death of the very old or the very young; estranged or criminally tainted losses; the loss of secret lovers or non-familial attachments; or losses as permanent, yet not as obvious, as those that do not involve a physical death. The 'fault' may lie with the nature of the deceased, the death itself, or the perceived distance or fractures in the relationship with the departed one. Or it may lie with the griever: He or she may not be old enough, perceptive enough, or socially sanctioned enough to qualify as a legitimate griever and thus receive the support of others. Whatever the factors or complications, the disenfranchised griever is left wanting, and the unacknowledged or unacceptable grief becomes insidious as trapped emotions devour from within. The disenfranchised griever may not even know she is grieving, or she may deny, even to herself, the extent of the sorrow she carries.

With the range of losses that we suffer as life unfolds, I'd wager that even if most people have never heard of disenfranchised grief, it's no stranger to many. We acknowledge and respect grief in acceptable, familiar contexts, and overlook its scruffier cousins and stepsisters. Until some form of disenfranchised grief hits—and registers—on our own turf, we miss seeing it in others. From then on—hopefully—we are sensitized to other forms of grief and the numbing, isolating effects on the heart of disenfranchised grief.

When I first learned of this grief phenomenon, I latched onto it like a drowning swimmer. Perhaps this explained my struggles. Applied to my relationship with Jack, some of the descriptors rang true: Jack had been my boyfriend, not my husband, in the eyes of the world. We were married in heart and engaged by word, but I wore no ring and our plans to marry had been eclipsed by his illness. I suppose we could've married in the hospital, but it never occurred to us. After all, we were both counting on his full recovery, up till the day we couldn't. By then it was too late. He had three short weeks and two final wishes, to visit his father and his best friend before he died, and both involved travel, summoning the last of his energies. I would remain Marilyn Mix and never Marilyn Metheany, the woman I'd become in spirit.

Everyone who knew us knew the deep bond we shared. Nothing could break it, including death. But to outsiders, it was a short-lived relationship: less than two years as an actual couple, though we'd been close friends for five years before. To some, the brief 21 months we lived together, half of them in and out of hospitals, might seem slight compared to the loss of a widow who shared decades of life with her husband. But to me it was just the opposite: I envied the older widows, left with years of wonderful memories and *children* and *grandchildren*—living reminders of their union and love. I felt utterly cheated: cheated out of marriage, cheated out of having the children we'd dreamed of, and utterly robbed of the glowing future we'd planned together. Not realizing any of these dreams only heightened my sorrow. More than anything, I grieved the future that dissolved the moment he died.

The three contexts Doka sets for disenfranchised grieving are these:

- The relationship is not recognized.

- The loss is not acknowledged.
- The griever is not recognized.

I could readily check the first box. The relationship was not recognized for what it was. No one, except our closest friends, could grasp how much we loved, how deep the connection, how rich the comfort, joy, and completion we found in one another. Few people are ever gifted this kind of love, in such great measure. I knew this from talking to others and from sharing my story. The fact that I wore no ring, that I was barely in my twenties when Jack died, that I still bore my maiden name, took nothing from the intensity of my loss. It only meant that the relationship was not recognized for every wondrous thing it was.

The second box, *the loss is not acknowledged,* fell on me and my actions. Instead of sticking around after Jack died, going ahead with some kind of memorial (even though he'd specified *no funeral*), and seeking comfort from our friends, I'd jumped on my bicycle and ridden off alone, away from everyone who knew Jack and me. Of course, my friends acknowledged my grief as best they could in the few days I stuck around. But I was in shock, detached from the vortex, and trapped in a bubble of denial. And my friends, still in their 20s and newcomers to grief, were almost as young as I, and what did we know of grieving and rituals?

Even worse, as I looked back over the 20 years since Jack's death, I realized it was *I* who'd failed to acknowledge the extent of my loss in the years that followed. I had immediately focused on a completing a personal goal—taking a long, solo bicycle trip—and had based my 'recovery' on its outward success. All I'd proven was that I could be tough and was a champion at suppressing pain that threatened to undo me. I'd been in denial throughout Jack's illness, believing against all evidence that he'd spring back to health, and then, when he hadn't, I'd essentially denied his death,

carrying his ghost with me for comfort. Paradoxically, I'd also fallen into rebound relationships, fooling myself into thinking there was room in my heart for another, then another, then another. On one level, I knew I'd been eviscerated, but on the surface, where I lived and moved forward, I'd acted as if his death had been a paper cut. The truth had been unbearable.

A recurring dream of Jack, even 30 years on, tries to inform me of this failure. I've dreamed the same dream dozens, if not hundreds, of times, in a script that rarely deviates. The dream is this: Jack has come back, into the present, and a sickening truth is revealed. He never died; instead, he was whisked away from the hospital by his father, the trickster, and delivered to a secret life without me. All this time, he's been living in the States, hiding from me.

The ugly revelation is that he orchestrated his illness and disappearance to escape me, who somehow disappointed him so profoundly that his only recourse was to fake his own death. This realization—that because of me he would permanently cut himself out of his entire world—is devastating. He's a different Jack in these dreams, older yet dressed in familiar clothes, but cool and aloof with me in a way he never was. As much as I plead, he never explains the reasons for his abandonment or what I've done to deserve such earthshaking deception and conspiracy.

As I dream, I'm aware of the web of complicity it took to pull this off: lies from the hospital, the doctor, the coroner, the crematorium that handed me someone else's ashes to participate in the ruse. Even endlessly repeated, the dreams are agonizing, the worst my subconscious mind can conjure. And I dream it so often that my dreaming self starts to address it. *This is just a dream*, I tell myself. *It's the same old dream; it's the same lie, the same trap. Don't fall for it again.*

No, but this time it's real, the dream answers. *Don't you remember? Jack really DID come back to tell you this; you saw him in real time, not dream time, and he really did run away from you. His heart so turned against you that he did this, cutting himself off from everyone else he loved, just to escape your grasp.*

Over the years, my dreaming mind adds endless loops and layers to this theme. Dreaming, I argue with the counter evidence, the counter-counter evidence, the supposed visits and lies upon lies, but the dream wins out, every time, and I awake in stark misery, wondering if Jack has, in fact, come back in real time to confirm his disappearance. Did that actually happen? Am I forgetting something? Am I still in some weird, unacknowledged state of denial?

I think of the failures which might contribute to this narrative. As well as not being with him at the moment he died, after two years of constant togetherness, I failed to sit with his corpse once I got to the hospital, 90 minutes late. I was raging with anger at the nurse who'd refused to let me stay with him the night before, so ferociously consumed there was room for nothing else, let alone rational thought. I stood in his room for less than a minute, barely comprehending the stillness on the bed, before bolting from the hospital. Later, too late, I berated myself for not staying, touching, speaking, and apprehending the evidence of death. His unseen body went for cremation, and when I went to pick up his ashes, I continued my denial. These were not Jack's ashes, necessarily; they could be anyone's. I wanted no contact with death, numbly dumping the ashes beneath a tree without ceremony or attachment.

There are many ways to bypass full-on grief, to disenfranchise our own devastation, and apparently, I, a complete neophyte in the death-and-dying department, was a natural.

The third box: The griever is not recognized. I was responsible for this lapse, too, by leaving everyone I knew, everyone who could recognize my grief and perhaps make it real for me if I'd stayed in my new world-without-Jack. Instead, I became the ghost, traveling with Jack, my invisible yet very present partner, as I set out to cycle from Alberta to Colorado, the uncompleted half of a trip he'd started in Arizona years earlier, until a bout of hepatitis had forced him to quit.

Rather than trying to rebuild my Jack-less life in the same place, I became rootless, homeless, nameless, passing through tiny mountain towns without a trace, using constant movement and change to outrun my emotions. It worked like a charm, and I had no regrets, except for some huge ones, like not sticking to the route I'd chosen, veering instead to the west coast and beyond, never touching Colorado at all, and the even greater regrets this departure fostered: falling into other arms mere months after his death. I was very good at side-stepping grief and just as adept at heaping guilt upon guilt on my ravaged soul.

Another memory of disenfranchisement wakes up to join the queue. Four years after Jack's death, when I'd been married for two years, my buried grief started rattling its bones. It troubled me. We'd just moved to Boston, and I'd thought my new relationship with God had dissolved the grief. I had a special breakfast appointment lined up, a coveted meeting with Top Leader, the lead evangelist of the church, to talk about whatever was on my mind. I was certain he'd empathize with my plight and bless me with wise counsel. But as soon as I disclosed the basics, that I was still mourning the death of my former fiancé, he cut me off.

"Sister," he said, "that was a sinful relationship from your past that you need to repent of. There's no place for any of that in your life now."

And just like that, the topic was sealed. If Top Leader denounced it, it must be shunned. I remember the devastation that flooded me, the intense disappointment and shame, and how I swallowed it, along with the last bitter dregs of cold coffee in my cup. There was no place in my life for unfinished business with Jack, no matter what my heart said. I'd never bring it up to another leader again.

THE SCIENCE OF GRIEF

The third type of pathological grieving, known as Complicated Grief, was another easy fit. The same clinical paper by Doka, published by the University of Pittsburgh, describes it thus:

"Normally grief does not need clinical intervention. However, sometimes acute grief can gain a foothold and become a chronic debilitating condition called complicated grief. Moreover, the stress caused by bereavement, like other stressors, can increase the likelihood of onset or worsening of other physical or mental disorders. Hence some bereaved people need to be diagnosed and treated."

Normal grief, according to the DSM-V, surges with typical manifestations of loss—intense yearning; frequent thoughts and images of the deceased; feelings of loneliness, emptiness, and meaninglessness without the loved one; and persistent feelings of shock, disbelief, or anger, among other symptoms—for an initial period referred to as 'acute grief,' before gradually dissipating and being integrated into the griever's altered life. This acute stage varies in length, depending on personal variables, but is

generally marked at around six months. When these acute symptoms persist beyond these parameters, the grief may be classified as complicated or persistent grief. It is estimated that around 10 percent of grievers fall into this clinical category.

Risk factors, according to the DSM-V, include being female, having a history of mood disorders, having low perceived social support, experiencing increased stress, having a positive caregiving relationship with the deceased, having pessimistic temperament and personality correlates, cognitions of bereavement, and having an insecure attachment.

Of these eight markers, I check seven—if not all at the time of Jack's death, then certainly by the time of my grief resurrection. The missing risk factor, having an insecure attachment, doesn't apply to my relationship with Jack. Or does it? My abandonment dreams about him seem to scream otherwise, though I felt more secure in his love than any I'd ever known. But I also had a history of insecure attachment with my parents, prepping me for an attachment to Jack that compensated for everything I'd missed while growing up. So maybe all eight markers fit.

The seventh marker, "cognitions of bereavement," is referenced to another paper that names "self-blame" and "negative cognitive response to one's own grief reaction" as two possible culprits. Bingo. This was exactly where I lived. I blamed myself for mishandling every aspect of my bereavement. And I was appalled at how long I'd stumbled through life in a state of numbness and denial.

The Pittsburgh paper also includes this bleak statement:

"Many patients have been on treatment-seeking odysseys for years after the death of a loved one, receiving little help. Our data from 243 individuals seeking treatment for complicated grief in Pittsburgh

reveals that 206 (85%) had previously sought treatment for grief. The majority had tried at least one medication and at least one form of counseling. Many had made multiple attempts to get help. Some had been told they were coping as well as could be expected because the loss was very difficult. **This type of reassurance was provided even when the bereaved person's life had come to a halt and years had passed since the death.**" {Emphasis mine}

If this sad group of complicated grievers in Pittsburgh is typical, it appears most people trapped in the mire of persistent grief want it to end. We are not wallowers, attention-seekers, or histrionic malingerers with no interest in getting on with our lives. We want help. We need help. Something has gone terribly wrong, including and beyond the death of our particular loved one, and we're spinning our wheels in a bog, not by choice, but by a tragic mix of circumstances. The odds were stacked against us, and then the sky fell, and we're still smothered by heavy, persistent clouds with nowhere else to go.

I could understand how outsiders—and by that, I mean anyone outside my own head—might scratch their heads in bewilderment when they heard the rough outlines of my troubles. On the surface, it should have been a straightforward loss to mourn—if such a thing exists. Jack had died three years after his first cancer diagnosis. I'd been with him through all of it, including five months of hospitalization after his spinal surgery ended our dream of riding to South America. I'd had all those months to prepare for his death, to visualize an altered future, and to talk with him about death, even to say goodbye—if such a thing is possible.

Except we hadn't done any of that. There'd been no talk of my future, no words from Jack to guide my pending widowhood, no whispers of

goodbye or even, *see you later*. We'd mutely acknowledged The End by leaving the hospital right after his doctor broke the news and predicted he had three weeks left. We'd sat by the river and cried without words. And then we rushed to fulfill Jack's dying wishes. He was swimming in morphine, and the last 21 days (the doctor nailed it) were all a hazy dream. As crazy as it sounds, I was as emotionally unprepared for Jack's death as if it had happened suddenly.

And now it was 22 years later, and I was reeling as if he had just died. This bizarre timing further complicated my complicated grief. *How can the pain be even greater this time around?* I could hear my headscratchers wonder. *How can she be stuck in grief after all this time, after all the great things God has done in her life? How can she be so selfish,* I imagined them thinking, *so self-absorbed and consumed with something that doesn't matter anymore?* I wondered the same things. But I knew it absolutely mattered, and unless I could put my agony to rest, there'd be no rest for me.

And so my little grief trio—disenfranchised grief, complicated grief, and delayed grief—tumbled out of the books I found, and I hoped by exploring all three, Theo and I could figure out why I was stuck, and how to unstick me. I was too close to the damage to disentangle myself, but it's much clearer now, the overlaps in the trio and all the complicating factors that had led to my eventual breakdown. But when I brought my little nuggets to Theo, he wasn't biting. I still don't know why. Working with him was like trying to read the wind from inside a tornado.

THE BIGAMIST

Theo's surprise that I'd written a love letter to Jack—the first thing from my journal I'd shared with him—baffled me. What did he think I'd write? An accusation? A renunciation? That I'd fallen back in love with Jack was the crux of the problem. I was a married woman, a *Christian* married woman in her 18th year of wedlock, yet my heart was entangled in the love I'd known with Jack.

It wasn't, as my husband suspected, that I'd secretly, knowingly smuggled this love into our marriage and fed it in the dark. The passion, memories, and pain had been buried deep, locked away where they couldn't interfere with my new life, though now I see how traces of pain had been leaking through most of those years like ill-sealed radiation. But unknowingly: I truly hadn't known. The phoenix of grief, when it finally broke through my reconstructed life, astonished and alarmed me as much as anyone.

Maybe I should have suspected, but I was like one of those oblivious pregnant women you hear about, giving birth on the toilet after months of

missed symptoms. *Where did **this** come from?* she wonders. And the head-scratchers marvel and doubt. *Umm, from inside you? Like, you really didn't know? Give me a break!*

I was—I *am*—a monogamist at heart, and this fealty fed my problem. Back in love with Jack, I had nothing left for Henry. As much as I needed his patience—nearly depleted as I failed to make progress with Theo—I couldn't connect with him. I wasn't even the same person. I was pre-Henry Marilyn, in love with my first soul mate, with no room in my heart for a second man. Of course, I felt very, very guilty over this, but no amount of "ought to" or guilt could make my heart obey the rules of time and propriety. *The heart wants what it wants,* as Woody Allen scandalously stated. It certainly does, even when it makes no sense and has no hope.

Remorse and regret consumed me. Although I see now, and should've known then, that I'd loved Jack to the best of my abilities, I longed for a do-over. With the perspective and maturity of a 44-year-old (however stunted), I looked back on my younger self with dismay. Why hadn't I been a better truth-speaker, a better spiritual support for Jack? I anguished over his last four months, when I'd refused to see the obvious—that he was truly dying—locked in denial when I could've been preparing us for what lay ahead.

I agonized especially over his last 24 hours, when I'd resented his collapse on our return flight from Arizona, wanting to step out of my caregiving role and eat my airplane food instead of attending to him, and when I'd let the nurse convince me to leave him at the hospital alone, rather than demand to stay with him for what would be his last six hours on earth. Instead of granting myself forgiveness and grace, I rubbed my nose in these failures again and again, boring Theo and myself with endless

self-flagellation. And then, in the midst of these incriminations, another horrible, long-buried memory surfaced.

The incident took place seven months before Jack died, while we lingered in Tennessee seeking a diagnosis for his knee pain (which would turn out to be cancer in the spine), our bicycle odyssey paused and soon to be aborted. We were staying with friends of Jack, after four months of traveling on our own, and I'd been caught up with the social stimulation of new friends, including Jack's oldest college buddy, our host. It wasn't an irresistible attraction, but I liked his attention, the way he got my jokes and sought me out. Not that Jack didn't—of course he did— but Michael fed my ego, and I let him do it.

I was busy cooking huge meals for everyone who dropped by the house, basking in that ego-stroking, too, and Jack must've noticed my wandering attention, because one morning he asked me to walk with him, and as we hiked the rolling hills of Hamblin County, he got straight to the point.

"I need you to be as completely engaged with me as I am with you," he said. "I won't settle for anything less. Our relationship needs to be the center of everything, always. I utterly love you, but if you can't maintain the intensity I need, I'll have to leave. I can't stay in a relationship that isn't like that."

His words gutted me. It was the first and only time Jack ever spoke of ending our relationship, and it shocked me so much I could barely speak.

"I'm with you," I told him, "all the way. I'm sorry for being distracted. I won't ever stop loving you or trying to be everything you need. I love you beyond words."

We stood by the side of the road and held each other.

The conversation ended there, and we never mentioned it again. Weeks later, we went to Knoxville, where doctors finally diagnosed the

pain source, surgically removed most of the tumor, and sent us back to Edmonton, where we lived at the Cross Cancer Hospital until May 22nd, the morning Jack died. He'd been my singular focus for the rest of his days, as he had been our entire relationship, minus some minutes in Tennessee, and I'd stuffed the memory of his threat to leave into deep bunkers, where it slept for two decades.

Or so it seemed.

Perhaps this was where the recurring dream of Jack's abandonment originated. Perhaps I'd never processed that conversation, throwing it off like a nightmare and consigning it to the pit of silenced-yet-seething memories, where it seeped into the dream narrative that continually raked me over the coals of *what-did-I-do-wrong*.

I wanted a do-over for the Tennessee chapter and a do-over for the year or two after Jack's death, when I should've been mourning intentionally, purposefully, with a view to completion, rather than chasing my heart all over the States and setting myself up for triple failure in the distant future.

My three failures, as I saw them, crushed me with hopelessness:

- Failure to grieve properly. The first time, when the loss was fresh and my life was unencumbered by other relationships.
- Failure to keep my vows to my husband: *Forsaking all others...till death do us part.* My continuing engagement with Jack was a phantom, yet it stole my heart with the power of flesh and blood.
- Failure to grieve properly, conclusively, even now, after being granted time and space in my heavily encumbered life to do so.

Such were the thoughts that consumed me, before, during, and after weekly sessions with Theo, where he refused to label my grief, provide markers, set targets, or be consistent in whatever advice he happened to suggest. Yet I loved him and had nowhere else to turn. He alone had seen the scope of

my grief and despair. He was my witness, and that fact alone was enough to keep me tethered.

Theo and I also discussed my marriage, which had become a torment. Henry's resentment of Jack and his disruption to our lives had turned his heart against me. We no longer discussed my struggle or appointments, leaving Henry to imagine the worst, in technicolor. He'd been relieved of ministry responsibilities for the duration of our counselling sojourn, apart from leading a family group of about 20 members, and although this was meant as a gift, it felt like a consolation prize.

Both of us were still expected to attend weekly staff meetings, where we sat as mute specimens of a crumbling marriage in the throes of break-down. In grace and compassion, most of the Philadelphia staff members reached out and remembered us for who we'd been. Nevertheless, I'd put my husband in a humiliating, helpless position, and he had every right to resent me, except for one important distinction. We were Christians, and Christians are called to love, a selfless love that forbears and forgives, 70 times seven and beyond, as much as God forgives us, as immeasurably and impossibly.

We both knew the standard: "Love is patient; love is kind. It does not envy, it does not boast, it is not proud. It is not self-seeking; it is not eas-ily angered; it keeps no record of wrongs. Love does not delight in evil, but rejoices with the truth. It always protects, always trusts, always hopes, always perseveres. Love never fails…"

From 1 Corinthians 13, these are lofty, stirring words, especially when read at a Christian wedding. We hadn't chosen it for our own matrimoni-als, but we'd heard it at dozens of other weddings, a beacon of hope and joy

as bride and groom accept the call to *agape*, loving each other so much at that moment that the scriptural challenge seems as effortless as breathing.

Of course we will love like that. Forever.

And such humbling, convicting words are these when considered years later, in the midst of a spiritual war, when early, easy love is mere memory, and Satan is intent on destroying a marriage, a ministry, and two tender hearts in the process.

My courtship with Henry had been nothing like the slow-building relationship I'd had with Jack, except for the unexpected love which flooded both. The two men were very different. Jack was eight years older than I, while Henry, three years my junior, was the only younger boyfriend I'd ever had. I'd looked up to Jack as someone far ahead of me in life and wisdom, and the thought that I'd one day be his companion had never crossed my mind until the magical day we fell in love.

Although I admired Henry's wisdom and boldness—at 21, he'd followed his own vision to start an inner-city ministry—I first regarded him like a younger brother, spiritually precocious but naïve in the ways of the world (compared to me), and certainly not my type. He'd had only one serious girlfriend before me, whereas Jack was undeniably a Jack of Hearts, putting romantic love ahead of every other quest in life, and melting my heart by choosing me, after all the rest, to be The One. I was drawn to older men; after Jack's death, two of my boyfriends had been 18 years older, and to me this was less strange than the thought of being with someone younger—especially someone with limited romantic experience. I'd had a *lot* of experience land on my porch, and in the period when I met Henry, I was trying to avoid romantic enticements altogether.

I met Henry while searching for a church. I had fallen for his radiant love for God and people and been deeply impressed by his zeal and knowledge. Initially, it was a fall into his mission, not his arms.

I remember having a random thought, soon after meeting him and his equally young ministry partner, Paul: *What if I had to marry one of these two brothers? Who would I choose?* The answer came quickly: neither. I loved them enough to stay in Toronto and become part of their ministry, but my love was purely platonic. They were too immature, too inexperienced, too soft and brotherly to imagine marrying. Plus, in the early days of my Christian walk, I'd forbidden myself to seek a boyfriend. I could only handle one great love at a time.

Three months after meeting Henry and Paul, after my baptism and subsequent daily meetings with them, I moved to Niagara Falls to attend a small Bible school from Mondays to Thursdays, returning by bus on Friday afternoons to spend the weekend with our little fellowship. Henry never missed meeting me at the Greyhound station, dressed each week in the same borrowed sweater I'd once complimented, hair freshly washed and face beaming. I knew he liked me: really, really liked me. And I liked spending time with him. We were friends and siblings-in-Christ, with a growing emotional connection based on our shared faith and long conversations. Being with him felt safe, and nearly all our discussions centered on the Bible and what I was learning in Niagara Falls.

Everything changed with a dream. One morning I woke up thinking, *How strange! I just dreamed I was in love with Henry!* Startled, I chalked it up to weird dream confabulations, like dreaming your cat talks and flies around the world with you and the President of the U.S. But the feelings stuck. I was still in love with Henry by noon, and even more in love by

the time I took the next bus to Toronto and saw him, wearing the same heather sweater in an attempt to dazzle me. This time, I *was* dazzled.

It was the strangest way to fall in love, and the only explanation I could muster was this: *God planted this love in my heart while I slept, knowing my resistance to falling in love with Henry was so strong, there'd be no other way. God wants me to love Henry. He's ordained it. This is part of my path.*

I kept these thoughts to myself, but my eyes must have given me away. On January 10th, 1981, Henry walked me home for the umpteenth time and paused on the sidewalk by my door, as he always did, for a few more minutes of talk. This time, he had a question. *Would I be his girlfriend?* He looked as wide-eyed and anxious as the last pick of the litter awaiting adoption.

I said yes.

We embraced—no kisses yet, not till our engagement—and he left to visit a young man dying of AIDS in a nearby hospital. An hour later, he died with Henry beside him, his last and only visitor. The two events etched January 10th on Henry's heart forever. Three months later, we'd be engaged, and four months after that, we'd vow a lifetime of fidelity, forgiveness, and devotion in a modest outdoor wedding.

But even these plans were steeped in prayer. Before meeting me, Henry wanted to be like the apostle Paul, single, celibate, and wholly devoted to the ministry. He was prone to extreme aspirations, having taken a personal vow of poverty right after his conversion. (Maybe this explains why we're chronically broke.) But I had disarmed him. We still joke about the saying, "If you have to wonder whether you have the gift of celibacy... you don't." We were chaste in our relationship, but yearning. Still, even after Henry proposed, he kept petitioning God to foist me from his life if marrying me wasn't part of His will.

He told me all this, and although it was strange to hear he was petitioning God for my extraction if we were misguided in our affections, I understood. We both wanted God's will to be done on earth as it is in heaven, and a marriage based on selfish and unspiritual foundations was to be spurned at all costs.

The story of our engagement and wedding bears telling too, providing more snapshots of the young evangelist and his lady love, the hippie rebel. This was in March 1981. We'd gone to my first Christian conference in a little town called Beamsville, held at the college Henry attended after his conversion at 18. The annual meeting was called a "lectureship," and that's exactly what it was: lecture after lecture on Biblical topics. I was all for learning. But the first session we attended was woefully boring and scheduled to last an entire morning. After 30 minutes, I gathered my Bible and notebook (as discreetly as possible) and left the room in search of a corner where I could study alone, unsmothered by lackluster delivery. I didn't want to insult the speaker; I thought leaving the classroom was the lesser of two evils, as I feared sinking into deep, visible sleep as he droned on and on.

But Henry was aghast. He followed me out of the building, and we had our first argument, standing in soggy, newly-thawed grass and debating the relative merits of faking it (pretending to enjoy the lecture) versus following your heart (refusing to let the Bible, or anyone teaching it, bore me). The speaker was one of Henry's former teachers, and Henry was sure I'd insulted him by leaving. I doubted that; it was a full classroom, and I could've been leaving for any number of reasons. It was a doozy of a fight, with no clear winner.

We left the college and paced through the empty streets of Beamsville, side by side and miles apart, no longer holding hands or seeing eye to eye.

We were on a quiet side street when Henry asked me to wait while he ducked into a tiny gift shop with an old swing on the front lawn. I thought he was going to the restroom. Instead, he came out with a single yellow rose in his hand and asked me to sit on the swing while he knelt on one knee. "I wanted us to have a real argument before proposing to you," he said. "I wanted to make sure we could handle it."

If I'd wanted to be difficult, I could've countered that our fight was hardly resolved. We were still in separate camps on the issue, though the hostility had evaporated. I was still convinced I was right, and he was wrong, and assumed he believed the reverse. But we'd argued loud and hard without damaging our love, and we could walk back to the lectureship holding hands, where I was ready to give the next session a fresh chance.

I wasn't sure what I'd do if the next speaker bombed, but I kept silent.

Of course, I said yes. Yes, I'd marry him, yes, I'd go anywhere with him, anywhere the Lord called us on God's green—or urban—earth. I already knew the ministry would mean living in big cities, where the people were, and that my bike touring days were over. There was one more stipulation tied to his proposal: Would I be willing to eat *anything* in the course of serving the Lord? For this, Henry's projected scenario was presciently specific.

If we were on the mission field and someone served us *pork fat*, would I eat it? I knew Jesus' instructions to his apostles: *Eat whatever is set before you.* For seven years I'd been a hard-core vegetarian, except for sardines when I biked and needed extra protein. Pork fat, to me, was pure poison. Yes, I said, even pork fat, if it came to that, though I doubted anyone would ever prepare a *meal* of pork fat to test my words. But two years later, that's exactly what new friends from Belize set before us: a table full of dishes, all fried in pork fat, made just for us. I choked down as little as I could get

away with, trying to eat like a good apostle, and exchanging covert grins with Henry over God's sense of humor.

Henry didn't have a ring for me, and I didn't expect or want one, only a wedding band, when the time came. We floated back to the lectureship, truly a couple now, with an unseen future of many unresolved yet tolerated disagreements before us. Jack and I had been hugely compatible in temperament, interests, lifestyle, habits, and quirks. Henry and I were opposites in nearly every way, except for the most important things: our view of Christ, the Scriptures, and our purpose on earth. It wasn't going to be an easy ride, but it was going to count.

Back at the lectureship, we searched for Henry's parents, eager to share our engagement news before telling anyone else. (Henry had converted both his parents soon after they'd witnessed his own transformation.) But they were nowhere to be found. As we drove back to Toronto that evening, we spotted their car, racing homeward on the busy 401. Henry zoomed through multiple lanes till we were beside them, honking our horn to get their attention. We were pushing the speed limit, windows rolled down.

"We're getting married!!" Henry yelled.

They looked at us quizzically. "What?"

"We're getting married!!" he yelled again.

This time they heard us, and their faces suddenly resembled the man in *The Scream* painting. We were moving too fast to say more and soon lost them in the heavy traffic.

I knew exactly what their expressions meant. Instead of yelling, *We got engaged!* Henry's three-word announcement sounded like we were on our way to the altar, post-haste. Like we were eloping right now, speeding to City Hall, blood tests in hand. This sounded exactly like something

their passionate, impetuous, all-or-nothing son would do, if he hadn't been praying so hard for God to pull the brakes.

Our courtship progressed smoothly after that, without arguments or roadblocks despite Henry's daily prayers for God to extract me if I were secretly a thorn. In May, I brought Henry to Edmonton to introduce him to my parents. I'd left Edmonton eight months prior to visit an old friend in Toronto and ended up staying. And getting engaged. And writing my parents a lengthy letter about my newfound convictions, not well-received. We were about to hit a high wall of spikey thorns.

My father had grown up in the strict Plymouth Brethren church, while my mother was baptized as an infant in the Ukrainian Orthodox church, but they'd both been United Church members when they met at university. As kids, we attended the United Church with them, returning home for Sunday lunches of smoked herring and a weekly dissection of the minister's sermon. They were struggling to reconcile the church's increasingly liberal theology with their own shifting beliefs. Accordingly, we moved from one United Church to another as my parents discerned that yet another minister didn't believe in the resurrection, or the Virgin birth, or some other tenet of orthodox Christianity. They wanted liberal politics with conventional teachings, not easy to find.

By the time I brought Henry home to meet them, they'd gone Baptist for a while, where my mother was permitted to teach Sunday school but was not considered a bona fide member (no star beside *her* name in the church registry) because she refused adult baptism. This did not sit well with her, and after refusing to budge for several years, she'd given up on the Baptists. I'm not sure if they were even church attenders by the time we visited.

My father resented his legalistic Brethren upbringing, entangled as it was with my grandfather's heavy-handed parenting, and it made him wary of the faith I'd embraced, which seemed too close to what he'd rejected. He was unconvinced that baptism was a central aspect of conversion. My mother had hated my letter, which gently (I hoped) urged them to consider restudying some vital doctrines. Who was I to be questioning their long-held beliefs? They blamed Henry, sight unseen, for pulling me into such Biblically saturated waters. In the days when I'd been church hunting, before leaving Edmonton, I'd been label free, and they'd been supportive of my search, curious about what I was finding along the way. But neither of them liked where I'd landed. That evening, Henry and I were walking into a bear trap.

Admittedly, we could have handled things better. Our first night visiting was a Wednesday—midweek service night—and we opted to attend a local church, similar to ours, rather than stay home with my folks. Looking back, this was a stupid decision. It also happened to be the night the Pope was shot. When we got back, my father was sitting in the living room, watching the news. My mother was at the top of the stairs, waiting to pounce.

"How was your meeting?" asked my father. "Did you pray for the Pope tonight?"

I fell headlong into their trap. "No," I said. "We didn't. But if we had, we would have prayed for his soul."

My mother pounded down the stairs and landed in the living room, eyes ablaze. She lit into us with all the venom I remembered from growing up—the venom I'd run away from at 14 and avoided for six subsequent years by never going back. I was surprised by the Papal trigger, having grown up with the parental view that the Catholic Church was

wrong on most counts. I had a vague memory of her once declaring she'd rather see me marry a Black man than a Catholic. But apparently their views had changed.

With a fury fed by her own spiritual turmoil (I assume), as well as unresolved business with me, she blasted my new-found faith. As always, it was impossible to interject even a half sentence into her diatribe, though of course my prophet-like fiancé tried. If my mother had even a tiny shred of favour towards Henry before this blow-up—and I doubt she did—this incident permanently obliterated it. She openly disparaged him ever since, right up until her death.

The next morning, she announced she and my father were going fishing in Saskatchewan for the rest of our 10-day visit. They'd be back the day before our flight to take us to the airport. They packed their tent and fishing gear and left us alone in the house. I think this was the only time Henry slept in their home. We spent the remaining time visiting old friends and haunts. On the tenth morning, I sat with my mother on the deck and discussed possible wedding dates. Henry and I wanted to marry in Toronto, among our church family and friends. My mother was determined to boycott any plan, without admitting it was an absolute boycott. "It's fishing season in June," she said. "And we'll be at the cabin till September. I don't think a fall date would work for us, either."

She knew we wouldn't want to delay our wedding for months, eager as we were to consummate our love. And she tried to dissuade me from marrying Henry by comparing him to Jack, whom she'd adored. "You and Jack were so compatible," she said. "You had so much in common, so many things you liked doing together. But Henry is so different…It's hard to imagine him taking a bicycle trip."

It was, but I'd given up the bike trips by then. Our life plans included missionary travel to bustling cities, not months-long wanderings off the beaten track. I had embarked on an entirely new chapter of life.

It was pointless to argue with her, so I didn't. We'd pretend everything was fine, that going fishing held equal weight with their only daughter's wedding and would plan our nuptials without them.

And so began a seven-year freeze that wouldn't melt until the welcome distraction of our first child.

Six weeks later, the prophet and the hippie exchanged vows in a sunny outdoor wedding with five guests: Henry's mother, father, sister, the minister who married us, and his wife. I was crushed by my parents' shunning and chose the simplest wedding possible. I baked a small wedding cake—apricot—and wore a white, beribboned cotton dress, made in India. Henry wore painter's pants and a tunic, also from India, which he dyed sky blue. Our rings came from pawn shops, personalized with our own engravings: *My Hero*, on Henry's, *My Song*, on mine. His mother brought a bucket of Kentucky Fried Chicken, and his sister tossed raw Minute Rice over our happy heads. We took dozens of pictures with a camera that turned out to have no film. A pair of chipmunks nattered on a picnic table as we gazed into each other's eyes and promised till death do us part. It was a perfect day.

With the money we didn't spend on our wedding, we rented a cabin near a quiet, shimmery corner on the Lake of Bays at a little resort called Bunny Hollow. Here we spent our first 10 days and nights, getting acquainted with our physical union. Mornings, I meditated over the book of Ephesians and shared pots of coffee with my new husband. Afternoons, we played Scrabble and took turns winning and losing. Every evening, I

ran up a long trail to the site of a fire tower, and at the hottest point of each day, I skinny-dipped in the pristine lake, safely out of sight but not bothered if anyone happened to spot me. There was still a lot of hippie in me, minister's wife or not.

Our first year of marriage was remarkably smooth. We lived on the third floor of a deteriorating walk-up, two floors above a Jamaican patty shop, surrounded by Caribbean neighbors who played loud reggae music at all hours, always different tracks and simultaneously. Mice and cockroaches ruled the kitchen. I moved in early and spent the week before our wedding painting the apartment while Henry attended his ministry partner Paul's wedding in Texas. (He was marrying a sweet girl he barely knew, after a whirlwind, long-distance courtship.)

I hated cockroaches, but mice were even worse. One night I set up a Roach Hotel in the kitchen, hoping to lure some insects to a sticky death, but instead of catching cockroaches, it trapped a hapless mouse. Stuck to the tacky surface of the trap, the mouse screamed all night. I hadn't known mice could scream and was afraid to enter the kitchen and see the critter, let alone touch it. Instead, I placed a radio near the kitchen door and set the volume loud. By morning, the screaming had stopped, but I was still afraid to investigate. Instead, I avoided that side of the kitchen and waited for Henry's return, figuring a rotting mouse was better than a seen one. Neither roach nor mouse infestation could be cured without burning down the premises, but I learned to flick on the kitchen lights and wait for 10 or 20 seconds, eyes closed, before entering, giving both species time to disappear into their hiding spots and continue procreating in the dark.

Several months into our marriage, we lay in bed one night congratulating ourselves on our harmonious union. "God has blessed us," one of

us said, "with a conflict-free marriage so we can concentrate on serving others." The other concurred; it seemed a wondrous truth. We knew how other married couples bickered and sparred, especially in the early days, but by God's grace we were above all that.

As soon as the words were out of our mouths, the tempter must have laughed.

The very next day we had our second and worst argument to date, the kind of fight that sends one spouse (me, in this case) running out the door to stalk the streets for hours, looking for a way out of hell. I can't remember what triggered us. What I do remember is a sudden, sickening fear: Our perfect union wasn't so perfect, after all, and I couldn't recall any moments with Jack when I'd felt such intense animosity and rage.

It was a foretaste of future struggles. After moving to Boston, a year into our marriage, we started having explosive arguments. We were battling pride, disappointment, and insecurity, and had no idea how to vanquish our demons. Between blow-ups, we worked compatibly in a shared ministry, complementing each other's strengths, and finding great joy in our work. We both wanted to please God and serve others. But whenever we hit a marital nerve, the demons rose up, screaming. It was clear something needed rooting out, but like the mice and roaches in our first home, we never got a handle on that infestation, either.

DREAMS, COMFORT, MEMORY, DESPAIR

Back in Theo's office, I floated between various ports of pain: Jack's death, my marriage, my childhood, my adolescence, and the losses accrued when I moved from place to place, loving and leaving wonderful friends and family in the process. Like an animate globe, I had oceans of grief surrounding every continent of my life so far. And like a cartographer mapping the seas, I was seeing only the surface of what lay beneath.

Perhaps Theo and I could have systematically explored each ocean, searching for connections and understanding, even closure, before moving on to the next. But Theo was never systematic. We drifted from port to island, blown by whatever wind had swept through my dreams the previous nights, and as the weeks sped by and our deadline approached and I was still in pain, I grew even more desperate.

One particular moment haunts me. I'd been talking at great and tedious length about all the ways I'd failed to grieve Jack before moving on with my life. The scope of my failure loomed over me like a dark, fixed firmament and clouded the future, where more dreaded insight awaited

my upcoming discoveries. As I recounted the many, many ways I'd been self-deluded, the horrifying, what-should-have-been obvious conclusion rose from the depths where I'd buried it: After losing Jack, I'd been utterly unready for marriage.

As the old folk song admonished, I should've been off with the old love before I was on with the new. Marrying *Henry* wasn't the problem; I hadn't been fit to marry anyone, in my unresolved state, and even the most perfect of men— even *Jesus*— would've fallen short when my heart eventually woke up and smelled the wretched, scorched coffee of delayed and aborted grieving. Seeing my folly, as if for the first time, was like stumbling through dark, brambly woods to the edge of a precipice, and the rest of my life was the fall. How could I recover from what felt like the biggest mistake of my life?

Theo's suggestion of creating a grief closet and setting a time each day to wail in private hadn't worked; I refused to enter our creepy basement, the only private space we had. And I resisted the concept of restricting grief to a set number of minutes per day. If I was going to get this pain out of my system, I needed unrestricted time and a place far, far away from *everybody* where I could let it pour out in a torrent.

To this end, I proposed a solitary retreat. I wanted to get in my car and find a place, a secret hideaway without time limits, eavesdroppers, a distressed husband, or outside distractions. Theo was adamantly opposed. "You're too vulnerable," he kept saying. "I'm afraid you'll hurt yourself. And I'm afraid you won't come back. I won't allow it."

In spite of my searing pain, I wasn't suicidal, and I had no intention of running away. I loved my husband and children too much for either. I knew I'd come back. I just needed to get away and DO something so I could come back different.

We argued this for several weeks before I decided to simply go, knowing myself better than Theo did. I had nothing to lose but the cost of gas and accommodation for as long as my quest might take. I'd bring nothing but money, a suitcase, and a fresh journal. I'd head east, towards the ocean, and probably south, unsure where my ideal spot might be, but certain I'd know it when I found it.

Henry hastened me off, relieved I was taking action, and promised to take good care of the kids, as he always did. There was no need to rush back till I got Jack out of my system. By this point, we were out of synch on almost everything but this: His desperation for a cure was at least as great as mine. I loaded my little blue station wagon and hit the road.

If you trace the route I covered over the next several days, searching for The Spot, it resembles a jagged, half-eaten starfish, like a drawing made by a drunk sailor. I can't remember if I was following a map or just instinctively driving as far as I could go in one direction before veering off in another. I drove through arms of New Jersey, Delaware, Virginia, Maryland, and Pennsylvania, past towns like Dover, Ocean City (both versions), Pocomoke, Cape Charles, and Wye Mills, before finding myself back in Pennsylvania. I took secondary highways and drove with one hand on the radio dial, searching and failing to find the right music. I pulled into obscure motels and explored each possible hideaway on foot, hoping to find the exact blend of privacy and tranquility I needed.

Something was wrong in every place. Several times I paid for a room and checked in, only to change my mind within minutes or hours and ask for a refund. The motel clerks were puzzled yet accommodating; I was clearly not a typical tourist. In a few places I spent the night, only to rise early, veto my latest choice, and jump back in the car for another day of

restless driving. My frenzied, directionless search perfectly mirrored my inner turmoil.

When I unwittingly crossed the state line back to Pennsylvania, this time into Amish Country, my focus intensified: if I simply kept driving, I'd be home again, completely unchanged. My next check-in was a roomy log cabin with red checkered curtains, a large writing desk, and enough privacy and space to pace and scream as I opened the door to my grief demons. It seemed perfect. But two hours later, the stench of nearby pig farms was getting worse, not better, and I woke up the night clerk to ask for a refund and check out.

This time, it was near midnight as I reloaded my car and drove into the darkness. By now I was beginning to sense the problem lay within me and not the contending towns and hideaways. I drove another hour before checking into a sleepy motel on the edge of a hamlet whose name I've forgotten. I wasn't even thinking this might be The Spot—the air was simply pig-free, and I needed sleep, but when the sun rose and I went for my exploratory stroll, I figured it was close enough. The search had to stop; I'd stay here and do my grief work, no matter what. My right arm was weary of scanning radio stations, and time was slipping through my fingers, which ought to be writing, wringing, and drying tears instead of driving and turning dials.

After breakfast, I opened my new, carefully selected purple notebook: 80 sheets of college-ruled paper, a one subject, wireless notebook with three punch holes. "To Jack," I wrote on the first page. "For me: for the rest of my life. April 2001."

It was time to write all of it, from the day 15-year-old Marilyn, out on a weekend pass, met Jack, the 23-year-old philosophy grad student who lived next door to her best friend's boyfriend, and on through our

instant and deepening friendship, our sudden, electrifying courtship, our few short weeks of pre-cancer bliss, and our almost two years as a couple while Jack battled cancer and we squeezed in four months of a bicycle trip that was supposed to carry us into South America and the next amazing chapter of life.

Since my grief had resurfaced, I'd written him numerous letters and laments in desperate bids to find closure, but maybe thoroughness—rehashing our entire relationship and recording every memory, every emotion I could remember—would be my ticket to a cure. I had nothing to lose but the possible failure of my last resort.

For the next three days, I wrote and cried non-stop, filling 50 pages of the purple notebook with themes from my favourite song, Neil Young's "Helpless." "Dream, comfort, memories, despair." (After writing this section, I decided to double-check the lyrics and realized I've been hearing it wrong for nearly 40 years; it's "dream, comfort, memories to spare." But I like my mistaken word better, and think it fits the melancholy song just fine.)

Most pages featured memories and despair, even as I relived the best moments with Jack and let my old joy dance around again before dissolving in pain. The words poured out, unedited and remarkably coherent, with barely a word edited throughout. I wrote and wept, breaking up my writing sessions with long walks so neither my head nor my heart would explode. I wrote with the same pen, a black ballpoint, in long, urgent paragraphs divided by single blank lines between each.

The journal rests on my desk now. Many pages, especially those written as I attempted to connect life with Jack to my 23 years hence, are rippled with dried tears. I remember the waterworks as I wrote, how they kept pace with my right hand filling page after page, and the trapped years escaping

like gas—dizzying, tear-inducing gas—as the notebook swelled with all of it: *dreams, comfort, memories, despair*. It seemed essential to write through the tears, and I was glad I'd chosen ballpoint instead of fountain ink so I'd have a document when finished, and not a blurry pad of Rorschach inkblots. Essential, because part of my self-prescribed therapy involved the writing sessions, but the second part, to be completed after my return, was sharing what I'd written with Theo. Maybe *then* he'd know how to guide me to the elusive harbour I couldn't seem to find.

On the third night, I reached the end. I flip now to the last page and see how my grief document ends on a strange chord: a note of hope—"I feel more at peace with everything than I have so far: this has helped me face some feelings and hurts I didn't see clearly before;" a note of incompletion—"I feel like I can't let go of you now, even as I know that I must;" and a note of wistfulness, my final words: "I still wish I could've walked with you to the end of the road."

It's a non-triumphant minor chord, haunting and aching.

Maybe homesickness made me put the pen down. I'd reached the end of my narrative, but not the end of my feelings, and there were 30 blank pages left in the journal. But I missed my children, waiting for their mother to return from her nebulous journey to find answers. Maybe my hand was stiff with writer's cramp and my mind weary of the despair which flooded the pages. The next morning I went for a long run, and then I headed home.

I must've had holes in my head if I thought Part 2 of my plan was going to work. If I'd stopped to recall how impossible it was to make Theo listen to a three-minute song that described me, or to read a ten-minute selection from a library book on grief, or to come up with even two weeks of non-conflicting advice, I'd have realized how absurd it was to expect he'd read

my purple notebook. "All 50 pages," I asked him, naively, inanely. "I need your witness on this."

In his typical Theo way, he said he would, and I passed him the notebook with two hands, reverently, hopefully, supplicant to priest. Over the next few weeks, I came for our appointments, hoping he'd have started—maybe even finished—my memoir/confessional. I offered to sit silently and let him read it during our appointments, so the reading wouldn't dip into his personal time. He declined; he said he wanted me to read it aloud to him, but I could read between the lines and see he didn't really want to do that, either. I declined to read aloud. The proposal made me dizzy with embarrassment and shame. What if he started to nod as I read my deepest thoughts into the room, his mind and attention drifting elsewhere?

Theo was increasingly crabby and forgetful, and I attributed this to encroaching old age (he was pushing 60, ancient to me at the time) and to his own lingering trauma. My fondness for him morphed into resentment, mixed with longing for the Theo I used to know, or maybe the Theo I'd imagined he was on better days.

But the journal still mattered. It needed other eyes to read it, other hearts to acknowledge my grief and all I'd lost. I gave it to my new best friend in Philly, the friend who'd been so gracious when I'd come to her in tears, letting me weep like a child in her bedroom. Unlike Theo, she read the journal quickly, with the urgency she sensed I needed, and gave it back within days. Her initial comments—"First of all," she said, "I need to tell you what a great writer you are! You need to do more with this gift, you're a natural"—both heartened and shamed me.

I knew I should be writing, I *wanted* to write. I believe we're beholden to cultivate and share our talents, but the day-to-day pressures of the ministry, coupled with years of stuffed emotions and inner turmoil, made

intensive writing impossible. Even if I'd had time to write, I'd been afraid of releasing my inner demons, even to myself. Still, it was nice to hear I had the gift, however latent, discernible even in a rough, tear-stained first draft.

More importantly, we talked about the contents of my journal, what I'd tried to express and release, and as she listened, at least a thin slice of my grief was assuaged. Finally, someone else knew what I felt, how I yearned, why I languished. She could understand why Jack had meant so much to me, and how he still did. *Dreams, comfort, memories, despair.*

I thought of Jack's closest friends from Edmonton, the ones I could still contact, and sent them copies of what I'd written. Having these friends read my words, 23 years after Jack's death, would serve as the memorial we never had, the eulogies never spoken. This too, I thought, could soften the pain. It was a big request; the photocopied pages were even harder to read than the handwritten scrawl of the original, and it was long: 50 pages exceed even the most indulgent of eulogies. I didn't ask them to read every page, but hoped they would. If they thought I was crazy, showing up in their mailboxes after all those years, heart exposed and bleeding, they were kind enough to keep it to themselves.

Back in the Philadelphia Mainline, spring was in full bloom, and the snow-buried hills we'd known since arriving in January were transformed into fragrant green layers bedecked with colourful blossoms. I got on my bike and took long rides in the countryside, invigorated by the wildflowers and sun-infused air. I felt fragile, but hopeful. The storm was passing over, and though I was far from healed, I was no longer flattened by despair. But the clock was ticking. Time with Theo was running out, and I tried not to imagine how returning to Indianapolis, back to our busy, responsible ministry lives, was going to feel.

And then, suddenly, Theo was gone. There'd been talks with the elders, and a decision was made (whose, I wondered) to send him to rehab. He'd been self-medicating with wine, imbibed in his home basement office. This I learned in dribs and drabs of heavily guarded information: no one would say exactly *where* he was, or if and when he'd be coming back. Even Cheryl wasn't talking. And of course, no one could predict how Theo's recovery would go, or even if he *wanted* to recover.

Despite the progress I was making on my own, Theo's disappearance was a devastating blow. Things had not been great between us lately. I was angry over so much: my extreme dependence on him, his consistent unreliability, his maddening refusal to read my journal, and his exasperating, contradictory advice. That he'd nose-dived in his personal life didn't surprise me, but it did infuriate me.

To my shame, I had little compassion for him at this point. We'd become friends as the blurred lines of our church/family/client-therapist relationships had intertwined, and I felt I knew him almost as well as he knew me. But mostly, he'd been my counselor, my confidante, and my bulwark against utter disintegration. By disappearing, he profoundly let me down. Worst of all, I couldn't even show up at his office to scream or complain or walk out on him.

He was gone.

His first disappearance, the day I arrived in Philadelphia for my first session, had been a harbinger of this ultimate departure. He wouldn't be seeing me through my journey, though I still believed he'd wanted to. But with his last vanishing act, I felt like he'd left me on the operating table.

This was the state of the patient when the surgeon disappeared: she'd been cut wide open, groin to neck. Her insides were on full display and in tender shock, exposed to the elements for the first time. There'd been

some poking around, some organs lifted and shifted as the doctor searched for clues. Those organs hurt more now, as did the ones that first sent her to the hospital. Stuff needed to be snipped, rearranged, excised, put to rights. There'd been a few attempts to make a start, but the surgeon was distracted, uncertain. Now he'd vanished, and the phantom nurses had all gone home. There was no one left to finish the op and sew the patient up. She'd have to do it herself.

The other major work that wasn't finished—or even started—was mending our marriage. Henry had been meeting with Theo sporadically, and there was talk of meeting as a threesome to address the state of our union—dreadful, volatile, and possibly unsalvageable—but all three of us had been dragging our feet. Earlier attempts at couple's sessions had terrified me, and I sensed Theo felt the same. Henry's hurt and humiliation over my public grief transmuted to anger: loud, explosive anger that triggered overwhelming fear and helplessness in me, an inheritance from my toxic relationship with my ever-angry mother. Henry and I could get along if we focused on the kids and avoided talking about my grief issues, but it was impossible for us to have a calm, rational counseling session about our deepest feelings. We were like two fully loaded bomber planes colliding in midair, and Theo hadn't known how to contain the damage.

There was nothing to be done. Theo worked alone, so there were no back-up counselors waiting in the wings to fluff us into shape before sending us back to Indianapolis. Everyone who'd been shuffled around to accommodate our six-month move expected to move back to their original cities at the end of June. Henry was eager to get back to our old life and the friendships he'd left behind, and the kids felt the same. But I was terrified. To me, Indy represented the depression and despair I'd battled earlier,

and I imagined myself sliding from the midpoint of my Snakes and Ladders game to the bottom tip of the lowliest snake within days of moving back. Not enough had changed in me, and I dreaded a repeat descent into hopelessness. I didn't think our marriage—or my soul— could survive another setback.

But what choice did we have? None, it seemed, until the eleventh hour, when a new option surfaced. We shared our need for a mature, older couple nearby, capable of helping us navigate our marriage issues, and no one in Indy quite fit the bill. But the couple leading the church in Virginia Beach could do it, and we'd be back in a place we knew. We spoke to the mature couple, and asked if we could move back to our former congregation.

After days of anxious waiting, we got our answer: Yes. Another family would take our place in Indianapolis. We'd move our stuff from Philly in one truck and ask friends in Indy to pack up our house and send the rest of our stuff in another. This time we'd live in Norfolk, part of the Hampton Roads area that includes Virginia Beach, and lead that section of the church. We'd be back with great friends in a place we all loved, and perhaps we could resurrect our dashed dreams of growing roots in Virginia. After all we'd been through, it sounded too good to be true.

Of course it was.

FALLING SKIES

As a family, we spent a day searching for a perfect rental house in Norfolk, and before evening came, we found it: a stately, three-story duplex Victorian with high ceilings, burnished wood floors, picture windows overlooking a tranquil waterfront, and built-in bookshelves flanking a tiered wooden staircase. My dream house. Our children felt otherwise. For the first time, our bedroom was on a separate floor from theirs—we'd sleep in the sloped-ceiling attic room above them. And what delighted me as character—the creaky floors and mysterious nooks, crannies, and odd-shaped closets—spelled spookiness to them.

Outside was better. A tire swing hung from an enormous oak in the front yard and a huge, shaded lawn behind the house bordered a duck-filled inlet. At night, our dog chased and killed water rats that surfaced in the dark, leaving them as souvenirs for morning. Inside the haunted house was plenty of room for birthday parties and sleepovers, which I hoped the kids would come to appreciate.

Within a week or two of hanging the last picture and unpacking the last box, our counseling arrangement unravelled. The couple leading the church—the same couple who were supposed to help resuscitate our ailing marriage—were now needed in Australia for six months. Could they salvage our marriage over the phone? And could we step up and lead the entire church while they were away?

Of course, and of course. Especially after the break I'd been granted and all the upheaval I'd caused, we were compelled to say yes when duty called.

Within the same week, I got an unexpected letter from Gwen, my best friend from the days I'd known Jack. She'd been moving an old desk out of her basement and a 25-year-old photo had fallen out—a picture of Jack and me reclining on the grass during an outdoor summer concert. We looked blissfully happy in the photo—as indeed we were. It was the first photo of Jack I'd had in 20 years, and my heart broke as the picture tumbled from the envelope and landed in my lap. A tangible piece of him was back in my hands, and the Marilyn who lay with her head on his chest looked perfectly fulfilled. I stuffed the photo into a journal and headed to the waterfront to cry.

Still, things in real time were looking up. The kids were happy in their new schools—for once, their darker skin put them among the majority in their schools' demographics—and Henry and I were surrounded by loving friends in the church. I started to reach out and make new friends in the community. Our huge, light-filled living room was alive with a continuous stream of friends and visitors. It was the start of a glorious Indian summer.

And then came 9-11. Everyone remembers exactly where they were when the towers got hit. I was just coming down the bookshelf-lined staircase when Henry ran up to meet me. He'd been listening to the car

radio and heard the news. "Turn on the TV," he yelled. "A plane just hit the World Trade Center!"

We were watching when the second plane hit. Along with the rest of the stunned world, we watched the replays till I couldn't sit still for anxiety, and then I pulled out my exercise gear and lifted weights to the accompaniment of Ryan Adams ("New York, New York"), one ear glued to the TV in the next room.

Along with every other parent in Norfolk, we'd immediately brought our kids home from school. As home to the world's largest naval base, there was stark and legitimate fear that our city could be the next target. Washington was only four hours away, and it hadn't been long since I'd eaten lunch in the Pentagon with friends who worked there. It all felt scarily close to home.

For the next week, the brilliant blue skies over Norfolk were eerily quiet as we waited with the rest of the world for the other shoe to drop. Thankfully, Norfolk and other likely targets were spared. When the skies returned to normal, it was impossible to not obsess over how a single day of horror had changed the world.

Still, we had no idea how September 11th was going to change our family's trajectory forever.

In December, we booked a one-week trip to Toronto to visit Henry's mother over Christmas. Over the years, we'd landed at her tiny one-bedroom condo numerous times, usually in the midst of renewing passports or visas or squeezing in a visit around speaking engagements. I always packed heavy—you never knew how the weather might flip in Ontario—and my mother-in-law never failed to note how much extra weight we lugged around—clothing we never wore, books and toys we never unpacked. This

time, I thought, I'll impress her with a single carry-on. I packed barely enough to get me through the week: a single black skirt, two or three shells and sweaters, and two pairs of tights. I wore the single pair of shoes I'd wear throughout our trip and packed one set of workout clothes. I tried to pack equally light for the kids.

On December 28th, our visit over, we took an early-morning taxi to the airport (Henry's mother lived an hour outside of Toronto, and she refused to drive the daunting Highway 401) to catch our midmorning plane to Norfolk. If the flight was on time, we expected to be home by afternoon, ready to greet the pets and change into fresh clothes. We needed an extension on our Religious Worker visas, which would require a few extra minutes at Immigration for a brief inspection before stamping. This part of the transaction was always quick and easy.

But not this time. When we reached his booth, Mr. US Immigration Man got very officious, staring ominously into his computer before excusing himself to confer with his colleagues. Ten minutes later, he slid our unstamped passports back to us. "I'm sorry, folks," he said. "I know it's Christmas, and you seem like a really nice family. I sure hate to be the one to wreck your plans. But we won't be able to let you back into the States again on this—or any—visa. These visas are only renewable for five years, and you're approaching seven. You'll have to wait a full year outside the States before you can try to reapply. Good luck!"

Seeing our stunned expressions, the official explained. It was fallout from 9-11, he told us. After the attacks, all border officials were clamping down on rules and regulations. No kindly exceptions anymore, no extenuating circumstances, no winking at deadlines or overlooked details. No special allowances for missionary families. Sorry.

His verdict was final. There'd be a wait while the airline retrieved our checked luggage—heavier now with Christmas gifts, still light on clothing—and then we were free to go. But go where? Suddenly we were homeless. There was no returning to Grandma's: one week in her condo was the lovely limit, as we quickly overpopulated her compact space. She lived miles from the city, in a high-rise along a busy highway. Plus, we'd just blown our last $100 getting to the airport after overspending on the kids at Christmas. We'd left ourselves with just enough cash to limp home, which was now as impossible as landing on Mars. In those days, we had no credit or debit cards.

Henry and I were no strangers to visa woes. Over the years, as we'd moved from Toronto to India to England to Nigeria to South Africa and back to the US, we'd faced plenty of snags and closed doors. During our move to Boston, in our first year of marriage, I waited in our empty rented house for ten days while Henry, traveling from Canada in a borrowed truck full of our ramshackle belongings, was refused entry. He eventually managed to cross the border, sans truck, with a single suitcase. (Meanwhile, all our worldly goods were stored in a Canadian church basement which subsequently flooded with sewage water, destroying everything.)

A year or two later, I'd been blocked at the American border for carrying a diary which noted the days I volunteered at a Boston soup kitchen; the official suspected I was hiding a paid job and turned me away, accusing me of deception, with a withering reference to my implied hypocrisy. "You seem like a good Christian woman, Mrs. Kriete...why are you lying to me?" (I wasn't lying; all our support funds came from Canada.)

A few years later, we'd been refused a new visa at the Indian Consulate in Toronto, only to reapply after a night of intense prayer and receive a reversal. Once I'd been flying from Canada to Nigeria with three-year-old

Daniel and got stuck for three days in London when an official noticed they'd failed to stamp my son's passport in Canada. Being exiled in an airport is a lonely affair as you watch everyone else arrive and depart, and this was even worse in the days before cell phones, when we didn't even have a home phone in Lagos to communicate with Henry. Several years later we'd had to wait four weeks in Cote D'Ivoire to score a visa to move to South Africa, since there was no consulate in Nigeria. And so on.

We hated red tape and spent months of our lives entwined in it. But this slammed door was as final as any. Now there were four Krietes locked out, each with new attachments and connections in Norfolk, after years of too many upheavals. Being yanked up by the roots minutes before we were to fly home was the last thing we expected, and the last thing any of us needed.

The airport was quiet that morning, and for a couple of hours we wandered the terminal like lost refugees, trying to grasp what had just happened. Even though we were technically in our native land, we *were* refugees: our lost home lay elsewhere, our jobs had been wiped out, and our bank account was hollow. We had only enough cash to buy coffee and make a few phone calls. By the third or fourth hour, we'd contacted a lawyer in the Toronto church and she and her husband were on their way to rescue us. For now, we'd stay in their basement suite while she wrangled with our visas and found a solution. Of course, since it was almost New Year's Eve, all government offices would be closed for at least another week.

She was as shrewd a lawyer as any, but there *was* no solution. Two weeks later, faced with this immutable truth, we considered our options— or rather, our singular option. Our employers—the powers-that-be who determined all our moves and ministry positions—would search for a church with the financial clout to move, hire, and support us for at least a

year. And that church had to belong to the "Commonwealth Sector" of our worldwide fellowship. (Years earlier, in our churches' quest to evangelize the world in one generation, our leaders had divided the world into eight sectors, based largely on geography. As employees, we were wedded to our particular sector for life, barring a rare trade agreement.)

Being part of the Commonwealth Sector limited our choices to regions like the United Kingdom, India, Australia, New Zealand, Malaysia, Singapore, and Bangladesh. The Canadian churches, in spite of our country's monarchist affiliation, fell under a different world sector, known as the Northern Federation, so we wouldn't be repatriated. We had no say in where we might go. Instead, our church superiors negotiated through international phone calls as we awaited their decision.

"I sure hope it isn't England," I whispered to Henry, afraid to awaken the duplicitous gods of fate. "Maybe it will be New Zealand this time. New Zealand sounds lovely, don't you think?" Landing in New Zealand was wishful thinking; it was unlikely the small churches our organization had planted there could support another family.

We'd lived in London for six months in 1989, prior to our six-year stint in Africa. I hadn't *disliked* London, but I remembered the dreary wet winter, and the dark, oppressive damp of London didn't seem conducive to the emotional healing I needed. All the sunny third world postings we'd prefer—India, Bangladesh, Indonesia, or Malaysia—were also unlikely to have funds to support us. When the call finally came, it was London calling.

"Hey bro!" It was Keith's raspy voice, the former MIT wunderkind and atheist my husband had helped convert back in 1983, now overseeing all the UK churches. "We can't wait to have you guys with us here in London! Everything's been arranged, and we'll see you here soon!"

I wasn't happy about London. But I was glad we'd be with Keith, who was very fond of Henry, and with other old friends from our years in the Commonwealth Sector. I shook off the negatives and looked for blessings: Several close friends from Nigeria now lived there; winter could last only so long, and then we'd be blessed with a classic British spring, brisk and green. The tea would be good, unlike second-rate American tea. Our kids wouldn't have to learn a second language while they adapted to a new culture. Hopefully they wouldn't mind wearing school uniforms; it would make mornings a lot easier. And with any luck, they'd get to ride a bright red double-decker bus to school. I looked hard for silver linings; if I didn't, I feared the sky would fall on my desolate head.

■ ■ ■

As we prepared for England, new trials hit us. Daniel needed a new passport, and there were missing documents we couldn't locate. Our Norfolk friends turned our house upside down searching for his original Indian birth certificate. We had copies on hand, and of course he wouldn't have been issued his current passport without having submitted the original, but this wasn't good enough for the Canadian officials. They rejected his application, and then proposed a six to eight week waiting period that involved traveling to the hinterland province of Newfoundland to appeal his case.

Upon hearing this, I had a full-blown meltdown in the passport office while Henry, distraught at my distress, called down curses from heaven. The wailing and the curses worked. The bureaucrats conceded that copies were proof enough of his existence—to say nothing of his physical presence every time we came to the office and waited the requisite hours to

be served—and agreed to issue a new passport, but on their ponderous timetable, which meant another frustrating wait.

By the time we got Daniel's passport, we had another tiny bureaucratic victory—of sorts. The American government allowed Henry (only) a one-week trip to wrap up our affairs in their country. He was instructed to return and shut down every aspect of our Norfolk lives: close our bank account, officially withdraw the kids from school, rehome the pets, and grab whatever paperwork we needed from our relinquished house. We asked friends to pack our belongings in a storage locker to await our hoped-for return after the requisite year. While Henry went through these rites of closure and goodbyes, the kids and I flew ahead of him to England. Once again, I was leaving a country and a small world of relationships without the opportunity to say goodbye—or even the knowledge that, once again, our departure would be permanent.

These sudden exits were so common in my life that I almost took them in stride. I say *almost*; I marched like a good soldier, but inwardly the cracks were killing me. This was the sixth time in my Christian life that I'd left a home, city, and country without advance notice or farewells, and in some cases, I'd never been able to go back.

When I had, the belated returns landed me in worlds painfully different from the ones I'd left. Almost 20 years passed before I was able to return to India, where Bombay was now Mumbai, swept of its earlier magic—camels and dancing bears and snake charmers on the streets where we lived, riotous color and smells—replaced by air-conditioned malls, appalling traffic, and millions of cell phone users in every strata of society.

I had loose ends and deserted friendships in every place I'd lived. I left behind chunks of my heart, and in each new city it seemed I had less to

give. Like a stray walnut languishing on a pantry shelf, my capacity to start fresh was shrivelling, getting drier and harder with every passing year.

■ ■ ■

Jack's death was the original, unforeseen loss that foreshadowed all the rest. In his case, I *should* have seen it coming. He'd been diagnosed with cancer a year before we fell in love and started living together. Without fanfare, he'd undergone surgery and then enjoyed the illusion of a cure until the day his one-year follow-up results came back, indicating stage three cancer. That day, the Day the Cancer Returned, we'd been a besotted couple for all of two months. Even then, I'd forgotten Jack's first brush with cancer; he was vibrant and young, too alive to ever die.

Naively believing that "in remission" meant cured, we embarked on our cycling trip to South America. When Jack was hospitalized again in Tennessee, the darkest chapter of our lives so far, I reverted to my autopilot-and-denial mode. He was sick, I knew, but he'd get better.

His final four months should've been my wake-up call. I slept at the Edmonton cancer hospital with Jack, anticipating the day we'd check out and get on with our lives. We were still dreaming of South America. Getting well was a matter of sustaining the conviction that this cancer was merely a blip, not a death knell.

We believed in surrounding ourselves with happy people, and our friends obliged. We believed in laughter therapy and the power of visualization. We never once spoke about death, never acknowledged the possibility of a different outcome. Swaddled in foolish delusion, I watched him waste away till he was coat-hanger thin, the telltale signs of death—gaunt, caved-in temples and otherworldly eyes—staring me in the face. Still, I was sure he was getting better; it was just a matter of time. Jack was a

miracle in my life, and a miracle of a man, and if anyone could spring back from wasted to vigorous, I believed he could. He *would*.

Someone brought a copy of Elizabeth Kübler-Ross's *On Death and Dying* and left it on the bedside table. I saw the book without registering its contents. It wasn't till the doctor walked into the room and sat next to the bed, holding our hands and crying, that the reality of Jack's impending death entered my conscious mind. It was 11 o'clock on a fresh spring morning: April 30, 1978. Like a good and terrible fairy godfather, he granted Jack three weeks to live and urged us to leave the hospital immediately. He knew Jack would want to squeeze whatever was left from his last 21 days on earth, floating in unlimited morphine and barely able to lift his besieged body off the bed. Even then, the message came too late.

I'm a slow absorber, the person in any disaster who seems to be coping better than everyone else. But it's only because I'm *not* absorbing the news, *not* letting myself feel what's going down. When tragedy strikes, I go straight to autopilot, creating the illusion of cool, calm, and collected, but I'm not really *there*. I know how to hit an emotional pause button and float there for years, over 20 years, in Jack's case, and for absurdly long spells over lesser griefs, too. I'm also good at forgetting the pause button even exists. I fool myself into a lot of denial.

At noon on that beautiful spring day, I wheeled Jack out of his last hospital, and we went to the river and wept. For another searing moment, I acknowledged death and let myself feel, but only briefly, fearing I'd never escape the howling chasm of grief.

Jack had a three-step end-of-life plan, and after we wept to exhaustion, he shared it with me. I didn't ask how long he'd been mulling it; I had no idea he *had* an end-of-life plan. The wish list was simple: A farewell party in the next couple of days, where he'd say goodbye to all his Edmonton

friends. This was in lieu of the funeral he didn't want. After the gathering, we'd spend a week in Los Angeles, with his father and two brothers, followed by a week in Phoenix, visiting his first best friend. On the 21st day, a return flight to Edmonton. And that was it: The End.

I hit pause and scrambled to make arrangements. At least 40 friends attended Jack's farewell party, laughing and crying as he addressed and eulogized each friend by name. It was a magical, tragic night, and I wept in a corner the whole time, unable to accept either truth or comfort. Jack saved his final words that night for me, and while I knew they were words I needed to hear—*desperately* needed to hear—whatever he said sailed past me. I was fighting too hard with grief to register anything beyond my pain.

After the party, I shut off the tears and focused on completing the rest of Jack's plan. He was emaciated, as grey and brittle as a wasp nest, his life force diminished to the energy it took to breathe.

In Los Angeles, where we joined his father on a cramped sailboat in the Marina Del Ray, he drifted through time, regressing to childhood, and was only occasionally lucid. He was lost to me, and my heart froze even more to block the pain. During his final week, in Phoenix, he surfaced enough to connect at moments with his oldest friend, but never long enough to have a meaningful conversation with me. Perhaps I was just as incapable of having an end-of-life talk with him. I was still in denial; it was impossible to talk about death or picture any future without Jack. We were fused, and I didn't know how to separate. I'd given him everything, heart, body, and soul, and detaching myself meant my own death, too.

■ ■ ■

Looking back at those final weeks, I see myself sleepwalking through a dreamscape. Jack was physically close but far away, opiated and doing the

lonely work of dying. My body went through the motions of caregiving while my mind swirled in wordless pain. On the 21st night, we boarded our last plane together: Jack, feather light and ageless in his wheelchair, and I, his shell-shocked attendant. Suspended between Phoenix and Edmonton, the cities that shaped him, he almost died on the seat next to me, gasping for breath until a stewardess cupped his face with an oxygen mask. My worst self, exhausted and hungry after two weeks of barely eating, watched in detachment as he struggled for life. As it had since Jack's diagnosis, cancer was robbing me of self-care (all I wanted was to eat my airline food and escape into sleep) and preparing me for years of self-reproach. My traitorous thoughts would haunt me for years.

I long to discuss those days with him. He would eagerly dissect such brief and weighty moments, analyzing and disarming them before linking them to a song lyric, a poem, a movie scene, or a proverb. He would forgive and erase and tame it all, making everything better. He would make me laugh. But he isn't around for any more talks.

■ ■ ■

We landed at midnight. He struggled to breathe, so back we went to the hospital. The night nurse insisted I go home, and by the time I returned, he'd broken through the veil.

Wracked with grief, anger, and guilt, I focused on the nurse who'd banished me from his side. For her sake, it was good she'd also left the premises. Anger was preferable to howling grief and guilt. Other nurses and Jack's doctor tried to console me, the inconsolable. Pacing outside Jack's room, my next faux pas, failing to view the body beyond 60 seconds, became my haunting.

An hour later, I was out of the hospital and on my bike, riding the river trails where I'd skied and walked and dreamt with Jack, whisking his spirit away from the death room. I went from darkness to light in a heartbeat. He was free now, and the cancer chapter was over.

The skipped funeral. I was too young to realize that memorials are for the living, not the dead, that even the loneliest grief finds comfort from touching others in the same pond. But we were young, Jack and me and all our friends, and no one was wise enough to say *Let's cry together*.

The dumped ashes. To this day, I'm not sure how I feel about cremains. And even as I went over and over these details with Theo, these missed opportunities to apprehend Jack's death and grieve appropriately, I still couldn't say those simple words. Goodbye.

I floated alone in this hazy state, alternately feeling and numb, flirting with joy—the joy of Jack's release from pain—and blocking out despair, before pressing pause again. Along with my emotions, I packed up our basement suite and erased all physical evidence of Jack, apart from our tent, the silky green parachute we slept in, and his old road map. Two weeks later, I grabbed the map, the tent, and the parachute, loaded them onto my bicycle, and rode away, an unknowing victim of my stifled grief.

WE ALL FALL DOWN

Londonwelcomed us with classic gray drizzle, and with Louis and Tamara, a couple we'd worked with in Nigeria. It was strange to see them in this context, bundled in scarves and far from the tropical streets of Lagos where we'd grown close. I'd studied the Bible with Tamara, watched the two of them fall in love, trained her in the ministry, and been her matron of honor.

Now they were flourishing in London, leading a fast-growing ministry with the fervor they'd always had. I was glad to see them, but inwardly ashamed: I wasn't the single-minded, hyper-focused women's ministry leader they'd known in Lagos. Leaving Africa and the toll of our subsequent moves had gutted me. I felt like I'd been living on different planets since we'd last been together, the twin planets of Melancholia and Despair. In Lagos we'd all lived on the sunny planet of Zeal. Seeing our friends reminded me of who I'd been and what I'd lost, and I doubted they'd understand what had happened to me, even if I told them. It had been 10 painful years of losing heart, and I didn't have the energy to describe them.

Keith, the lead evangelist, had asked Louis and Tamara to find and furnish a flat for us. They'd stretched the ministry budget and found an elegant, two-story row house in North London, freshly installed with borrowed and rented furniture. Like most London homes, it was narrow and tight by American standards, but perfectly adequate for our family. Its most striking feature was the rosy pink carpet throughout, not exactly a match with the blue and white walls, and Tamara had either failed to take note of the colors or had sent someone else to buy bedroom linens and curtains without apprising them. The garish African patterns, in muddy shades of yellow, green, and purple, clashed so painfully with the rest of the house that I resolved to shut the blinds till I could replace them.

Downstairs was an added-on kitchen so chronically cold that we hopped about in triple socks, constantly brewing tea and cocoa to keep warm, but, overall, the kids and I were pleased. Next to the kitchen was a tiny room where they watched British TV, puzzled and intrigued by the new, distinctly non-American culture. To their satisfaction, all three bedrooms were on the same floor and close together; no doubt our frequent moves had fostered a need to sleep close.

By the time Henry joined us, we'd explored the High Street (multiple times), found a car, and bought three notebooks—one for each of us—to make a running list of "What I Like about London," a tactic I hoped would encourage positive thinking. We were all a bit rattled by culture shock, especially over the nebulous school situation. Unlike American and Canadian public schools, which scramble to accommodate any student landing in their catchment, London's schools were a hodgepodge of church-owned and private institutions seemingly disinterested in attracting new students and under no obligation to accommodate anyone. I needed someone to

explain the system to me—how it worked and how to break the code—but my new London friends didn't realize their system needed expounding.

Left to my own devices, I drove throughout North London (in what always felt like the wrong lane), searching out schools and seeking interviews. I was not yet online, and I doubt these stone-and-moss institutions were. If I was lucky enough to land an interview, the school was invariably a dud. It took four weeks to get our son into *any* secondary school, and it turned out to be one of London's worst—already under probation and soon to be closed for good. For Tassja, the wait was even longer: two months to enroll her in the first of three schools (poor, slightly better, decent) in the course of a year. The schools were officially free, but unspecified donations were expected. I was baffled and frustrated by the arcane system, and as our children languished at home without friends or purpose, it added another layer of stress to my already burdened heart.

Our church life was better. Our North London sector was internationally diverse, with Africans, Indians, Slovakians, Croatians, Greeks, and other Europeans outnumbering the English members. It was a witty and well-educated crew, and although it wasn't Africa, it was the closest thing to being back in my former happy place. Plus, being with so many other displaced people made me feel a little less displaced. In a setting like this, everyone's backstory was different, and I wanted to hear all of them.

The large church-wide staff met weekly in Central London. That year, the church was celebrating its 20th anniversary, and plans were underway for a huge service at Wembley Arena in June. Our churches were obsessed with growth and numbers, and our goal was to fill the arena with 10,000 friends and visitors. To achieve this, every staff and regular member was expected to evangelize almost daily for the next six months.

In London, evangelism meant walking the city's ubiquitous High Streets with invitations and hanging around Tube stations to solicit commuters on their way to work. Neither of these methods was statistically the most effective way of drawing newcomers, but sheer volume overcame the odds. Many current members had been met on the streets, and it was something the London church had always done. They called it *blitzing*. Accordingly, we got on board and started blitzing in February for our June event. The goal was to get phone numbers so we could persuade potential visitors to come as the date drew near. (Most people, handed an invitation for a free event *four months in advance* would likely forget within a week or two.) Everyone from the head evangelist to the youngest teen was blitzing like crazy and constantly reporting their progress to their leaders. Like most groups, we had our share of shy members, but no one was exempt from the mission: street evangelism was expected from every member.

A strong work-and-obedience ethic prevailed in all our churches, as directed in this scripture: "Obey your leaders and submit to their authority. They keep watch over you as men who must give an account. Obey them so that their work will be a joy, not a burden, for that would be of no advantage to you." (Hebrews 13:17)

Of course we wanted our leaders to be happy! Obeying them meant we did whatever was instructed without grumbling or excuses. Although the daily expectations for the Wembley service were onerous, the overall goal—to bring as many as possible to our celebration—seemed right and good. The ultimate hope was that many of these visitors would eventually join the church, too, and, by extension, join all of us in heaven. We continued to invite guests to our Sunday and midweek services as well. But we were putting way too many eggs in the Wembley basket, and the service couldn't possibly live up to our burgeoning expectations.

If there were misgivings among the members (and I know there were), we kept them to ourselves and kept blitzing, wishing June would hurry up and arrive so we could reap the harvest and move on. "Wembley" was our mantra, the mecca for all our seed. It was all Wembley, all the time.

Once the kids were in school and we established our new routine, my unresolved grief surfaced like a stone-released corpse in a river. But I had nowhere to put it. It was the corpse of Jack, plus all the losses since Africa I had yet to process. Unresolved childhood grief also clung like seaweed. As we'd moved from place to place, our focus was always on building new relationships as quickly as possible, leaving no space to grieve the past.

I'd had time in Philly to assess the damage, but little had been put to rest, and now there were new losses: my grief over Theo's abandonment, and losing our home and friendships in Norfolk. I didn't tell Henry the corpse was still with me. I'd had my time to grieve and had failed. Asking permission to wallow, journal, or vent any longer seemed indulgent, even as my grief corpse bloated.

For comfort, I turned to classical music. Drawn to the melancholic adagios, cantatas, and requiems of Mozart, Elgar, and Bach, I listened every night, letting the familiar laments lull me to sleep. The music beautified sorrow, and even the most heartbreaking pieces were underscored with mystical hope. I was convinced by now that my heart was permanently broken, that Sadness was my middle name, and that I may as well have a soundtrack to match. And if these great composers had known such transformative, heart-stirring grief, I was in good company.

My yearning for Jack was a dull ache that robbed me of joy, but I shared little of this with my London friends. Even for me, my story was getting tiresome and pathetic with age. The closest I came to happiness, apart from spending time with my kids, was hiking through meadows

and country lanes near our North London home, where grazing sheep, wood stiles, stone walls, and ancient, ivied churches delighted my senses. Accompanied by our new golden retriever, I loved the pure *Englishness* of my country walks and found comfort in moments when I could steal away. I was determined to fall in love with England. This was our new home, at least for now, and the best way to cope was to forget the past and embrace what lay outside my front door. I did so, literally. We had a huge oval planter in front of the house and I filled it with flowers and shrubs, consulting my elderly, very British neighbors for advice on the hardiest and brightest English plants. They were happy to oblige.

Still, the sadness lingered over everything I did.

■ ■ ■

As June approached, we ramped up our evangelism till it completely consumed our lives. Staff meetings were accountability sessions, tallying our prospective visitors and pushing for more. It was imperative to reach our numeric goal. Plans for the service itself grew grandiose and worldly; it was turning into an enormous Look-at-Us rally instead of public thanksgiving and praise for what God had done in our lives. When the big day finally came and we thronged into the arena, there was momentary rejoicing in the turn-out—we'd surpassed our goal of 10,000 in attendance—but as the service progressed, a pall of disappointment hung in the air. Five months of hard work and perseverance—for what?

The service turned into a Who's Who of past and present church leadership, as well as a boring parade of thanking various public officials for simply showing up. As a visitor, nothing about the service would've inspired me. The church was putting on a show, and the show wasn't matching the hype we'd pitched to our visitors. We entered the gates of Wembley with

thanksgiving and left with our heads hung low. The three-hour spectacle and our obsession with numbers embarrassed me: This wasn't the church I lived and sacrificed for.

Did most members feel this way? We were all fiercely loyal to the church, but most telling was how *little* anyone spoke of the event afterwards. No one wanted to voice how dreadful it had been. Overnight, the word "Wembley" passed into oblivion. Going back to our regional Sunday meetings was a relief, because at least those services were heartfelt and warm. And we were no longer obliged to spend early mornings handing out leaflets to preoccupied commuters.

Life in the London church went back to normal, though a weariness prevailed. But that fall another tempest was brewing across the Atlantic, as the top leaders of our churches met to discuss the spiritual state of our kingdom. Competitiveness, worldliness, and materialism were tainting the upper core, and the next tier of leaders—those more actively involved in the day-to-day work of the church, and apt to be living in large, third-world cities—decided it was time confront their mentors.

News of the confrontation reached the London and UK staff, and it pushed at the cracks in our own fellowship. After years of repressing their own frustrations, the staff members called upon Keith for their own freedom of expression: the opportunity to vent hurts and resentments, without censure, in open staff meetings. A lot of unresolved pain lingered after 20 years of shifting, complicated relationships and one-sided discipling. As the staff began venting in painful, protracted staff meetings, the regular members of the church asked for the same freedom. Church-wide forums ensued; these meetings were even more explosive than the staff versions, and I think everyone would've hit the brakes if we'd foreseen the tragic outcome. But the brakes were long broken.

Disillusionment from the Wembley event, combined with years of fatigue and inner conflict at putting membership responsibilities ahead of personal and family needs, had soured many hearts, and suddenly our united kingdom was a battlefield, with members and staff caught between divided loyalties and past and present grievances.

I remember the blood freezing in my veins during the first church-wide open forum, as several angry and embittered members shouted at the row of leaders seated in a grim and defensive line across the stage. It was similar to what I'd felt at other moments of imminent, life-altering change: when I learned Jack had three weeks to live; when the door was closed to India, Lagos, and ultimately the rest of Africa; when our breezy pass through U.S. customs turned into a locked gate after 9-11. In each case, my heart went into crouch-and-protect mode, shutting down my feelings so I could endure what came next. I didn't know yet how profoundly the present crisis would upturn my world, but I must've sensed its weight.

The crisis raged from December till April. There were meetings upon meetings, each fraught with increasing pain and alienation. Staff members, many with relationships going back 15 years or more, were now scarily at odds with one other. Staff meetings, once an oasis of joy and encouragement (apart from the accountability sessions), became cesspools of tension and distrust.

Early in the negotiations, when many members began withholding their financial donations in a show of displeasure, the staff were instructed to stop doing the work of the ministry, which was all we'd ever been trained to do. Now, like an army of idle soldiers with loaded guns, we had nothing to do but fan the flames or withdraw. Almost all of us were Type A personalities, so withdrawing only worked for a few. We were used to fighting for what we believed in.

Many members aligned themselves against the staff, or against certain groups of staff, breaking years of friendship and apparent trust. Everyone was hurting and no one was blameless; Satan was having a field day, fomenting suspicion and bitterness where once there'd been love, forbearance, and the surface unity of a shared group vision.

There were attempts to resolve the conflict through a committee of member-voted delegates, but even this failed when a group of leaders from the States flew over for the first meeting and imposed their own agenda. Frustrated by a lack of openness and humility among the leaders, more members decided to vote with their wallets, withholding their weekly tithes for lack of a stronger voice. By April, all the UK churches were running out of money, and in the course of a very sad week in April, all but two of its 102 staff members were made redundant—the polite British way of saying *you're fired*. The final two, being the church administrator and the much-loved children's ministry director, were only retained till the last items of business had been dispatched, and then they, too, would be forced to seek other employment unless the church could coalesce and heal.

With very few exceptions, everyone on staff had given up early career paths to enter the full-time ministry in their early 20s. Many had left university and gone directly into the ministry. Nearly everyone had families to support. Now they were tasked with building a secular future on a very religious-looking resume. Or, as they say in England, a *curriculum vitae*, loaded with life experience but not a lot of alternate employment experience. Our little fantasy talks—*What would you be doing if you weren't in the ministry?*—were suddenly real questions.

Arriving in London at such a time was like having front row seats at the Roman Coliseum. We were in it, though not of it, unwilling spectators in unwanted seats. Henry and I were in the splash zone, well within range

of the martyrs' blood. It was like watching a beloved friend tear herself apart, hair by hair, limb by limb, to a horrifying death. It was like watching a once-happy family hack itself to smithereens with steak knives and kitchen shears, or watching a horde of Barbarians ransack and plunder a lifetime of careful building. It was utterly devastating.

While we watched, Henry wrote. He'd been noting the warning signs for years, alarmed by the leaders' obsession with numerical growth, which fostered competition, envy, and pride among the evangelists, and a constant pressure to produce among the members. Our obsession/mission was a conundrum, because growth meant more people were going to heaven and that was absolutely worth everything. But the push to be the biggest, fastest-growing church in the world, congregationally and collectively, was having ugly side effects, and we were depending on worldly strategies instead of trusting in God's wisdom, power, and timing.

Henry had discussed these concerns with other leaders, as had many others over the years. It was a dreadful truth, evident in the stress and dysfunction many leaders exhibited—almost all the top leaders' wives had chronic, often serious health conditions, for example—to say nothing of the pressure endured by overextended members. But the caveats had gone unheeded. Now the London church was demonstrating the next crooked turn in the road, what lay ahead for other congregations if the faults weren't corrected.

Those in London believed the implosion was caused by the sins of particular leaders in the span of their 20-year history. But this was not merely a local calamity: it was a precursor to world-wide collapse in all our congregations if the lessons weren't heeded, and quickly. Convinced of this, Henry wrote a 40-page appeal/manifesto to the churches' top leaders, documenting the events in London and begging for action to address

the wrong turns our movement had taken. He described the systemic sin impugning our corporate and individual integrity and sent his plea to 70 preeminent leaders.

The letter (still alive and well on the internet) was a passionate, logical, scriptural appeal for repentance, but to our dismay, all but two of the 70 recipients stayed silent. Of the two responders, one was supportive, while the other chastised us for a lack of gratitude towards the church and its upper echelon. We had, after all, been granted an unheard-of, six-month hiatus for my sessions with Theo.

Wanting to show the London members that they were dealing with a systemic, not local, problem, Henry distributed copies to the London quorum appointed to steer the church to recovery. One particularly frustrated member of that group, who had recently lost a friend to suicide, posted the letter online—against Henry's wishes—and the rest is history. Within days, his impassioned epistle ignited a worldwide firestorm.

The viral effect was like dominoes, as congregations everywhere demanded the same open forums and freedom of speech that had devastated the London and UK assemblies. Around the world, many hundreds of ministry workers lost their jobs—most of whom had given up post-university careers to work for the church and had little to fall back on after decades of service. These were our friends, our colleagues, our dear brothers and sisters, and Henry was alternately lauded and blamed for the worldwide fallout. London was not his fault: He'd acted as reporter before donning the mantle of reluctant prophet, but it was convenient to have a scapegoat in the midst of the inferno.

In London, our own sector invited us to stay, pledging to pay us independently in hopes we could help salvage 200 broken hearts and move forward. The offer was tempting. At least we wouldn't have to pull up stakes

again, and London was starting to feel like home. Our dream to return to Norfolk at year's end had been dashed when we learned another family had been hired in our absence, another crushing blow. Our family had counted on going back and our pets and possessions were still there. The new hiring was a simple, heartbreaking matter of expedience, finances, and broken promises. At least London wanted us, and we were already in place.

Perhaps the easiest choice would have been to accept the new offer. But I was traumatized by the emotional war we'd just witnessed, the bitterness and despair that had erupted through the church, and the swift collapse of something I thought was unshakeable. I was struggling to pray and my inner resources were depleted. Going numb could protect me from meltdowns, but not from the very real consequences of spiritual defeat.

I still had faith in God, but my faith in His church—or at least my perception of it— was shattered, and it was impossible to see this as a phase and not the end. I was also very tired: tired of analyzing what went wrong, tired of the finger-pointing, factions, and demoralizing gossip. Henry, engaged on multiple levels and pulled in every direction by those who wanted his perspective, was also weary and dismayed by the discord among his closest friends. Neither of us felt up to the task of inspiring the devastated survivors in our sector.

Daniel, miserable in his soon-to-be shuttered high school, where classmates in navy blazers and neckties cursed, smoked, fought, and bullied their overwhelmed teachers, was more than ready to leave. Only Tassja, untouched by the church drama and befriended by many who flocked to our house to give and receive encouragement, was eager to stay.

We weighed our options. If we left London, where would we go? It was the worst time in our church's history to seek a new position. Hundreds of seasoned ministry people were losing their jobs and congregations were

shrinking, even as we deliberated. And Henry was a hot potato, cheered by most of the rank-and-file, but feared by many leaders. He was a lightning rod, viewed as an instigator, though more by conviction than temperament. Yet we couldn't conceive of leading a ministry outside of the ICOC. Leaving London meant leaving the ministry, something we'd never considered in almost 25 years of service. It was our *life*, our purpose, our calling, our identity. When I thought about leaving, my heart went into freefall. Stepping out, voluntarily or otherwise, was like stepping off a cliff…in the dark.

But there was another pull. We'd been out of Canada for nearly 20 years, living on visas and borrowed time, perpetually unsure where we'd land next. We were so tired of starting over, time after time, with serially dashed hopes of ever staying in one place for the long haul. Even if we chose to stay in London, how long would we actually be *allowed* to stay? It seemed whenever we wanted to stay, the rug was pulled out from under us. The thought of returning to our homeland, the only place where no one could pull the rug or demand a visa, was enticing.

Could our next move put us somewhere permanent, at least long enough to let Daniel finish high school in the same city, at the same school? Given our track record, four years of stability would be amazing. The longest we'd stayed anywhere, even in Boston and in Lagos, was less than four years.

Back in Canada, my father was trying to find out if my grandmother's birth in England entitled me to a permanent visa. He thought it might. (The offer held true for him, not for his children.) The visa trail turned cold, but as we talked, I learned more about my grandmother's family and where they'd lived before emigrating: just a few miles from our London home, in a neighborhood I regularly visited. My great-grandfather had been a Baptist preacher in Hackney, working with Charles Spurgeon, until

his decision— in his 40s—to move his family to Alberta and be a farmer, not a preacher, near a little town called Tofield, an undertaking in which he had zero prior experience. Still, he took the leap and farmed for one difficult year, doggedly if not successfully, before moving to the bigger city of Edmonton and taking up a new trade as a cobbler. He'd taken a strange path and I wondered why he'd given up preaching at such a crucial age. But he'd made it.

As far as we knew, his family had food, shelter, and well-stitched shoes at every step of their new life in Canada. My grandmother, his youngest child and only a toddler when they ventured across the ocean, had kept the faith and turned out fine. Their story inspired me.

If he could do it, I thought, *in his 40s, with twice as many children to support and no safety net apart from God's goodness, then surely we can, too.*

Now all we had to do was narrow our plans to a *place* in Canada. It could be anywhere. But I knew it wouldn't be Tofield or Newfoundland, and we wouldn't be farming.

CHAPTER

A STRANGE NEW FREEDOM

Henry and I had met in Toronto and lived there twice, but instead of returning to Ontario, I wanted to live near my siblings. I'd run away from the family home at age 14, moved to Vancouver, left for numerous sojourns in the US, traveled to Toronto and got married, and then lived abroad for most of my adult life. It was time to seek family again. Three of my four brothers lived on the west coast, so we narrowed our sights to the Vancouver area. Henry had a cousin living in Port Moody, near Vancouver, so we called her. Without having met me or our children, she graciously invited us to stay with her while we figured things out.

Finances were a huge concern. All of the now-redundant staff members in the UK churches had received a standard severance package: one month's pay for every year they'd been on staff. Between us, Henry and I had 36 years of service in our churches worldwide, but in our case, only the year and a half we'd spent in London counted towards our severance. In addition to our combined six weeks' pay, the church would pay our flight and moving expenses, including the cost of flying with our newly-acquired

pets—our golden retriever and a cat that belonged to Tassja. Beyond that, we were on our own. At least we'd have free housing for the first month or two.

But God provided richly. After the London members heard we were leaving, several gave personal donations, and in an amazing act of generosity, one member sold his London house and gave some of the proceeds to us: around 5,000 pounds. His generous gift was humbling and faith-building. For the first few months, at least, we'd have enough to make it.

Once our plans were set, I numbly prepared to exit yet another chapter of our lives with a sudden ending. It was my old, familiar way of coping: shutting off feelings and compensating with hyper-efficiency and busyness. The church implosion had stunned me as much as Jack's death had, and it felt like another death—or, more accurately, like multiple deaths: the death of our dreams and of belonging to something powerful and meaningful, as well as the death of our life's investment.

What remained of the church wasn't dead, but it was deeply wounded and actively bleeding, and our part in it had irrevocably changed. We'd been part of the Boston church that had sent the London team to plant the church, had been friends with its many leaders over the years, and had been joined in heart with the London ministry through our work in India and Nigeria, overseen by London leaders. It was our *family* that had blown up. I was in much greater shock than I realized. And for the first time since joining the ICOC, we were not being sent, but were sending ourselves to a place where no jobs or security awaited us.

Before leaving London, we made a quick trip to Paris; the kids would be cheered by going to Euro Disney, and I wanted to see the City of Lights before we left the continent. The last-minute trip threw glitches in our plans when our car broke down in France and we scrambled to get back in

time for our flight. In the last-minute confusion, someone forgot to bring the dog's crate to the airport, and we were forced to leave the dog with friends, who promised to send her after we were settled.

It was heartbreaking to leave her at the airport, a foreshadowing of much greater loss ahead: when she flew over two months later, something went wrong with the cargo pressure, and within days of her arrival to Canada, she was dead. She was three years old, already a lovely, devoted member of our family. Her accidental death prompted even more grief and anger, as well as fresh guilt for not taking better care of her. What could I have done differently? I didn't know, but it felt like another blight on my course of wrong turns. That's one thing depression always does: It points the accusing finger back at me.

■ ■ ■

Tassja, the cat, and I flew from London to Vancouver on a direct flight, while Henry and Daniel flew to Norfolk so they could load our stored belongings in a U-Haul truck and drive across America to join us. In a comical moment on the plane, Tassja had imitated the southern American twang of our flight attendant, and in that instant dropped her own English accent like a used hanky. Henry's cousin met us at the airport and delivered us through the fresh coastal night to her home in Port Moody.

Setting out to explore our new, temporary neighborhood, I experienced a sudden bliss, similar to how I'd felt soon after Jack's death, when his release from pain and the glorious spring day fused into a fleeting happiness. It was the same gorgeous time of year, and I was captivated by the stunning beauty of the coastal mountains, forests, and seascapes that surrounded us. The condo was a short walk to a green and gold inlet with miles

of beautiful trails. The freedom I'd felt after Jack left his pain-wracked body was similar to what I felt now: freedom from fear and responsibilities.

For now, all I needed—and all that was required of me—was to bask in the scenery and praise God for its magnificence. I felt like we'd landed in the most beautiful corner of the world. For days, we took long walks around the inlet, Tassja on her scooter and I on foot, and when we tired of exploring, we ambled home to indulge in daytime TV—something I'd never done. There was no need to discuss the London collapse with anyone, and I tried to stop mulling it. Like a traumatized war veteran, all I craved was peace and distraction.

When Henry arrived with our household junk in tow (we wondered, in the unpacking, why we'd bothered schlepping most of it from coast to coast), we began exploring the metro area for a home base. There was beauty everywhere, but especially around Coquitlam, just up the road from Port Moody. It had everything we wanted: parks, trails, mountains, nearby schools and libraries, and a salmon-filled river flanked by huge cedar and Douglas fir trees. After studying local maps, I'd honed in on a particular neighborhood, and one night, as we toured Coquitlam in a borrowed car, I waved at the magic area and said, "I wish we could find a little house *just there.*" The next morning, we found a new ad for a house exactly where I'd pointed, and a week later, the little rental was ours.

This move was utterly different from all our previous ones. In every other move, our housing was chosen for us in advance, or we'd find our own, but always based entirely on ministry criteria: being close to public transport, accessible to other members, large enough to host big meetings, and near to the madding crowd, since a large part of the ministry was befriending potential converts.

Now we were free to live anywhere, based on our own criteria, and this made everything simpler. But in all our other moves, church friends helped us through every step of the transition, from meeting us at the airport to helping us unpack. There'd been instant friendships and babysitters for the kids and plenty of dinner invitations from our new congregants. This time we were finding our own way and taking our time. No one was dropping off casseroles and no one cared which house or neighborhood we ended up choosing.

In our past moves, there was also immediate pressure to start meeting with staff and members, usually before the first boxes were unpacked, and to quickly learn dozens, if not hundreds, of new names and faces (along with backstories, future ministry potential, and spiritual status) so we could effectively lead. This time, we were attending the ICOC Vancouver church without an agenda, apart from seeking new friendships and wanting to worship, and since we weren't on staff, no one was scheduling our time or assigning relationships. It was a strange new freedom.

As the apostle Paul wrote, we were "known, yet regarded as unknown." In the past, we'd visited and preached in the Vancouver church several times, but our recent notoriety, due to Henry's provocative letter, made the current leaders nervous—exceedingly nervous. No one in Vancouver grasped the magnitude of the London collapse, though by now most members had read the letter and the church had embarked on its own unraveling.

Many supported Henry's appeal for repentance, while others kept silent, afraid of upsetting their leaders. The Vancouver meltdown was a slower, quieter, Canadian version, but Henry was anathema to the current evangelist, who felt eclipsed by Henry's influence and longstanding popularity and was a self-described conflict avoider. That we had chosen to land in *his* city, of all places, was the worst luck he could imagine.

It was hard to make peace with our new freedom. On the one hand, I had oodles of personal time to spend with my kids, to hike and wander and explore, to attempt to heal and seek new avenues, buckets of time free of the accountability we'd carried for years. No one was calling to see how I'd spent my day. No one was calling for statistics and details on how the flock were doing.

For the first time in 20 years, I wasn't responsible for the spiritual wellbeing of anyone beyond my own family. (Even then, apart from setting a good example for my kids, I wasn't ultimately responsible for *anyone's* spiritual health but my own. After 25 years, this would prove to be a hard habit to break.) I wasn't compiling attendance reports, tracking down members who'd missed a service, or worrying over a list of the "spiritually weak." I was simply living.

On the other hand, after the initial bliss wore off, I felt stuck, like a bird clinging to its perch even after her cage is opened wide. My former identity, *women's ministry leader*, had been erased, and I had yet to create another. As I moved around my new neighborhood, suddenly bereft of belonging and purpose, I felt like a poser in a witness protection program: anonymous, devoid of history, and lonely.

My former life, with all its connections, movement, and urgency, was impossible to convey to others who'd never been part of a such a tight-knit, life-encompassing group or part of a movement that really believed it could change the world. I was back in my home country, but after 16 years away, I no longer felt Canadian and I couldn't relate to the materialistic, somewhat provincial lives around me.

I was used to having far-flung friends from far-off places, people who'd seen a lot of the world and were still very much in motion. Moreover, Henry and I were used to being *somebodies*; we were known around the world in

our churches and had been popular speakers at international conferences and seminars. Now I was a nobody, with a complicated and unrelatable backstory I kept to myself.

To fit in with my neighbors, I needed a conventional storyline— high school, college, marriage, kids, the suburbs, and an uncontroversial career—and my life had been supremely unconventional. I hadn't finished high school, hadn't gone to university, hadn't married my high school sweetheart, hadn't had biological children, and certainly hadn't stayed safely in the land of Tim Horton's, devoted to my local gym and nail salon, and growing deep Canadian roots.

It was a little like being back in Indiana, minus the church, except this was supposedly my culture.

Even at church, where I expected to feel a connection in our shared spiritual culture, I felt like an outsider. I'd just been through a devastating war, and nobody seemed to notice. It was as if they'd missed the international reports and tuned in to their local station news, where their own skirmishes consumed their attention and energies. Understandably. There were casualties in Vancouver, too, and the wounded needed tending.

A year after our return, another triggering movie came out: *The Incredibles*. I watched it and wept. The formerly fantastic Incredibles, glumly making do in a humdrum world that knew nothing of their hidden strengths and past glories, resonated with our current anonymous life. We too found ourselves stuck in a world without soul and stimulation. Luckily, the Incredible family got a second chance (and even a second movie, 15 years later). Would we be so blessed?

For me, freedom from responsibility, accountability, and belonging came at a terrible cost. It reminded me of one of Jack's favorite quotes, a

line from an Eagles' song he used to apply to all manner of circumstances: "I guess every form of refuge has its price."

I had freedom, yes, but it felt empty and lonely. Although I now had space and time to heal, if I even knew how to speed or encourage that healing, the current vacuum in my life, emptied of busy relationships and purpose, felt as if I'd lost far more than I'd gained.

■ ■ ■

Henry's new, mostly unpaid career took off as soon as he set up his computer in our little rented house. After many weeks of disconnection, his email account was flooded with urgent letters from ministry and lay members around the world, all of them recounting personal and collective turmoil as churches engaged in public and private confrontations and apologies. The vast majority of writers seeking Henry's perspective thanked him for the overdue yet necessary push into church-wide reformation, however distressing the process might be.

His letter hit hard because the fault lines and hypocrisies he'd exposed were real; most members had inklings, if not grave concerns, and had had them for years. If its message had been mere conjecture, its impact would have been negligible. As it was, the Letter continued to circulate and expose the church's sins. He'd refrained from naming names or citing specific incidents. Most members could see it was an appeal for reform, not a message of bitterness or rejection. Henry spent countless hours reading and responding to the emails, as consumed with the issues and the people it had affected as he'd been in London.

Soon, three large contingents from the New York City church began flying him out once or twice a month for meetings and lessons. He became a frequent flyer on Cathay Pacific, catching the coast-to-coast leg of its

Hong Kong to New York flights for arduous three-day sessions with all three groups. The meetings continued for almost two years, giving him ample opportunity to process his feelings with other traumatized members. He returned exhausted from each trip, his bags crammed with snack-sized treats he scarfed from the frequent flyer lounge for his waiting family. (All the attendants knew him and encouraged him to help himself. They also upgraded him to business class whenever there was a spare seat. Henry has a natural way of prompting such goodwill; I'm sure they sensed his sincerity, fatigue, and relative poverty.) Serving as a consultant on these trips provided both income and healing; he was starting the long paddle back to hope and faith.

I was in opposite, lonely waters. I made new friends in the Vancouver church, but unlike the men who spent time with Henry, none of the women wanted to discuss the crisis. No one asked about my experience in London or how I was doing in the aftermath. I was a thin piece of glass, fragile and flat. The pain, if I let myself feel it, would shatter me, and I kept it at bay with my usual strategies: vigorous hiking, running, and biking, and copious reading—anything to escape. I knew how to soothe myself with relatively healthy addictions and it was good I'd developed these tactics over the years instead of turning to more destructive outlets. Nevertheless, as Jack would say, *every form of refuge has its price.* My new grief was gathering force and would either explode, once it reached boiling point, or silently erode me.

I also had life concerns to distract me, such as figuring out a new career. Serving in the ministry had been my dream job, in spite of the constant pressure, insane schedule, and excessive meetings, and I'd never imagined doing anything else. The closest I'd come was playing the what-if game with my ministry friends: *What would you be doing if you weren't in the*

ministry? My answer to this hypothetical question was always the same. I'd be a counselor—not much different from what I was already doing, but with framed credentials on the wall and a sunny, plant-filled office (I pictured lemon-colored walls) full of books and soft chairs. Now, having witnessed the floodtide of pain among our shattered members, counseling was the last thing I wanted to do. A new mental image of myself as counselor deleted the lemon walls and featured red: me sticking useless bandages on bleeding clients while I bled out next to them, an unappealing vision that crossed counseling off my list of potential careers.

I knew how to lead people to Christ, how to impart the fundamentals and beyond, and my faith in these truths was intact. The gospel still shone. This current disaster was no fault of Jesus, but rather the predictable result of sin and pride. But helping the disillusioned recover their trust in the church was a different matter, since my own heart was still reeling with bitterness, anger, and sadness. We were all guilty to some degree, but it was hard not to think that some leaders were guiltier—and far more responsible—than the good-hearted members who'd simply followed their direction. Still, the fallout was contaminating everyone, and even the purest of hearts had to deal with the blame, guilt, and responsibility they carried or assigned.

The possibility of becoming a counselor and working with clients *outside* of our faith community never occurred to me. Or, if it did, I dismissed it quickly. I couldn't imagine helping others without the power of the Holy Spirit; no human philosophy or methodology could substitute for God, though I believed God could work through them. But if I couldn't point people to Christ in my counseling, I'd be the blind leading the blind, bypassing the spring of living waters to lead them to a shallow, murky pond.

So, I wouldn't be a counselor, after all. Money was another big factor, as we didn't have tuition funds for intensive schooling. The future was a blank slate and I had no idea what to write on it. In my pre-ministry days, I'd worked as a waitress, cook, janitor, chambermaid, fisherwoman, retail manager, and bill-deliverer. None of these were appealing in my middle age. Even so, I needed to point myself in *some* direction, and for this I attended a free, three-week, government sponsored course called Career Builders. It was designed for people like me: 40 to 50-somethings whose jobs had dead-ended for whatever reasons, who were short on up-to-date academic or technical credentials, and who needed something viable to carry them to retirement. For once, I ticked all the right boxes.

The course, full of discussions, group projects, job research, and personality and aptitude tests, was exactly what I needed, and it was comforting to be among other rudderless, somewhat desperate souls. We'd all lost our vocational way. Many of us were pushed to use a computer for the first time, and when I finished the course, I borrowed my son's computer while he was at school and taught myself to type. Without knowing how vital my typing skills would someday be, I was preparing for my future of writing and editing.

I threw myself into every assignment and group project like the avid sixth grader I'd been before puberty and psychedelics ambushed my galloping ambitions. It was stimulating to probe the unused corners of my brain, and being forced to enter the computer age was invaluable. But after three weeks of casting in the waters of potential careers, I caught nothing. Instead of The Answer, I had a pile of notes, an empty hook, and a panicky sense of failure. And since this was a free course, I couldn't demand a refund.

During my evaluation on the last day, I was nearly in tears. What if I never figured it out?

The instructor was reassuring. "It will come to you," he said. "Just give it time for things to gel."

So I went home, honed my skills with *Mavis Beacon Teaches Typing,* and waited, periodically reviewing my notes and test results from the course. An aptitude test I'd taken indicated two top picks for my profile: Corporate Trainer or English as a Second-Language Instructor.

The hippie in me discarded the first option on the basis of one word: corporate. I'd never worked in the corporate world and shuddered at the thought of wearing corporate clothes and spouting corporate lingo. But the second pick...? I loved teaching, language, and working with internationals. Coquitlam was a hot spot for foreign students and their parents, many eager for private tutoring. And tuition for a part-time, six-month course was affordable. I took an English proficiency test to qualify and aced it. Like tea leaves in the bottom of an emptied cup, my future was taking shape—just as my instructor had promised.

WHEN THE BODY SAYS NO

Being part of a group that *might* be a cult makes you quick to point out groups that definitely are. Jonestown, Heaven's Gate, the Branch Davidians: *Those* are cults. Each had a delusional leader spouting dangerous, outrageous teachings, stuff nobody would believe if they weren't insidiously beaten down, brainwashed, and indoctrinated. Each swarmed with dark undercurrents—paranoia, deception, separation from society—long before the worst of their teachings were exposed. Each new detail you learn about their lifestyles and the lies they were told makes you queasier. And look where their followers ended up!

Being part of a group that's suspected of being a cult also makes you quick to defend your organization by pointing to signs of orthodoxy. Accusations had been flung at our group since its inception, but they were easy to deny. For starters, we were theologically conservative and based all our teachings on careful Bible study.

No extra-Biblical revelations were allowed. The Bible, for us, was the ultimate authority, and we didn't believe in modern-day prophets, apostles,

miracle-workers, divine leaders, or prophesying. We were simply trying to imitate the early church, minus the signs and wonders that marked the apostolic age, which ended when the apostles left this earth. But our intense relationships, group conformity, and relentless focus on evangelism made us more cult-like than we realized or wanted to admit.

We were quick to point out that even the first century church was labelled a sect, and its members were loved, feared, or despised by outsiders, simply for following Jesus. Persecution was to be expected. "If they hated me, they will also hate you," Jesus said, and great blessings were promised in suffering for his sake. For us, being persecuted for our beliefs was a badge of honor, however much it stung in the moment. It seemed clear from the New Testament that if we *weren't* being hated and persecuted, something was wrong.

But as our church morphed from an extra-zealous congregation in New England to a rapidly growing worldwide fellowship, the degree of control and conformity expected from members also grew. This was both our strength and our weakness.

To wonder aloud if we might be veering into cultishness was an unspoken taboo. Although every potential member was taught about persecution and the labels people threw our way, any possibility that there could be kernels of truth behind the rumours was denied. We were following Christ, not man. Our blueprint was the New Testament, not the ravings of a megalomanic, self-appointed leader with shocking skeletons—or weapons—in his closet. If our practical application of scripture crossed the line from biblical to weird, we weren't supposed to *think* it, let alone mention it.

But elements of weirdness seeped in, and what should have raised eyebrows, even among the oldest members, became normal practice. For example, the teens and singles in the church were subject to very strict

dating guidelines. In principle, this was a good thing, as the slide from lustful thoughts to immorality can be sudden and steep, but in practice, it meant constant questioning and restrictions, as well as serious repercussions if a couple dared to break the rules by going on dates alone or exchanging anything physical beyond a chaste side hug.

Members with strong leadership potential were counseled to date only those who showed equal potential, and unequal pairings were quashed. Marriages weren't exactly arranged, but dating relationships often were, especially among those in leadership, and couples who'd been matched for their ministry potential often ended up married, convinced by their superiors that they'd found the perfect spouse. Once engaged, having sought advice over every aspect of the big moment, they'd be advised on every detail of their wedding, including who to include in their bridal party: other strong leaders, of course, and *maybe* a childhood friend or cousin if everyone was focused on evangelizing the non-Christian bridesmaid.

The weirdness wasn't limited to the young and single. Inexperienced young leaders, often chosen for their innate talent and potential, dispensed marriage and parenting advice for older members, and 'advice' was essentially law. There was no seeking a second opinion or questioning the counsel. "To obey is better than sacrifice," the Lord instructed King Saul and this favorite scripture was often quoted. Obedience was paramount. Sometimes the obedience itself was a great sacrifice, particularly when the advice we got conflicted with our inner counsel. (As, for example, the parenting advice I got when we adopted Tassja, which troubles me to this day.)

Although we loved the Old Testament, we were fanatical about the New Testament. If there was a scriptural command, example, or inference, we were all over it. I suppose this made us rather Pharisaical, like the religious leaders in Jesus' day; the Pharisees were fond of taking simple

commandments and breaking them into specific, situationally appropriate applications. No working on the Sabbath? The Pharisees came up with 39 scenarios to define what was or wasn't work. And even these needed further clarification, arbitrarily determined by the ancient scholars. Could you sin by walking too far on the Sabbath day, even to visit your family? Was it a violation to pluck a few grains of wheat if you were hungry? If a woman looked in a mirror on the Sabbath and plucked a gray hair, was that a sin? (Yes, yes, and yes, according to the Pharisees.)

Fortunately, we weren't concerned with Old Testament laws; they were obsolete, apart from the principles behind them, summed up in the greatest commandments: to love God with all your heart, soul, mind, and strength and to love your neighbor as yourself. We were all over those commands, which was a good thing. Learning to wholeheartedly love God and others is a lifetime challenge, and it helps to be given examples and tools to make the aspirational practical.

But we had a field day applying— and mandating—New Testament precepts. "Confess your sins to one another," a verse from the book of James, meant every member met every week with a more mature Christian, their discipler, and confessed their transgressions of thought and deed. This was usually a good thing—spiritual transparency trumps guilty secrets, and there's refreshment in being open and honest—but not always. Sometimes those private confessions were later shared in leaders' meetings in pursuit of 'seeking advice.' Some leaders were careful to protect the identity of those whose struggles were under discussion, but others could be careless.

And we had plenty of group discipling times where personal sins would be shared and dissected in the presence of the sinner. Again, this was not always a bad thing; peer transparency and support can be wonderfully freeing. But there was potential in these settings for abuse. I remember a

particularly painful evening when Henry and I walked into a group discipling session and the night's topic was announced in a mock-serious title: "What the Heck is Wrong with the Krietes?"

In the course of that long night, every aspect of our life and marriage was probed and analyzed in an effort to identify why we weren't thriving. (This was soon after we left Africa and we were essentially in mourning. But the mourning was unacceptable—I remember being told, "Consider yourself lucky you got to spend any time in Africa at all, and move on!"— and our emotional struggle was seen as spiritual weakness.)

Henry and I had been so entranced by the love, unity, and excitement we witnessed when we first visited Boston that we were willing to overlook any weirdness. But there'd been red flags along the way, signposts to our increasing cultishness. At an early conference in the mid-1980s, one of the churches put on an absurd skit demonstrating how several verses on imitating leaders ("Imitate me, as I imitate Christ") were meant to be practiced.

One by one, a bevy of young female interns crossed the stage, walking, talking, gesturing, and dressing like the lead women's ministry leader. In the audience, several of us roared with laughter till we realized they were dead serious. *I'm not doing this*, I thought, putting the theatrical lesson out of mind till it came back to haunt me. I hadn't done it, ever (I'm too busy being myself), but the lesson should've troubled us more. Instead, we chalked it up to regional differences: it was just *that* church, going a little off the rails, but surely they'd rein it back in. Too bad we'd laughed, but it *was* pretty funny. Yet the worldliness of the skit wasn't something we wanted to challenge, for fear of being labelled as critical, insubordinate, or unsupportive.

The weirdness only got worse as the church moved into the 1990s, but our years on the mission field protected us from the worst of it, swirling in

the American vortex, where many of the top leaders competed to lead the fastest-growing groups. In Nigeria, we were off the radar and could do our own thing, tailoring the church to local culture and trying to avoid the pitfalls we associated with the American churches. Like many leaders around the world, we also tried to shield our members from the constant, top-down pressure to produce great numbers of visitors and converts, though not always successfully.

During our time in South Africa, I did utter the "C" word aloud, and our cultishness was swiftly and ironically revealed. It happened during a meeting with our mentoring couple, who mentioned a new practice spreading in the American churches. Instead of passing traditional bags or baskets down the pews to collect members' contributions, some churches were collecting the tithes in small groups, during their midweek meetings, *using clear plastic bags* to ensure everybody gave. This was a step beyond the audacity of sending small group leaders to go to absent members' homes immediately after services to collect missing checks or cash—or else make up the difference themselves. The plastic bags flabbergasted me.

"Isn't that a bit cultish?" I blurted.

Even tagged with an *ish*, the cult word was alarm-worthy, and within 48 hours we were on a plane, headed from Pretoria to Los Angeles to meet with the top leaders. Henry and I were considered too influential to harbor doubts about the church (as indeed, the impact of the London letter, nine years later, would verify). It was crucial to nip our misgivings in the bud. For several days, we met with the leaders and discussed the plastic bags and the growing, insane focus on numbers as the only measure of a congregation's health, as well as other church shenanigans that alarmed us.

Top Leader was a master of persuasion and reassurance, and in spite of our burgeoning doubts, he managed to talk us down. To sweeten the deal,

we were afforded an extra week after our sessions to explore California in a red convertible—a break we were expected to embrace. We returned to South Africa with beachy T-shirts and our somewhat mollified misgivings tucked in our luggage, inwardly torn but wanting to believe the best.

God is in control, I told myself, over and over and over. *It's His church. He'll sort it out.* I thought about the parable of the wheat and tares, representing the good and the bad within the kingdom of God. *Let both of them grow together.* Jesus' parable assured us that God would not let hidden or blatant transgressions go unpunished, even if the reckoning only took place in the afterlife.

Although we were consistently loyal and grateful for all the good things we experienced in the church, many things troubled us throughout the years. Every month, copious statistics on all 400+ congregations were distributed and parsed amongst the leaders. The competitive and prideful urges this fostered was like throwing sugar on yeast, leading to the temptation of fudging and compromise. In some places, leaders took large numbers of 'weak' members off their membership rolls right before a change of leadership, so the new leaders could meet with said members and call them to 'restoration', adding them back to the fold—which they'd never physically left—and counting the 'restored' as numerical growth.

We ourselves had never been called to be part of this practice, but we knew it happened. Lessons and preaching focused far too much on what we (particularly the leaders) were doing, rather than on God—though speakers typically ended each man-centric message with the disclaimer: *And to GOD be the glory!* The lifestyle of many former missionaries, now returned to the States and overseeing from the comfort of their affluent suburbs, was a far cry from the sacrificial example of their early years. No one flew in private jets or built mansions, but over time the church had adopted a

corporate administrative model, along with generous salaries determined by the size of each leader's group or the range of their global oversight, while most third-world leaders were paid a pittance by comparison.

All these things troubled me, but I when looked at the evidence of grace before me—the transformed lives, vibrant relationships, answered prayers, and supernatural love that bound our hearts to God and each other—the good outweighed the bad. I hadn't found any other church in the world that matched our unity and passion or rendered such profound life changes by taking the Scriptures as seriously. Wherever we traveled in the world, this same vibrancy prevailed and in every place the church felt like home.

This couldn't be a cult. It was the family of God. It was as if I belonged to two churches: the loving, joyful fellowship that filled most of my life, and the driven leadership behind the scenes, pushing for prominence and willing to compromise or treat lesser leaders as pawns to win the praise of men.

Many common cult-like practices never took place in the ICOC. Marriage was honored and all forms of sexual immorality were condemned. Single members often, but not always, lived in shared homes or apartments, but only with their own gender. Married members and families had their own homes. Children weren't homeschooled. Women weren't relegated to wearing frumpy dresses and staying in the kitchen. We had a Top Leader, but he wasn't idolized (by most members), and we weren't subjected to long rants or lectures based on fanciful delusions of grandeur. In fact, when Top Leader DID become prideful and difficult to work with, he was ousted from the organization.

Nevertheless, being part of a group that borders on cultishness messes with your head.

■ ■ ■

After 22 years of belonging, it was a shock to be free. I felt like I'd been thrown headfirst off a speeding train full of family. The fact that many others had jumped or lost their faith in the meltdown was no comfort; the whole affair was tragic, and the further I got from it, the worse the damage seemed.

We hadn't planned on leaving the movement. Henry had penned the letter not as a parting shot, but as an appeal for change, from the perspective of someone who'd been deeply committed from the outset. He was still working hard at repairing the damage in New York, but the chilly reception from the top Vancouver leaders felt like the mark of Cain.

I was weary of conflict, too tired to fight for a hearing, and I showed up for Sunday services like a tolerated pariah, conscious of every shallow conversation or averted gaze. We were viewed suspiciously by some who feared we'd come to make trouble, though we'd come in peace, simply looking for home among our people. I see now that the Vancouver church was also a ghost of its former self, its members gutted by the conflicts the letter had roused in them. Things were far from resolved. The most militant members had left in frustration, while many members who stayed were frozen, unsure how to proceed.

In hindsight, leaving the ICOC was a trauma equal to my worst: losing Jack. I had a legacy of losses. I'd lost my parents and family at 14, lost Jack at 22, lost my hopes for fertility at 30, lost the foster daughters we'd unofficially adopted at 36, lost our beloved Africa at 39, and lost countless close friends and homes as we moved over a dozen times across countries and continents. This final step into civilian life was the ultimate unraveling. Oceans of grief flooded every fiber of my physical body, and soon the impact was impossible to ignore.

■ ■ ■

Alarming symptoms sprang out of nowhere. The first emerged on a hike called the Grouse Grind, a steep climb in North Vancouver that should've been easy since I'd been hiking mountains all summer with ease. This time, my heart rate surged into overdrive, forcing me to stop every few minutes to let it slow. I couldn't remember feeling so defeated by exertion since failing a mandatory one mile run in sixth grade. Driven by sheer pride, I finished the hike but resolved to see a doctor the next day.

New symptoms followed. Along with the spiking heart rate, I developed a tremor, and my hands and feet turned purple whenever my heart raced. Exercise was no longer required for my heart to speed up; sometimes all it took was *thinking* about my symptoms. I had feelings of impending doom. I'd always had low blood pressure, leading to fainting spells, but now my blood pressure was dangerously high.

The doctor I consulted put me on heart medication and referred me to a specialist, who suspected a condition called pheochromocytoma: a tumor in the adrenal glands which causes spiking levels of adrenaline and cortisone. Two rounds of 24-hour urine collection partially confirmed the diagnoses by measuring the hormones, both exceedingly high. I then waited several weeks for a radioactive scan to confirm the actual tumor, a test that required stopping my thyroid medication for a week and drinking iodine to block the organ's activity.

After the imaging test, I heard nothing from the specialist. I called his office and was brushed off by his receptionist, who said it was up to him to contact me. After two anxious weeks (the hormone surges and racing heart didn't help), I showed up at his office and told the receptionist I'd wait till he had a free moment. In fact, I'd glimpsed him when I came in, sitting at his desk in a consulting room with no patients in sight.

The receptionist and the doctor kept me waiting for 30 minutes before he stormed out, berating me for turning up at his office without an appointment. All I wanted was the test results, I told him, and he wasn't returning my calls. He answered harshly. "You don't have pheochromocytoma. There are no tumors. And I'm not your doctor anymore. Go back to your family doctor."

Crying in shame and confusion, I fled the hospital and drove to the family practice clinic, where my doctor paused her queue of patients to comfort me in her office. "He has a reputation for being unpleasant," she said. "I should have warned you." Later, I remembered the bizarre first consultation I'd had with him, when he'd performed an electrocardiogram on my bare chest without a nurse present, taking time to gaze at me and commenting on my youthful figure.

In fact, he *never* had a nurse around, and his receptionist seemed to function as a shield, repelling unwelcome eyes from his private sanctum. I should have reported him. But I was preoccupied with my condition and cowed by his intensity. Without pheochromocytoma, I was no longer interesting. And now that the likeliest explanation for my symptoms was eliminated, I was back at square one, with only a half-drunk bottle of double-strength iodine and a bruised spirit to show for it.

There were more medical tests, none of them conclusive. My family doctor was sympathetic but running out of ideas. I continued to take the blood pressure medication and briefly took an antianxiety medication, with no discernible effect. Unable to pinpoint a cause, she suggested stress as the likely culprit, but I wasn't buying it. How could it be stress?

For the first time in decades, my life was free of the insane pressure and pace of the ministry. Nobody, apart from my family, expected anything of me. I had time to study for my ESL training, time to practice typing, time

to hike, bike, and run. Financially, we were staying afloat. Daniel was enjoying popularity at his new high school, and Tassja, in second grade, was settling into her eighth school so far. I was trying to live in the moment, trying not to dwell on our latest trauma or to worry too far into the future.

But I was kidding myself, and my body knew better. My hidden grief and pain were screaming for attention. I was pushing down recurring dreams about Jack, missing Theo's listening ear, and still in shock over London and our sudden displacement.

Our little miracle rental was a one-year lease, due to expire when the owners moved back. By then I'd finished my course and was beginning to find private students. We took a leap of faith and rented a much larger house, several blocks away, with plans to rent the extra bedrooms to international homestay students.

For the next nine years (in two different houses) we had an endless succession of short and long-stay boarders, usually several at a time, for whom I cooked, tutored, parented, drove, and cleaned. Some were endearing, others, not so much. When Henry's New York trips ended, there was pressure to make ends meet, and I took on more and more private students until my schedule was nearly as hectic as it had been in the ministry. I started my days getting students off to school and tutored through the afternoons and long into the evenings.

During these years, my medical symptoms flared and grew. I'd suffered for years with gastrointestinal problems and migraines, and these worsened. In addition, I was embarking on 10 years of perimenopausal misery: round-the-clock hot flashes, insomnia, anxiety, and irritability over nearly everything. (I am not, by nature, either anxious or irritable; this was an ugly new chapter.)

I exercised almost daily, but sometimes my arms felt so weak, it exhausted me to lift them. And I started fainting again, as I had at tense moments throughout my life. This time, my loss of consciousness was often prolonged, and on two occasions I was rushed to the hospital with injuries.

One morning I was sitting at my computer checking the weather forecast, and the next thing I knew a fireman was shining a light in my eyes as I lay at the bottom of the stairs, battered and bleeding. I needed stitches to repair my lip and added two extra inches to an old chin scar. On both hospital visits, the doctors offered no explanations for my collapses. It seemed that simply being a woman in my 50s merited strange, inexplicable symptoms, and the doctors left it at that.

Spiritually, I was sinking lower. We continued going to the Vancouver church until Henry was offered a position at a small local church, outside of our ICOC family. We needed a fresh start, and Henry needed to preach.

But the new church left me cold. It lacked the transparency and warmth of our ICOC relationships—even in the diluted Vancouver version—and as much as Henry tried to cultivate change through his preaching and example, the core group remained superficial and, to me, unrelatable.

I struggled to wear a happy face to church and found refuge in teaching the middle school class, where I could be creative and spontaneous with more responsive hearts. I also took on post-service refreshment duties, so I could escape to the kitchen without attracting attention when I found myself crying. Unsatisfying church relationships and stirring hymns did that to me.

At home, my devotional life was nearly dead in the water. Since becoming a Christian, I'd had daily times of prayer and Bible study—Quiet Times, as we called them. Now I couldn't read the Scriptures without flashing back to ICOC memories, recalling lessons, sermons, studies, and

devotionals I'd either taught or heard from every chapter of the Bible. I'd been deep in the Word, nearly every day for over 20 years, and there was a lot of remembering. The flashbacks triggered deep despair, regret, and longing, as well as crushing self-recrimination for not doing what I was meant to be doing: teaching the Bible, using my gifts, and bringing others to Jesus. (Teaching my Sunday school class didn't count, because I wasn't converting anyone; the kids were too young to become disciples. This was my compartmentalized thinking.)

The rush of emotions every time I tried to read the Bible became too much, as I couldn't bear to start or finish my day with sad, tormenting memories. Once my comfort and delight, the Bible now brought grief and condemnation, and only with the psalmists, as they cast their wretched souls on God's mercy, could I find trickles of comfort. "The darkness is my closest friend"… at least *that* verse was relatable, if not exactly inspirational.

The same was true with prayer. My days were busy enough to keep my emotions at bay, or at least from swamping me, as I hurried from one task to the next. But when I closed my bedroom door and knelt to pray, face to face with God and the brokenness of my life, the tears would come in torrents. They seemed bottomless, inexhaustible, and letting them flow brought no relief, only migraines and despair. I couldn't afford the agony or the aftereffects of reading or praying. The intimacy of kneeling before my Creator or reading His words cut straight to my heart, and to the dismaying truth that I was angry with Him. Why had He let all this happen to me? Why the waves upon waves of sorrow, disappointment, endings, and broken promises, year after year? Why, when I'd tried so hard to be faithful, had He sent me into exile? And yet how could I fault Him, the Perfect One? I couldn't—at least not out loud—so the finger pointed at me. I must deserve it, all of it, because God is never wrong.

I didn't know how to be kind to myself. Accusatory thoughts bombarded me constantly, and I kept them private, sharing only a sliver with friends. I was convinced no one I knew could relate to my history or pain. I'd lost contact with nearly all my former ICOC friends (Facebook would fix that, years later), and shared next to nothing of my past with non-Christian friends and acquaintances. The non-stop, self-condemning soundtrack in my head was a secret, even from Henry.

There were pockets of respite; my teaching career was taking off and I loved working with my students, but outside those hours, my life was a widening funnel of darkness.

The losses were catching up with all of us. Henry was functioning with yet-to-be diagnosed cyclothymia, a rapid-cycling form of bipolar disorder characterized by wildly fluctuating emotions that made him difficult to live with. His passionate nature, coupled with all the upheavals of our life in the ministry, had masked the obvious. Daniel was deeply missing his best friends from the ICOC and felt excluded from their ongoing, Stateside connection. And Tassja, although sociable and adventurous, struggled with issues stemming from her abandonment as a relinquished toddler, her relationship losses as we'd moved from place to place, and the sadness and tension permeating our family. We loved one other, but our individual and collective pain was exacting a heavy toll on each of us.

CHAPTER

I FALL TO PIECES

In the midst of this misery came a possible reprieve. A ministry friend who led a large congregation in Nashville invited us to interview for positions in his church. It was Henry he knew and wanted; my husband is a gifted speaker, and he wanted Henry to share in congregational preaching and lead the small-groups ministry. I made sure Henry conveyed I was in no shape to lead anything, though I hoped the change, if we chose to pursue it, would bring healing.

In December of 2007 we flew to Tennessee and spent a week meeting with groups and individuals in the church. I was tentative until the fourth night, when we met with a group of 50 former ICOC members, who were now part of the Nashville congregation. I knew none of them personally, yet within minutes of entering the room, I felt a level of connection and belonging I hadn't experienced since leaving London. It was an instant reunion…with strangers.

Like close family members, we *got* each other: the jokes, the jargon, the friends we had in common, the shared references to the past, and our crazy

love/hate relationship with the organization that had irrevocably changed our lives. Our host was amazed at the electricity and stunned when I told him I'd never met anyone in the room before that night. We shared and laughed and cried for hours, and before the long evening ended, my heart was convinced. I wanted to move. I needed to be with other survivors. This little group of 50 knew how I felt and understood at least part of what I'd been through.

The Nashville church was encouraged by our quick decision, and we flew home, broke the news, and started getting our recently purchased house ready to sell. Buoyed by hopes of spiritual renewal and deep, nurturing friendships, I threw myself into repainting and renovating. We had six months to prepare, far more time than our past moves usually allowed. The time frame was a luxury, along with making our own decision on whether to move or stay.

In April, two months from our moving date, we flew to a huge church leadership seminar in Florida to familiarize ourselves with the movers and shakers of our future alliance. Although there were a few familiar names among the featured speakers, most of this network was new to us, and they were loosely aligned. The mishmash of ministries lacked the unity and closeness of ICOC conferences, and it was disconcerting to wander through crowds of attendees and not recognize a single face. At past conferences, we'd be stopping every minute to hug old friends and fall into another circle of laughter or catching up.

Most unsettling was discovering I was expected to man a booth throughout the seminar. I'd agreed to help set up a ministry training program in Nashville after we moved, but mostly in an administrative role; I still wasn't ready to recommit to guiding people's souls. When we got to the conference, I was led to a booth stocked with handouts about

an intensive, hands-on training program in Nashville that I'd apparently be overseeing. Next to the handouts were business cards embossed with my name and role in the program, as well as stacks of impressive bios about my prior ministry experience. I was expected to sit in this booth and recruit families and individuals, people I didn't know from Adam, to sign up, move to Nashville, and commit themselves to a training program *I knew nothing about.* Oh, and I was also expected to answer questions about said program.

The overzealous leader who'd written the bio and printed the cards assumed I'd be thrilled by my new responsibilities. Instead, I had a meltdown. How could he throw me into the deep end, knowing I'd asked for time to heal and recover my convictions before embarking on anything big? How could he expect me to promote a program designed by someone with a completely different ministry background? What if I didn't agree with it? And how could he compile and distribute a bio of my past experience and achievements without consulting me? The printed page of postings and positions I'd held in the ICOC didn't bolster me; rather, it made a mockery of my current insecurities and weaknesses. I couldn't relate to the driven, productive leader portrayed in the bio. She was gone.

Within minutes of my meltdown, the cards and bios were packed away. I was promptly excused from booth manning. The leader was apologetic; he'd misread my animated euphoria the night we'd met with the 50 survivors, mistaking my momentary joy and high spirits for a miracle recovery. He'd caught a glimpse of the old Marilyn, the extraverted leader described in his bio, but she wasn't solid; she'd merely broken through in a roomful of countrymen. Already she was back in hiding. A lot of recovery was needed before she'd be ready to resume any sustained spiritual caretaking.

Henry and I floated through the conference, anonymous and detached, listening to new speakers and lessons and filtering all of it through our ICOC perspective. The seminar seemed like a pale, generic version of past seminars we'd known, a far less satisfying version without the electric fellowship and personal connections we craved. Two days in, I was still shaking from the ministry booth incident when we were invited to a dinner banquet with a hundred or so ministry couples affiliated with our new leader's network. These would be our new American colleagues.

We walked into a conference room filled with round tables, candles, and silverware, where dozens of chatty groups mingled and circulated before dinner was served. Here were established friendships and shared history—but not ours. I bumped around the room, awkwardly trying to introduce myself to strangers far more interested in finding their old friends than chatting with me. Who could blame them? I was a nobody, with nothing in common. Within minutes, hot tears surged behind my eyes. I bolted the room and walked circles in the lobby to compose myself before trying again. But it was hopeless. After three attempts at harnessing my tears, I gave up; nothing would stop the torrent. Even more than the rejection I felt from these strangers, my soul wailed with craving for the deep friendships I missed in the ICOC.

Sobbing, I left the building and started walking through an endless sprawl of hotel swimming pools and picnic tables full of sun-burning tourists, through miles of bathing suits, flip-flops, barbeques, and sun-crazed kids stretching from one overcrowded resort complex to the next. This was the heart of Orlando: overfed Americans soaking up the sun between runs to Disneyworld and Universal Studios. It felt utterly soulless, pointless, valueless. As I walked, I wept like Jeremiah wading through the rubble of

besieged Jerusalem, but no one seemed to notice the pale, stricken woman passing through. I was invisible, as disconnected to the world around me as an alien fallen from the sky.

I was missing the banquet and worrying my husband, but on I walked, the tears of a lifetime breaking through. Everything I saw made me weep: the world was going to hell in a handbasket and I was already in that hell, unable to think a single positive thought, or even a neutral thought that didn't provoke tears. It was a crystalline, sickening moment with only one conclusion: *Everything in my life has brought me here, to the pit of existence. There's nothing left.*

Eventually I came to a freeway. By now it was dark; I'd found no comfort in weeping and now, as I stood at the highway's edge, a darker thought took hold. I wanted to throw myself into the rushing traffic and end it all. This sudden compulsion felt rational and inevitable.

Who was I kidding? I didn't know myself anymore, and I hated the person inhabiting my body. My life had unravelled, leaving my core to wander this hollow slice of America, hating everything it represented and extinguishing my spirit. My children felt far away; my husband was probably making friends by now, soldiering through the banquet with equanimity, picturing a future in our new Nashville life. As for me, I was disposable and meaningless, the best years of my life long over. I wanted to end the pain with a flying leap. The dark night seemed to demand it.

Of course, I didn't leap. But I stood there a long time, watching the cars race by and picturing a world without me, a world that would barely notice I was gone. Never had I come so close to embracing death—death by gruesome choice. I wept my way back to the banquet hall and found Henry, who was angry and scared and bewildered by my disappearance and my whelming emotions. Mostly, he was angry: this was something

terrifying, something he couldn't fix, and anger covers a multitude of fears and inadequacies.

The next morning, I met with the man who'd invited us, the friend who'd paid for our tickets, written my bio, and gone to great lengths to secure visas for our upcoming move. I told him about the long walk and the flood of tears, about standing by the freeway and drowning in the darkness, picturing my exit. I told him I was in no shape for anything, much less a ministry position. I told him more than I'd dared to tell Henry, because he listened to my confessions with alarm and concern but not anger, because I wasn't *his* wife, scaring the hell out of him.

I tried to explain how it felt to fall out of a group that was almost a cult after 22 years of the deepest relationships I'd ever known. How it felt to long for something that also repelled me. My years in the ICOC were some of the best years of my life, and some of the worst. I had friends I'd never forget, never stop loving, and perhaps never see again.

There were couples who'd mentored us who'd been helpful and gentle, and others who'd been harsh, who'd said damaging things and left scars. I also harboured resentment against leaders I perceived as arrogant and worldly, who seemed untouched by the mess they'd helped create. It was difficult to separate the good from the bad, the nurturing from the toxic, the willing commitment from the hierarchal control. The closest analogy I could imagine was how a child must feel toward a parent who is alternately loving and abusive, and also the only parent he's ever known.

He still wanted us. There was a program, he said, a two-week intensive counselling retreat for ministry couples that specialized with cult survivors. He was sure it could fix us; many friends had emerged from the program with healed hearts and marriages. I thought back to my six months with Theo and how little the counseling had helped.

Two weeks? With my troubled history, all the layers and years of pain, loss, and grief I carried, two weeks would barely scratch the surface. And if the counseling was primarily *couple's* counseling, I figured it would amount to a few days' worth of personal digging, and then we'd inevitably open a huge can of worms—the ugly worms in our marriage—which would still be alive, wriggling, and probably multiplying by the can-full by the time our fortnight was over.

I tried to convey my misgivings, gently and without seeming ungrateful, but he urged me to discuss the program with Henry and give it more thought. Our move would be conditional on doing the program. But he really wanted us. Or at least, he really wanted Henry.

We flew back to Vancouver in a series of short flights and long layovers. Heavy decisions—about going forward with the move, about trying the program—still hung in the air. Between flights, we had short, choppy conversations about our hazy future before retreating into ourselves. Henry's bipolar disorder symptoms were flaring; he was rapid-cycling multiple times in the course of a conversation, from compassion to anger to hope to despair. He was undiagnosed—or rather, had been *misdiagnosed*, as having unipolar depression—and though in retrospect it's clear what was afflicting him, I was frightened by the intensity of his ever-changing moods. One moment he felt like a friend, the next like absolute danger. His rotating personalities were strong, and they overwhelmed me.

Midway through our journey, we got a call from Daniel. Two of our homestay students, high school girls from Korea, had fallen from a fast and cozy friendship into war. They were cat fighting, literally pulling out each other's long hair as they shrieked curses and threatened to kill each other. One of them had called the cops, who couldn't make sense of the conflict without calling in a translator...at 2 a.m. The girls had to be

physically restrained, and once the police determined who had seniority—who'd been first to arrive at our house—the second girl was banished from the premises. Daniel, in charge of the house for the week we were gone, was deeply shaken.

Great turmoil churned the air that night. As we drove home from the airport, we listened to the first reports of the BP oil explosion in Louisiana, an oil spill soon ranked as one of the world's most disastrous. The breathless reports made it sound as if Armageddon had erupted in the bayou. The scenes I pictured perfectly matched my mood.

After a short, sleepless night back at home, I rose to another school morning, clouded by swirling thoughts about the conference, my breakdown, Henry's mood swings, and our pending decisions. After school let out, the second student came home to retrieve her belongings and within seconds both girls were at it again, hungry for blood and more hair. Again, they had to be physically restrained.

The first girl had stolen or hidden all of her enemy's shoes, and girl number two left our house for the last time in her stocking feet. (My own proffered shoes were too small, and she padded out to the waiting car in the rain, like an asylum escapee.)

There was no time in the day to reconnect with my own children; hours of afternoon and evening tutorials were calling. Life felt heavy and relentless, and my dreams of a fresh start were withering on the vine. I didn't think our marriage could withstand a two-week intensive comb out and was terrified that the recovery retreat our friend insisted on would only bring worse pain to the surface.

Being in Florida had stirred other thoughts. Orlando's sprawling theme-park mecca, devoid of nature or quiet space, represented some of the worst of American culture to me (except for the absolute worst:

gun culture), and being among American evangelicals for a week hadn't endeared me to the narrow world view I perceived in the Bible Belt. There were churches—mega-churches—everywhere; even the Nashville church was flanked on three sides by competing congregations. Was this really where God wanted us?

Back in Canada, where perhaps one out of ten people bothered to attend church, even sporadically, we saw a greater need. Also, after 20 years away from our native land, we were starting to embrace our Canadian roots and everything that distinguished us from our neighbours to the south. And I was finally living near my brothers and their families. Did I really want to give all this up to move back to the Land of the Free, the Home of the Brave?

I didn't. On a practical and aesthetic level, there was also the matter of our house. After some minor renovations and major house painting, I was enjoying our domicile (as much as a depressed person can enjoy her surroundings) and it seemed a shame to sell (if we'd even break even) after such a short time. Reasons to stay were piling up. The call we'd felt so strongly on our visit to Nashville was fading, and we talked round and round our options for seven days before making a decision. We wouldn't go. We'd remain in Canada and stay the course.

Staying felt like the right choice. But how quickly we'd spun from yes to no to yes, and back to no.

CHAPTER

THE CULT QUESTION

I wrestled for years with my ICOC history, alternately yearning and appalled by memories of our time within "The Movement." My dream life exposed how much my psyche roiled with ambivalence and unfinished business. Night after night, my dreams were peopled with top leaders from the church, and I was always in a state of failing to meet crushing expectations. Most of the dreams were set at conferences, where I'd be late, lost, luggage-less, and headed for trouble. The settings were wildly international, as our lives had been.

Often I'd be stuck at one far-flung conference, knowing I was expected the next day at a completely different one across the globe, in Cairo, perhaps, or some obscure country I couldn't reach. I'd be utterly unprepared: no passport, no wardrobe, and no preparation for the classes I was supposed to teach. I'd be separated from my kids for long periods and expected to fly off for another extended trip without contact. Essentially, I was always far from home and struggling with guilt and expectations, with censure from above and torn loyalties as recurring themes. The dreams replayed for *years*

(15 years on, I still have them, though less often), and no matter how many times I replay the same conflicts and scenarios, I don't get any better at solving my dream dilemmas.

■ ■ ■

It's not as if Top Leader didn't try to warn us. Back in 1981, during the week we were originally checking out the Boston church, we met him and asked if we could move there for training. In response, he handed us a thick stack of articles and asked us to read every page before making our decision.

We read through the night. The articles weren't pretty; they mostly featured frightened parents, desperate to extract their converted offspring from campus ministries started by the so-called Gainesville churches— the network associated with Boston. Most attempts utterly failed. Their converted kids were happy, all-in, and full of scriptures that strengthened their newfound faith. In some places, picketers turned up every Sunday to scare off church attenders, but the members breezed right past them, unfazed, and continued to spread the word. Professional cult deprogrammers weren't in vogue yet, but they would be, and we'd have our own special spot on their list of dangerous groups.

The articles scared us. As morning dawned, we made frantic plans to interview the least-conventional members we'd met so far: those with a hippie-ish background (like ours), who seemed both committed and free-thinking. (*Independent spirits*, we came to call such members, and over time the label became a mark of judgement, though I always gravitated to such souls.) We wanted the inside scoop from these former outliers on how they'd transitioned from nonconformity to being part of such a tightknit, conservative group. We spent the day walking through Boston, badgering

our new friends with questions, and occasionally stopping for thick slabs of oozing pizza, sold by the slice. By evening, most of our concerns were put to rest. Nobody seemed brainwashed, and everybody seemed happy—really happy—and biblically grounded. After another day of cross-examinations, we made our decision. Articles aside, we really, *really* wanted to be part of this community and learn how to reproduce it in Toronto.

Our early Boston days were like our sun-splashed honeymoon a year before: mostly euphoric. At Top Leader's request, we moved to a rough-neck corner of Boston—Dorchester—and started a Bible study that quickly grew into a large house church. Friends brought friends; family members turned up, suspiciously checking out our agenda, and got converted. Our group was eclectic and truly cross-sectional: young, old, black, white, professional, blue-collar, conservative, and artsy.

What we all shared was love. There were no strange, hidden teachings, waiting to be revealed once members were ensnared. Everything came from the Bible, and those who wanted to convert were expected to study hard, reviewing everything we taught and asking lots of questions before being baptized into the fold. It was impossible to not see the Spirit of God at work, drawing hearts to the cross, to Jesus, and into his spiritual family.

The Dorchester house church felt like home, but at staff meetings I felt like an outsider. All the staff and interns were university graduates from privileged backgrounds, and they dressed and looked sharp in a way that eluded me. Part of this was personality (I'd always be a hippie girl at heart) and part of it was finances. Our tight budget limited my shopping to the local Goodwill—a $50 shopping spree, twice a year, covered my entire wardrobe.

But it wasn't just clothing and education that set Henry and me apart. My colleagues shared an American mindset as foreign to me as the ghetto

culture in Dorchester, yet somehow, the ghetto culture was easier to comprehend. In Dorchester, I quickly felt accepted for who I was, but at the staff meetings, not so much. There was an insistent yet unspoken expectation for me to join the club and follow its rules. When I learned Top Leader had submitted my name for entry into a yearly volume of Who's Who in America, I was baffled. I wasn't an American or a graduate. But I guessed he wished I was and assumed he wanted as many names in the book as he could garner—that was part of his prestige-seeking behavior.

Soon after our arrival, Henry met with one of the co-evangelists, eager for spiritual input and advice. What life-changing counsel would he impart? To Henry's dismay, the advice was merely sartorial: Henry needed to get a three-piece suit to fit the current model and stop parting his hair in the middle. The next day he bought a cheap, $50 department store suit, which was all we could barely afford.

I start noticing more situations when his desire to fit in smothered the trailblazing Henry I knew. His growing concern with how the leaders perceived us bothered me, especially when it trumped his concern for me. Staff meetings triggered tension in both of us and on many mornings we'd argue during the one-hour drive to the meeting—arguments that left me blubbering and red-eyed upon arrival. *Get it together and look happy,* Henry would hiss as I struggled to compose myself for entry.

On one memorable morning, we entered a few minutes late and 20 pairs of eyes watched as Top Leader asked how we were. "Great!" replied a beaming Henry, while right behind him his wife collapsed in tears. A meeting recess was called as concerned Top Leader pulled me aside to inquire about our marriage. This was not cool with Henry.

As you'd expect, Henry's shifting priorities—he'd gone from being my protector to being my public image controller—brought a painful dynamic

into our marriage, and I struggled with hurt and resentment. I'd been attracted to Henry's unconventionality, his insistence on being true to his own convictions and indifferent to the opinions of others, and now he was becoming a company man, at least to some extent. You could dress him in a suit and tie, but he'd never fit the all-collegiate aesthetic either, or forsake his original thinking. He was just a lot better than I was at keeping some thoughts to himself—at least till much later.

Other weird dynamics bothered me. Most interns had moved to Boston to be trained and 'discipled' for future church plantings, and all of us wanted whatever personal time we could get with the top leaders. For the men, it was simple; they met with Top Leader or the elders or associate evangelists over breakfast or lunch, and in the straightforward way of men, mentoring needs were met.

For the staff women, things were different. In order to get time with the top leaders' wives, we were expected to go and clean their houses. This miffed me. I was busy keeping my own house clean (as a site of frequent large gatherings and non-stop hospitality) and traveling to their homes took over two hours—one way—on public transit. Once there, the only nuggets we gleaned from our superiors were hasty cleaning instructions. I'd been cleaning for *years*, even professionally, and hardly needed more domestic training.

Still, the expectation was clear: make the trek, do the cleaning, and consider yourself 'discipled.' If you weren't willing to spend most of a day traveling to fold a leader's laundry and wash their floors, you were proud, willfully rejecting an opportunity to be discipled (even in their absence, as they were often nowhere to be seen while we cleaned). "Proud" was the worst label in our vernacular. It meant you were resisting God's authority and probably needed mighty humbling at the hands of others.

There was a disconnect between the loving, non-judgemental fellowship we enjoyed in Dorchester and the way I (sometimes) felt at staff meetings. From the beginning, I struggled with the lengthy commute and lengthier meetings and was always eager to return to the day-to-day ministry where my heart thrived. I preferred *doing* the ministry to being instructed, at length, on what to do. I guess that made me proud. And it wasn't that I didn't have friends on staff. I made friends, but my deepest bonds were usually with the women I helped convert. We lived closely, in and out of each other's homes and workplaces constantly, in ways that didn't happen with the women on staff unless we were working in the same local ministry. My failure to make staff relationships a priority would be seen as an ongoing weakness on my part, but partnership in reaching out to others is what bonded me to my closest friends.

Do awkward staff dynamics indicate a cult? Not necessarily, though mandatory housecleaning for the leaders could be a red flag. Top Leader wasn't amassing wealth and didn't live in a mansion, but in a boxy little manse in Lexington, barely large enough for his family of five. This would change as the church expanded, though never to the outrageous extent flaunted by televangelists.

Does believing you represent God's true church constitute a cult? Maybe, but many groups do, including the Catholic Church. Believing you have something the world desperately needs and hasn't found is what motivates proselytizing. Does having no time or inclinations for activities outside of church, unless they're linked to evangelism, suggest cult membership? Again, maybe, but many realtors, visionaries, and businessmen could be accused of the same hyper-focus. I never felt I was part of an insular group because of the constant flow of new believers into our midst;

we all had more friends than we knew what to do with, and getting to intimately know new members always thrilled me.

Does too much intimacy constitute a cult? We cultivated transparency, starting with the personal study series everyone was taught and extending into our weekly discipling times. Being open was key to defeating Satan by exposing the sins he uses to entangle and shame even the strongest believers. Handled properly, openness led to the joy of being known and loved, even in our weaknesses. But in the wrong hands, confessed sin could lead to gossip and broken boundaries, and it was always wrong if the openness was one-sided and lacked a compassionate, humble response. Like the high priests of Old Testament times, we were called to such a standard: "He is able to deal gently with those who are ignorant and are going astray, since he himself is subject to weakness." (Hebrews 5:2). Did hit-or-miss discipling make us a cult?

I'd place our group on the low end of the cult spectrum, if such a thing exists. We were hardline on sexual purity and other vices but had no rules about food or drink (other than strictures against drunkenness and gluttony) or clothing (other than basic modesty and evangelists wearing suits at services).

We weren't stockpiling for the end of the world or caught up in paranoid conspiracies. Did things get strange? Absolutely—especially when viewed in retrospect. It took leaving for me grasp how much the church shaped every moment of my days, my identity, and my place in the world. But even this perspective, that of being utterly different, called to be *in* but not *of* the world, comes from the New Testament and so does the call to rescue others from this doomed world and point them to God's kingdom. The earliest Christians were radical outsiders, meeting daily, sharing all their possessions, and filling Jerusalem with their astounding,

all-or-nothing message. They stunned the Roman world with their unity, sacrifice, and devotion. Were we that much different?

As for the way leaders were moved like pawns from one place to the next, with little regard for the short and long-term impact of such inconstancy— and of this phenomenon, Henry and I were international experts—we could always point to the apostle Paul's itinerant lifestyle as a measure of what it took to evangelize the world. Of course, Paul was a single man, and his promptings came directly from the Holy Spirit.

As I write and remember, I'm still mulling the cult questions. Were we or weren't we? I Google "Top Ten Cults in America" and we don't make the list of the Most Dangerous. But on another list we sit at a solid Number Six, sandwiched between the Moonies and the Children of God. Our crimes? We're labeled as a "highly evangelistic group" (undeniable) that professes to be the only true church and is "highly authoritarian, with immense control over members' lives."

Guilty as charged, I suppose, though not everyone believed in the "one true church" and we willingly submitted ourselves to one another and the cause of the greater good, believing we were ultimately surrendering to God. We *did* believe we were closer to the truth than other groups and sometimes wondered if there were others like us that we just hadn't encountered. This seemed doubtful. We weren't being evangelized by members of groups that mirrored ours, whereas our members were continuously sharing their faith with strangers and acquaintances.

Did the good outweigh the bad? I still think so. Tens of thousands of people became strong Christians through our ministries and are still faithful and grateful to God, in or out of the organization. I could write volumes about the amazing friends and experiences I had through my involvement with the group, from the first day until the big crash, and even now, I share

a connection with past and current members that feels indelible. But the after-effects of leaving make me wonder. Would I have struggled like this if it *weren't* a cult?

Who can say? I wrestled with other griefs and losses for decades. Maybe this is the cost of loving and investing too deeply, or of not knowing how to process losses as they happened.

As for all my conference dreams, I still have traumatic dreams about not graduating high school, not being able to find my locker or pass a vital math test. Does that make high school a cult? Or does my brain concoct these conference and school scenarios as shortcut ways to process anxiety? Other people are chased by wild animals or rabid killers in their dreams. My tamer yet intense dreams indicate I wrestle with issues of authority, insecurity, and regret. Does that make me a cult survivor? Or simply someone whose strange life journey has mirrored her search for belonging?

I'll leave it to the reader to decide.

RAPID CYCLING

Deciding to stay in Canada was easier than packing up and moving to Tennessee. But it didn't fix anything. I was still depressed and still miserably attending a church that fell short of my longings. The constant stream of homestay students was a monetary boon, but hosting students who were immature, inconsiderate, or outright delinquent was an added layer of stress.

When Daniel and Tassja got home from school, I was already off teaching until nine or 10 pm, with no time left for family. Henry's mood swings ricocheted off similar moods in Tassja, and I became the peacekeeper—or tried to be. Their battles flared from a spark to a wildfire in seconds, and my interference only poured gas on the flames. It was impossible to stay neutral, and hard not to hold Henry responsible even when her behavior was off the charts since he was the adult. But she knew exactly how to trigger him and vice versa. In the midst of these battles, Daniel withdrew to his room, resenting the family dynamics and unsure where his own life was heading.

Our Nashville misadventure brought some mixed benefits. I was much more aware of my post-ICOC trauma, and Henry and I were discussing our feelings more deeply. Over the years, we'd prided ourselves on our see-saw relationship: if one of us was down, the other typically stayed up till it was safe to reverse positions. This time, the seesaw was broken and both of us were down, way down, and unable to lift ourselves from the pit. I was wracked with unrelenting sadness and anxiety, while Henry battled anger and overintensity.

One bleak morning we sat in the living room and discussed separating for the first time in 28 years of marriage. I was the instigator. I wanted out. I couldn't stand the tension and conflict anymore, and I was terrified of the damage it was inflicting on our family. We still didn't know the enemy's name: We were staring at bipolar II disorder without comprehension, unable to pin a cause to the behavior. It was impossible for Henry to be objective about his actions or feelings, or to see how disproportionate his emotional outbursts often were. All I knew was I hated the person he'd become (as well as myself) and I couldn't see any way forward.

After the icy talk, we pulled back, unable to formulate a plan. We'd gone into marriage with a solemn promise to never speak the "D" word, but even uttering the "S" word—separation—felt like a broken vow. We carried on, alternately civil, angry, or distant. I woke each morning with dread and ended each day with a desperate urge to escape my life through sleep. Between teaching sessions, I drove from house to house with a black cloud around me, wishing I could crash and escape my life altogether.

On another bleak morning, Henry started crying and couldn't stop. He'd had a similar breakdown nine years earlier in Washington, D.C., leading to a diagnosis of depression and a prescription for an SSRI, which he'd been taking (off and on) since then. Again, something was terribly wrong

and I urged him to see his doctor, who sent him directly to the emergency room. The ER doctors knew a crisis when they saw one and advised him to self-admit to the psychiatric unit, long enough to be diagnosed and started on the best treatment. There was concern that some kinds of mood-stabilizing medication might be contraindicated by other medical conditions, and his treatment would include blood work to determine which medications were safe. He was quick to comply. The treatment made sense, and he was at the end of an utterly broken road.

The official diagnosis was cyclothymia, a less-common form of bipolar II disorder, and despite the scary implications of receiving such a label, it was a huge relief to learn there was a medical reason for his radical mood swings. Cyclothymia is less intense than other forms of bipolar II disorder—the highs and lows are not as extreme and it never leads to psychosis—but left untreated, the disorder gets progressively worse, as it had in Henry's case. Still, we learned, it *was* treatable, with the right medications.

As happens with many patients suffering from bipolar disorder, the correct diagnosis came years after symptoms began. For nine years, the wrongly prescribed antidepressants had exacerbated his manic symptoms and sped up the cycling. It was heartbreaking to look back at the damage and pain we'd endured, knowing it could've been different with the right diagnosis years earlier. His untreated illness had torn a jagged hole through our lives, along with so much else: my buried grief, the impact of 9-11, our years of lost relationships, the ICOC implosion, and our inability to nip any of these vandals in the bud.

Whether timely or belated, a mental illness diagnosis is hard to embrace, no matter how much it illuminates and clarifies. Henry had to cycle through the classic valleys of grief—denial, sadness, anger, and back again—before making peace with his condition. (There was probably some

bargaining in there, too.) It was easier for me, though I chided myself for not connecting the dots and pushing him to get help sooner. Knowing what he'd been dealing with softened my heart, and compassion replaced the anger and resentment that had widened the gulf between us. He had no more control over his brain chemistry and the three-ring-circus moods it provoked than I had over mine.

My mental illness is less exotic: plain old garden-variety depression, a shadow that's nipped at my heels since my teens. During my busy years in the ministry, I tried to outrun it, convinced that committed Christians shouldn't get depressed. This presumption, and the need to present as a strong leader, kept me from facing things squarely until my breakdown forced a reckoning. I soldiered through good years and bad, heavily dependent on my favorite weapons: exercise, prayer, and deep involvement in other people's lives. These were the best depression suppressants I'd found, and without them I knew the shadow would win. But now my prayer life was weak, my spiritual involvement was tentative, my life was full of new stressors, and exercise alone wasn't cutting it. The shadow was gaining control.

Depression still carries a stigma among many Christians. But bipolar disorder carries a far greater stigma with nearly everyone.

As far as disclosing Henry's condition to others, it was obvious his employers (specifically, three men from the church he was currently leading) needed to know his prognosis, which was good, according to his psychiatrist. These men had seemed supportive when he'd asked for time in the hospital, but now they cited our almost-move to Nashville and another ministry opportunity we'd briefly considered, and used these as reasons to fire him, or, as they gently worded it, "to take some time to get better". There was no return or paycheck waiting on the other side of *better*. Instead, they

hired a new pastor, a bland Universalist who preached lessons from the Quran and turned the church gym into a yoga studio: someone the exact opposite of Henry.

Letting someone go in response to a mental health disclosure isn't legal, but when you have to work closely with the people who fired you, it's not a battle worth fighting. I was dismayed by their response, but not sad to leave. At least this time we didn't have to pack up and move house. But it was an emotional blow for Henry and a quick, brutal lesson in how others view bipolar disorder.

On the upside, Henry now had unlimited time to heal and pursue his creative pursuits, mostly writing and research. On the downside, we wondered how low the path could go. Financially, we'd survive for a time on Henry's unemployment insurance and my earnings, but it was hard to imagine any future in the ministry after all our troubles.

It's not as if the leaders God chose had stellar mental health records. Moses murdered a man and spent 40 years wrestling with his past before he was ready for service; King Saul was subject to fits of madness; David spent years as a fugitive before becoming a king who'd impregnate the wife of his loyal friend and have him killed in battle. Elijah and Jonah wanted to die. As for New Testament leaders, Peter exhibited the impulsivity and passion of a man suffering from a mild form of bipolar disorder or ADHD, and John the Baptist must've struck some as a raving maniac, living on locusts and honey and blasting the Pharisees who came to see him. Amid such company, Henry was clearly average. He was a bit like Peter, wildly devoted to Jesus and unpredictable, and a bit like John the Baptist, unafraid to speak his mind, without a materialistic bone in his body.

Leaving this last church gave me the chance to do something I hadn't done since meeting Henry and jumping into the ministry: attend church

as an anonymous visitor. I chose a popular community church on a nearby hill. For the year or so that I attended, it was a welcome change. I could drift into the service of my choice (early or late morning), with or without Henry, take a seat in the balcony where I got the best view, and take in the service without any obligation to minister to those around me.

This was a completely different way of 'doing church' (and one that I'd previously scorned as lukewarm) and it felt strange, loose, and easy, but also lonely. Most Sundays, in an effort to be encouraging, I reached out to at least one person sitting near me—we balcony folks were mostly loners, church shoppers, or visibly depressed—because in this congregation only the faithful core, who sat downstairs nearer the pulpit, seemed socially engaged. Most balcony attenders came a little late and left as soon as the last hymn ended. They sat politely apart from their nearest neighbor. They didn't expect to be approached and seemed surprised if I engaged in anything beyond superficial chitchat. Sometimes, inspired by the worship songs, I tried for deeper talks, and sometimes I succeeded, but each week the faces in the balcony were different.

For a while, this suited me. I could focus on the sermon and the worship instead of scanning the crowd to see who was missing, who had visitors I needed to meet, who I should schedule time with, and who seemed downcast or preoccupied. This absence of responsibility let me focus on God and how I really felt about Him, without getting tangled in other people's lives. For as long as I'd been a Christian, church had been about taking care of others, and as my responsibilities had grown, engaging in worship had taken a back seat. I knew that the 'Lone Ranger' Christianity I was practicing wasn't biblical, but it served its present purpose. I could rest in God's grace and avoid the emotional triggers set off by attending an ICOC church. I considered the interlude as a kind of church sabbatical; I

was attending, but not expected to contribute anything more, apart from some dollars in the collection plate.

Several things happened around this time that quickened my healing journey. The first was my return to writing, something I enjoyed and knew I was good at, but had abandoned for decades, apart from sporadic journaling or writing articles or chapters for church-published books. My excuse—and legitimate reason—had been a lack of time for 23 hectic years. Any 'free' time I had in the ICOC was spent with other people. I'd always known that one day I'd write a memoir about Jack and my spiritual wanderings, but I'd never felt ready, even if I'd had the time. I still wasn't ready to write my first book, but it was time to *make* time and start practising.

If the "10,000 practice hours of writing before you write anything good" theory held true, I faced a daunting task, but I hoped some innate talent would cover the difference. I began with daily, two-to-three-hour writing sessions at the local college library, a neutral setting away from the emotional soup at home. Toting my spiral-bound, 240-page notebook, a bundle of pencils, and a sharpener, I began my late-blooming practice hours.

But I made it hard for myself. Like many new writers, I was superstitious, terrified of writer's block, and obsessed with the physical details around me. Everything depended on the absolute right conditions. The first 10 minutes involved circling the library multiple times in search of the 'right' carrel. Like Goldilocks, the spot had to be just so: not too hot, too chilly, too sunny, too dark, too noisy, or too close to any potential noisemakers. I'd often unpack my gear, open the notebook, sharpen my pencils, fret over the first sentence, and end up moving to another carrel—or two or three—before writing a single word. Talkative students drove me batty; a particular whiney-voiced librarian who doled out longwinded advice and opinions at high volume was enough to squelch the muse, and I was sorely

tempted to report her to the college president. Some days the pencils were the problem. My arthritic fingers cramped quickly, the pencils were too ridged or large, the lead broke or wrote too faintly. In frustration, I wrote about the pencils or my lack of inspiration, hating the inane drivel that issued forth. But I pushed on and began to shape short, autobiographical narratives with a beginning, middle, and end.

Apart from the occasional phrase or sentence that seemed gifted from a higher realm, my writing was mediocre at best. I was editing as I went, erasing, backtracking, tearing out pages, and moving from carrel to carrel to escape the sounds of snacking, snoozing, coughing, or chattering students. I looked around at the other patrons and felt old and out of place. I wondered if anyone would care about anything I might ever write. I worried my cramping hands would ultimately fail me. But no matter how many times I moved seats, crossed out paragraphs, or nauseated myself with bad writing, I kept to my set time before stuffing my gear away and trundling home.

It was a start, albeit a rough one. I didn't share a snippet of my scribbles with anyone and my heart never soared as I wrote, though sometimes it fluttered a little faster. Writing felt like work, and the restlessness that claimed me every time I opened my notebook made every session a secret battle. Still, I kept going. It wasn't gratifying, but it felt necessary. Nothing I wrote was worth keeping, but the requisite hours were being paid.

The next writing chapter began with an empty, freshly painted room. One of our long-term homestay students, an odd introvert who'd used black Sharpie pens to secretly cover a wall with inscrutable Chinese writing (was it poetry? Ancient Chinese proverbs? Study notes? Graffiti?) finally graduated and moved out, and I had my first writer's room. It was summertime. Tucked into the cool basement, the room was a sanctuary,

blissfully free of paper-rustling students and cacophonous librarians. I could leave my notes and pencils in place, ready to be taken up whenever I slipped downstairs. I could drink tea while I wrote. And my first session in the blue room brought me a gift: the first poem I'd written since childhood, apart from the humorous tribute verses I wrote for friends and family on special occasions.

It wasn't a great poem. But it came from my heart and slowed me down, exactly what I needed. The first line was also the title: "Restless Soul." And the first lines—"Why do you roam? Come close. Sit down. Stop moving"—got my soul's attention and calmed my inner agitation. The poem acknowledged my scattered state, my Self in pieces, "spinning from mirrors, from looking too close, from looking too long," and urged me to set my troubles down, to "leave it here," knowing they would scream and cry and call me back, but to "keep waving as you walk away," and to venture into writing unencumbered. The breakthrough poem worked some magic. For months afterwards, I entered my little blue writing room and wrote a poem—or revised one—nearly every day.

The poems were as varied as the restless west coast weather. Many explored my inner landscape, one manageable sliver at a time, while others were witty confections, wry commentary on a phrase, an attitude, or some aspect of life that caught my attention. Some were frivolous, yet satisfying and fun to create. I combed the dictionary and a hefty book of famous and obscure quotes for words and ideas that could spark a poem. The daily verses were like exotic birds, alighting from unknown quarters to delight me. I wrote dozens and dozens of poems and returned to the best to polish and revise, seeking an ever-elusive perfection. Unlike writing prose, writing poems didn't cramp my fingers—the words were fewer, and carefully considered—and my brain swirled with fresh material from previously

sealed chambers, the whole right-brain, left-brain mystery. My inner critic shut up and took a nap while I wrote and, as my output grew, I bought new notebooks to scribble my drafts and explore where the poems would take me.

Some of the poems were about Jack. Writing from different vantage points let me explore aspects of grief—the ambivalence, the guilt, the longing, the selfishness, the regrets, and the lingering hauntings in my dream life—in a concentrated form, bringing a measure of clarity I hadn't achieved in all my journaling. Turning my pain into anthems and art made it precious (in the original sense of the word), not costly. Like other poetry, the Jack poems came from a subterranean source connected to my dreams. Writing them didn't bring complete healing, but it brought the bittersweet to light, where it could be acknowledged, framed, displayed, and partially absolved.

Unlike my discomfort with my clunky prose, I wanted to share my poems. They were short and well-received, eliciting laughter, tears, and meaningful feedback when I read them aloud. Henry and I were part of a Bible study/friendship group that met on Friday evenings and the group became my audience and supporters. For several weeks, they graciously let me turn the meetings into poetry readings. At last, instead of stuffing my emotions and withdrawing when I felt sad, I was finding my voice with a loving, receptive circle of friends who wanted to listen and talk about what I'd written.

The readings were like stepping onto a sunny beach after years of dark clouds, even though life was far from perfect. Tassja, now in high school and as hormonally challenged as I, was increasingly volatile; Henry was still unemployed and trying to make peace with his situation; and even Daniel, formerly even keeled and easygoing, struggled for a time with low

moods and a lack of purpose and direction. Perimenopause was like riding a hormonal rollercoaster, and I couldn't tell what was causing what.

Were my health issues and emotional struggles caused by change of life, unresolved grief, post traumatic stress disorder after leaving the ICOC, or were they simply the symptoms of long-term, chronic depression? The correct answer was probably D: all of the above. But it didn't really matter. At last, through writing, I'd found an outlet and a return to something I was always meant to do.

CHAPTER

THE RECKONING

After finding my literary voice, I chanced upon another key to heal-ing during a coffee date with old friends. Our relationship with this couple stretched back to Boston, and although our paths crossed often at conferences, we hadn't lived in the same city since the mid-80s. The ren-dezvous was a last-minute plan on their way through Vancouver, and we huddled around a tiny table in a crowded suburban coffee shop, unsure where to begin after years of upheaval and change.

Henry's letter was a starting point—the two men didn't see eye to eye on how it had gone from being shared with a select group of leaders to becoming a viral sensation—and we had a four-way discussion until the wife and I wearied of church politics and pulled our chairs closer for more intimate talk. How were our families, our children, our hearts, after years of moving round the globe and starting over? They'd moved almost as much as we had, but had chosen to stay in the church, in the upper ech-elons of leadership, after the Letter came out.

Lately, she said, she'd been mourning the 'loss' of her daughter, grown up and soon to be married and settled on another continent. She made a passing comment, "I'm doing *The Grief Recovery Handbook* with another sister over this one"—and my ears twitched like a bunny's. *The Grief Recovery Handbook?* What was that?

Hadn't I heard of it? She was surprised; the book's been around for years, she said, and she and other ministry friends were using it to process all kinds of grief, from dead parents to miscarriages to lost ministries and relationships—the carnage of our ilk. It was a deceptively slim little book, she continued, that presented a powerful way to process unresolved grief with the help of another person—anyone who wanted to do similar work in their own life. No clinical expertise required, no fees, beyond the modest cost of the book, and no limit to how often you could use the process to deal with old and new sorrows. I wondered how, in all my years of grieving for Jack, I'd never come across the Handbook or heard of others who used it. Had Theo never read it? Or was it kept secret among grief therapists, afraid its $20 price tag and high success rate would cure their clients without clinical intervention?

I could probably find it at the library, my friend suggested, after I'd asked a dozen more questions and pressed her for success stories. Wasn't this what I'd been searching for: a tested, proven way to process, release, and alchemize grief into something bearable, *wearable*, like a dainty cross on a gold chain, rather than the heavy, splintered, wooden version crushing my soul? It seemed my elusive grail might actually be real.

I have no idea if my friend knew what she'd given me that day, if she had any clue how much I needed those four simple words, *The Grief Recovery Handbook*, along with her assurance that the process really worked. There wasn't time to share with her about Jack or the ocean of grief where

I was still doing the dead man's float, despairing of rescue. But I knew a door had opened.

Our husbands, when we looked over, were still debating the Letter, oblivious to the life-changing talk we'd just had. But it was time to leave; the coffee shop was short of seats, and we'd overstayed our welcome.

Someone paid the bill and we moved to the parking lot, where we sat in their rented car and prayed before saying goodbye. When we returned to our own car, a $75 parking ticket flapped on the windshield; we'd exceeded the three-hour limit posted on tiny signs around the lot. But it was money well spent. *The Grief Recovery Handbook* was going to save my life.

The next day I went to the local library, five minutes from home, and found the book, just as my friend had said. It was skinnier than its shelf companions and easy to miss; maybe that's why I'd never spotted it in all the libraries where I'd perused the grief section—all the "158" books in the Dewey Decimal system—over the years. Or maybe it was always checked out. The paperback had a pale grey cover and weighed all of four ounces.

After my friend's glowing testimonial, I was astonished to find a copy on the shelf. Surely a book of such worth would be in heavy circulation! I pictured the entire population of Coquitlam and wondered how many of its 140,000 souls were in need of grief healing. No doubt there were many. But here it was, waiting for me, ready for nine weeks of checkouts and renewals if no one else put in a request.

I am not a paid endorser of *The Grief Recovery Handbook*. Up till now, I've never contacted its authors or attended a workshop or any other events sponsored by their institute. I don't know anything about the organization and its founders beyond the information posted on its website. What I *do* know is that the book's method of dealing with unresolved grief is the closest thing to a magic wand I've found.

Perhaps I need to cut Theo a break. The first printing of the Handbook was 1998, two years before my frustrating, circular sessions with him. I'm going to assume he'd never heard of it; after all, he wasn't actively seeking new methods by the time I knew him. He was a product of earlier times. The only book he'd recommended, *How to Survive the Loss of a Love*, was published in 1976, sporting a promising title and groovy 1970s graphics and quotes. Too bad it wasn't the lifeboat I needed; for me it was as lightweight and useless as a paper skiff.

I'm a fast reader and could've finished the Handbook in one sitting if swallowing the contents whole was the point. It wasn't. The early sections, which examine some common (and harmful) misconceptions about grief, also make one thing perfectly clear: simply reading the book accomplishes nothing. The point is to do the work, the multiple-step exercises spelled out in the second half of the book. The work is orderly, specific, and non-negotiable. No short-cuts. And to do it properly, you need a partner: a friend or family member wanting to do their own grief work alongside. The partner can be almost anyone, and the griefs don't have to match; after all, no two griefs are alike. What's essential is a mutual willingness to see the exercises through to completion, within a reasonable timeframe, so no one is left dangling or half-baked. No prior experience—except the universal experience of grief and loss—is required. How hard could it be to find a willing partner?

Harder than I imagined. Within days of getting the book, I asked six different friends if they were interested in partnering. Each of them, I knew, had unfinished heart work: loss of a parent, a family member's suicide, divorce and abandonment, severe health issues, and the like. When I described the program's potential for healing, each friend brightened at the prospect of finding closure. None of them, however, headed to the library

to get started. Instead, excited by my preview, each hastened to the nearest bookstore and bought a copy. I'd been too cheap to buy my Handbook, but these women were on it! Or so it seemed.

Of the six friends, only three read beyond the book's introductory chapters and completed the first assignment. The others fell through; they liked the book, they *wanted* to do the grief work, but they just couldn't move past reading to doing. I met with each of the three who put pen to paper and got started, reasoning that with the amount of grief work I required (each grieved person or situation requires a complete cycle of assignments), having three available partners could be useful. I was also hedging my bets, since even the three starters were dragging their heels as the work got harder. Because it *is* hard work; deep emotional work that requires a good deal of desperation and longing to push through to the end.

The Grief Recovery folks give a simple reason for why their approach works while so many others don't. They say it's because grief is an *emotional* response to loss, and steps to healing, closure, resolution—whatever you want to call it—must engage and release those emotions, rather than focus on logic and intellect.

I was living proof of this. For decades I'd tried to heal myself through logic, painstakingly raking through the big and tiny details of Jack's death and how I'd (mis)handled it. The list was long. *I couldn't accept his death because I didn't watch him die. I hadn't sat with his dead body. I'd been selfish on the plane. We never talked about his death or what he expected me to do. We never said goodbye. I couldn't.* And so on.

All of these things were true, but no matter how much I reviewed them, rehashed them, journaled them, or turned them into poetry, the long list of failures and mistakes still haunted me. I was still angry with myself for not handling death with greater wisdom, something impossible for someone

in her early 20s, new to the land of bereavement and surrounded by other shocked neophytes, but *still*. I was certain I could've avoided years of fruitless grieving if I'd known what I was doing back then. I was still wishing I'd done things differently and better, instead of packing my grief into yellow bike panniers and riding off into the mountains. I didn't regret my bicycle travels, though I wished I'd finished the symbolic journey I'd intended to honor Jack, and further honored him by steering clear of doomed romantic rebounds, at least for a good while. And I wished I'd done other impossible things, like stick around, instead of running away, *and* taken the trip, so I could've processed Jack's death with friends, in familiar settings, *and* found myself on the road of discovery and personal challenge.

Even as I write this, the folly of hindsight logic and circular thinking hits me hard. What happened *happened*, and there's no escaping it, especially 40 years on. This must be the logical essence of making peace with death, especially unfair, untimely death: no amount of wishful thinking can change the facts. But accepting the facts and accepting the finality of death doesn't disarm the emotional powder keg lurking at the core of great bereavement. That's where the real work lies, and I'd wasted too much energy over the years, picking at the logical fronds sprouting from grief's surface and trying to reason my way into peace of mind. All my *feelings* about Jack's death—not to mention the long queue of other losses hankering for resolution—were still ravaging my heart. Time hadn't done squat with the emotions; in fact, all my subsequent (and earlier) losses had only kept the feeding frenzy going.

The Grief Recovery system proceeds through a series of steps towards resolution. One of the first exercises involves making a lifetime loss inventory and tracking each episode of loss/grief on a line graph. I was familiar with this concept, having used it with a different application when I

studied the Bible with seekers; I often asked them to graph their spiritual journey thus far in a similar way. It was a simple way to view emotional, often intangible events more objectively. In the spiritual lifeline context I used with others, the lines might number less than a dozen, marking times of God awareness, repentance, sinner's prayers, personal epiphanies, or various church rituals. It helped to see the journey on paper before examining the Scriptures.

In terms of life losses in the Grief Recovery method, most people will have between 10 and 20 events, according to its authors. My lifeline was slashed with dozens of events, reaching back to early childhood. Life losses go beyond physical deaths, and my perpendicular lines tracked profound disappointments and betrayals as I grew up: lack of maternal love as a child, emotional abandonment and loss of security during and after my father's affair, loss of both parents when I ran away, loss of hope when I went to the Girls' Home and my parents refused to capitulate, loss of education (and wasted potential) when I left school to live independently at 16, loss of other family relationships in the midst of this drama, and so on. Other losses included loss of virginity (and self-respect) after a gin-soaked, regrettable evening with someone I barely knew; loss of my best friend through heartbreaking betrayal; loss of nearly everything resembling a normal, nurturing childhood and adolescence. There was probably more; I'm reconstructing my graph through memory.

These were mere forerunners to the ultimate loss: loving and losing Jack. After his death, the losses tumbled like trees off a logging truck on a steep mountain road: all the friends, homes, and communities I'd left behind as we criss-crossed the globe; the broken promises and closed doors as we started and ended new, hopeful chapters; an ectopic pregnancy and the verdict of infertility; our lost foster children and the babies we almost

adopted, taken by death or bad timing; pets, dying young, or unwillingly relinquished because of our sudden moves; lost dreams and connections to the ICOC, and my complicated relationship with the group that shaped my world for nearly 25 years; and the lost hope of having a 'normal' family in the midst of our collective mental heath struggles, robbing us of stability, trust, intimacy, and confidence.

As I graphed the losses, the Handbook instructed me to rate the intensity of each loss by length of line: the greater the loss, the longer the line. Strangely, this was not hard to do. My heart seemed to know exactly how much pain each episode had exacted without my having to think. As I recalled each breach and robbery, I could also sense which had been lessened by time and which were still raw. There were many long lines and plenty of shorter ones, too. But my line looked nothing like the book's relatively tame example. In mine, there weren't many clear stretches, indicating smooth waters, but a wild string of short, medium, and long spikes, like badly cut bangs.

Looking back, perhaps all my ministry-associated losses should've been tabulated into one huge episode, in which case the line would extend far, far below the bottom of the wide sheet of paper I'd used for my graph. I could've processed the whole shebang in one long, harrowing assignment and perhaps worked through all that trauma much sooner. But that didn't occur to me. Instead, with sober clarity, and as the Handbook instructed, I focused on the three longest lines. The Jack line surpassed all, but the other two lines ––loss of mother and father, not through death but through estrangement and withholding—competed for attention. The mother line, lengthened by all the animosity in our troubled relationship, was longer. The father line was its inverse, full of emptiness and denial, and it too was long, but not as dark.

At the completion of each assignment, the griever is instructed to meet with her partner and share what she's written, one person per session. When my turn came, I apologized in advance for the busyness of my grief graph, anticipating an inordinately long session and wondering if I'd scare her off. She was game. But when I finished reciting my litany of woes, as succinctly and matter-of-factly as possible, her face had paled. The listening partner's role is to listen without judgement, and she isn't supposed to comment on what is shared, beyond thanking the griever for sharing. But my friend couldn't help commenting. "I see why you need this work," she said. "I had no idea."

■ ■ ■

Once the history of loss graph is completed, the Handbook directs grievers to choose the top three losses—the longest lines—to work on first, starting with the least intense and working up to the most. I started with my relationship with my father. Using another graph format, I charted our relationship from my earliest memories, focusing on the emotional highs and lows of our history together. In this case, the high moments were few and far between, and the lows primarily marked episodes when he'd been emotionally absent, or silent when my mother was verbally abusive to me.

I thought back to the sleepless night in Philadelphia, when memories of his near abandonment had surfaced after 30 years of forgetting. For most of my life, I'd pegged him as the Good Parent in contrast to my explosive mother, the obvious Bad one. I'd given him a pass without ever dealing with the emotional holes in our relationship. But I had no memories of ever sitting on his lap, being told I was pretty, or having anything remotely like a Daddy's Girl relationship. As his only daughter, the only father-daughter times I remembered were socially mandated ones, like

Father-Daughter Pie Nights put on at school, and even those rare events, made bearable only by the prospect of pie, felt immensely awkward. If he drove me to or from an activity and we were alone, I insisted on sitting in the back seat, unable to handle sitting next to him. That seemed strange. I remember telling him I liked to sit in the back where I could look out both sides, peeking into strangers' windows at night as we sped by. I still like doing that. But better visibility was only part of the reason, though I don't fully understand the other part.

On the plus side, I knew he respected my intelligence and he'd always encouraged his children's creativity, though he could also be critical and could devastate me with an offhand remark. The affectionate, protective, attached components of a healthy father-daughter relationship were missing. As a child, I was jealous of his students, convinced they got the best of him while we, his offspring, got leftovers.

But he'd been a good provider and hadn't left us for the Other Woman, a widowed school secretary with four children. Also, as we'd grown older—and especially after his retirement—he'd become a better father, more engaged and expressive with all of us. Still, the present couldn't erase the past. The truth is, I'd been in great crisis as a child and young teen, to such a degree that I permanently fled home, and he'd never discussed any of it with me, never pulled me aside and tried to understand, intervene, comfort, or reassure me. There also was no effort to commiserate with me. My mother was hard on him, too, though not with quite the same power and control she had over me.

All of this had a huge impact on my relationship with God. Despite my years in the Scriptures and prayer, my years of leading others to Christ; despite all the lessons I'd taught and convictions I'd held, and my confident assertion that God is loving, compassionate, gracious, and kind, that He

loves us with a perfect, personal love that defies measure or comparison, that He *adores* us, far more than the world's most besotted new parent; despite all this head knowledge and the ultimate evidence of God's love— the sacrifice of Jesus on my behalf—my emotional sense of God's love had been shaped by the relationship I had with my father. It was another example of how one's emotional truth—or perception of truth—doesn't necessarily square up with one's cherished beliefs. I believed God loved me and could point to a thousand ways He'd guided and protected me.

But did He *like* me? Was He delighted when I talked to him, and did He run to meet me when I needed Him most and was too weak to pray? I could easily imagine Him running for others. But the father I knew held back, providing for my physical needs but never seeking me out, pulling me in, or showing affection. My slice of God's love was based on deductive reasoning: *God so loved the world, and I'm part of the world; therefore God loves me.* He *has* to love me—that's His job, His nature, and His promise. I knew—intellectually—that God loves all of us, *each* of us, equally and as much as He loves Jesus, as mind-boggling as that is. But it was hard not to think humanly, that God might have his first, second, and third tiers of favorites and lesser thans, and that I belonged to a group He loves mostly on principle. Again, I knew this was wrong thinking and barely admitted it to myself, let alone another living soul, but it *felt* logical.

When I prayed to my heavenly father, I came with bushels of guilt to confess before I felt worthy to ask for anything, apart from forgiveness. Sins of omission stood in the way. I hadn't done this and I hadn't done that. I'd promised to pray more and hadn't. I'd asked Him for opportunities to share my faith and kept silent. I'd felt guilty in the ministry because I didn't love everyone perfectly and felt even guiltier out of it. And I couldn't

fathom how God could enjoy my company; I could barely stand seeing myself as I pulled out endless baskets of dirty psychic laundry.

Jack's potent love had overflowed my hungry heart because he *saw* me, knew me, and loved me, just as I was: the greatest gift we can give another person. But even his love hadn't been enough to compensate for the missing childhood love. In the beginning, I thought it had—I felt utterly loved and validated, made alive with him—but his abandonment through death had tainted the love. Was I not enough? Death is the perfect excuse for leaving someone (how can you refuse?) yet here was another case of logic and emotion opposing each other. What I knew and what I felt were at loggerheads. *Of course* he hadn't chosen to die. *Of course* he wanted to stay with me. *Of course* he'd hoped for a long, full life together. Or had he? Some stubborn, warped corner of my brain held him responsible for dying. He'd broken the pact we made to deny death an audience. He'd given in, when we'd agreed we never would, and when my back was turned, when I fell asleep in another room, he'd slipped away. And a nasty, neighboring corner of my brain held *me* even more responsible: I wasn't worth staying for.

That was the maddening, dispiriting message my heart kept playing, sent through dark, recurring dreams that made perfect sense to my subconscious mind. The message and the dreams and the sense of having fallen short were linked to my earliest memories, to the holes in my earliest attachments, and to all the self-hatred that came with it.

And all of this led to God and how He had or hadn't watched out for me: His bringing Jack into my life, and then, within months of my newfound joy, letting him sicken and die. His decision to birth me to these particular parents, whose 'care' had left me fiercely independent, but damaged. It could've been worse, I know. I know. I wasn't the child called It; I wasn't locked in a cellar; I wasn't trafficked or beaten or given away. He'd sent

others to love and look out for me in their own way. But it could've been better. Reviewing the past and examining the highs and lows and blanks in my relationship with my father brought all these feelings to the surface, disturbing deep waters I'd ignored or hadn't known existed.

Writing this now, several years after my Grief Recovery period, it's easy to see why most people avoid plumbing such waters. Each loss and heartache links to the rest and it's impossible to pull on one buried rope without jostling the others. I began the untangling with my father, expecting a mild practice run before I faced the Big One, but its tentacles caught me by surprise, and even though he's still alive, still theoretically capable of mitigating some of this old pain with me, I know it will never happen. My father doesn't do feelings, beyond his own unexamined ones; he claims to never dream at night. He is supremely disinterested in the road not taken, except to bemoan his own difficult marriage. He won't go deep, isn't able or willing to dive with me and look at the wreck, or to give me a hand with underwater repairs that might or might not make a difference, so many years later.

It took 40 years before he asked the first question about my missing years—the six years of no contact after I ran away. (My mother never asked a single question.) My father's query wasn't about how I'd felt or coped or fared, but about whether I'd had contact with his parents, my grandparents, during those years. I had, sporadically. But apparently they'd never mentioned our meetings or how I was doing. Everyone was afraid to further enrage my mother by getting involved with me. His questions ended there, until a few years later, when he had his first (and only) hallucinatory episode, triggered by surgical drugs, and he asked for the first time about my own experiences with psychedelics. That talk went a little deeper and

we *almost* got into feelings territory, but not quite. Still, it felt wonderful to step into the past with him, even briefly.

The Grief Recovery system summons the griever's ghosts, heartaches, and suppressed memories for a big, messy reunion and reckoning. The process ultimately leads to writing a personal letter to the dead (or to the living-but-unapproachable, like my parents), one mourned relationship at a time. Instead of focusing on only the Good or the Bad, as we tend to label our most passionate relationships, the Handbook guides the griever into a more balanced assessment. What are you thankful for? What are the good (or bad) moments you've overlooked with that person? What do you wish had been better, different, or more?

That last set of questions was key to my recovery. Not only could I chart my life's sorrows and losses, bringing them into the light and laying them flat on a graph where they could be viewed objectively and holistically, instead of stuffed into a huge, entangled ball of pain, I could also get a fresh perspective on each relationship. None of my Top Three was all good or all bad, though I remembered Jack as a demigod and my mother as a demon. In my father's case, I needed the questions to realize the profound impact of his emotional absence and withholding. The Handbook hadn't instructed me to link our relationship to my relationship with God, but insights from my graph and the better-different-more questions naturally led me there. In the process, I got the sense that perhaps the biggest line I needed to explore was a fourth one: my relationship with my Creator.

This prospect was so daunting that I put it off forever. I'd be like Job, wailing my woes to the Maker of the Universe and being countered by the Voice of Authority in a terrifying storm, with no real answers at all, except that God is God and I am not. Though I wasn't exactly like Job; he was a righteous man who suffered at Satan's dare, and I hadn't been plagued with

total ruin and running sores from head to toe, unless you counted my festering psychic wounds. It was a confrontation I'd willingly forego, though I let myself be comforted by Job's ordeal. I wondered if I'd get anything back after years of losing. Job certainly did, in spades, but then again, he'd been righteous from the outset, while I'd simply and shamefully lost trust in my Truest Friend.

■ ■ ■

When I began charting my relationship with my mother, I was compelled by the Handbook instructions to search for good memories as well as the obvious bad ones. There wasn't much tenderness to be found, but there were rare moments when we *almost* connected, and a hard chunk of my heart softened when I let myself wish there'd been more of those moments, and better ones. Still, it seemed in every brief, positive interaction we'd had, there'd been an immediate twist of the knife to end it. My first happy memory of her—a summer afternoon when my brothers were out and she'd bought me a rare fudgesicle—plunged from delight to despair when the ice cream melted down my yellow dress and she started yelling. By reimagining, I stopped the scene before the melt and wished it had ended there. Different. Better. More.

As a vulnerable young child, I'd closed myself off and focused on her faults to deflect the pain of what was missing. It was easier to feel anger than longing. Now I was looking through fresh eyes, and asking the better-different-more questions brought yearning and compassion to the surface. The yearning was for a different version of my mother, the tender woman she might have been had she not been damaged by her own trouble and losses. The compassion was for me, and also for her. Surely, behind her great wall of stubborn pride,lived a woman who'd wanted things different, too.

I knew that in real time our relationship would never change; she'd still blame me if I brought up the past and I didn't dare go there. Doing so would destroy whatever fragile peace we'd achieved. We'd learned to be cordial to each other—I believe she actually *liked* me now—but she'd never apologize, and even though I'd forgiven her for the past, I couldn't ignore her critical spirit (and words) towards my own family. Now I was protecting my children from her, trying to minimize her impact, and it was time to accept the fact that she'd never change.

To do this, I needed to express my longing for a different, better relationship, at every turn of our tortuous past, but only by verbalizing these things with someone else: my grief recovery partner. I worked through the graphs and charts and lists, culminating in the unsent letter I read to my partner. None of this would make her a better mother, but the goal was not to change her—an impossible wish I needed to let go of—but to heal my heart and be at peace with whatever had or hadn't been.

This letter was as painful to read as the letter to my father. The hardest parts were not the episodes of pain she'd inflicted, but the gossamer incidents that hinted at something warm before melting back to my mother's default setting: anger and hostility. What if these moments had been sustained? What if we'd had a loving, warm relationship, with intimate talks, shared adventures, and mutual respect and goodwill?

With Daniel and Tassja, I'd passionately tried to be the mother she wasn't and could truly thank God for the impetus my childhood memories gave to my parenting. If anything, I'd taken my quest to an extreme: whatever she'd done, I aimed for the opposite. Still, even if I'd been too permissive and revealed too much of my own struggles, I loved my son and daughter with fierce affection and they knew it. I still ached for a mother who'd delight in her grandchildren and be there with comfort and wisdom

when things got tough with my kids. This, too, would never be. She had two favored grandkids, and they weren't mine. All these longings needed to be spoken and then put to rest, a series of small but terrible deaths tucked in their graves like a field of stillborn babies. Naming them loosened their hold on my heart, and I could stand beside each plot and release each broken dream like a sky-seeking balloon.

The Recovery process took months as I waited for my partners to finish their assignments and find time to share. I knew the delays weren't intentional, but psychological: it takes courage to face our worst demons and darkest chapters, and to find the psychic space to step out of everyday life and delve into the past. I was at a different stage of life, more conducive to heavy reflection, and for me, healing was a matter of life and death. For my younger partners, the unresolved past was a pesky terrier nipping at their heels, and it hadn't felled them yet. But I knew what lay ahead for them if life kept piling on losses, and I sensed the heavy motherlode of trauma in each of them. It wouldn't help to push or harass them into finishing what we'd started, but I wanted all of us to reach the finish line. The release I felt after processing my parental relationships gave me hope that actual healing was possible, and that even the Big One, my entanglement with Jack, could be finally put to rest.

My renewals for the Handbook were running out. I returned it to the library, waited a day, and checked it out again. The book was a miracle worker, but I was still a cheapskate. And no one else in Coquitlam had put in a request.

Charting my relationship with Jack was relatively quick and straightforward. After all, I'd spent years ruminating and remembering, journaling, writing poetry, and grappling with why his death had become the overarching theme of my life. One difference, this time around, was trying

to identify more low or negative moments in our relationship. Up until he died, only two came to mind.

There was the rotten tomato he'd thrown at me in an attempt to be funny, and the Tennessee incident, his shocking threat to leave if I couldn't maintain the intensity of love he needed. A minor and a major transgression. His worst betrayal was dying and failing to leave any instructions for carrying on without him, leaving me floundering and devastated. Were we psychically bound forever, having no need for goodbyes? Did the rest of my Jack-less life matter to him? Was I nothing without him or was I meant to carry his torch? It was as if we were written on the same calendar and he'd torn off the pages and absconded, taking me with him but disappearing at the first turn.

I needed to confront him over this, instead of making the same old logical excuses that made perfect sense to my mind but not my heart. *He was dying; he was awash in morphine; he had other, more important work to do.* Yes, yes, and yes, but he'd also failed, at the deepest level, to include me in his leaving. To settle some vital business in the most important relationship of his life.

We needed to talk about this, even if it was 34 years overdue.

The different/better/more questions stirred up more unfinished business. One of my greatest longings had been to have a child—several children—with him, a shared dream we often discussed. In fact, one of our few arguments had been over how we'd parent our future children: would it ever be OK to bring doughnuts home for the kids? (I was an alfalfa-sprouts-and-carrots kind of girl; he liked Fritos.)

These longings, scenes from our imagined life together, needed to be spoken and released. I had a lifetime of shattered dreams to mourn and as I moved through each decade of my life, I mourned more of what I hadn't

been allowed to share with him. I wished he could've known the older, wiser Marilyn. I wished I could've watched him age slowly, over years of normal life, and not in the space of six terrible months. I tried to imagine how he'd be as a father, a doctor, a middle-aged man, a grandfather: all unrealized dreams.

Even though God had replaced these dreams with a different, rich, and meaningful life, and a godly husband who was helping me get to heaven, the loss of my first great love could never be erased. There would always be a shadowy, parallel, unlived life to mourn, the what-ifs and might-have-beens. Death had robbed me blind. And I needed to stop blaming Jack for 'giving in,' and accept the truth: he hadn't wanted to leave, and perhaps his silence with me had not been neglect, but his own stubborn denial of where he had to go.

I'd loved too much. I'd utterly entrusted myself to him, holding nothing back. I hadn't pictured our adversary, Death, and hadn't perceived any risk from my total investment. All my eggs were in one mortal basket. But I couldn't help myself; like a meteor, he'd blazed my heart wide open. These things, too, needed to be spoken through the letter I'd write and share with my partner.

Let go, let me go
Never let me go.

I can't remember which partner listened to my Jack letter. It doesn't matter; each partner was receptive and present at every session, patiently bearing witness to my confessions, yearnings, and tears. I also can't say which insights and admissions brought the most closure. But the speaking calmed my heart. Jack was still dead, and I still missed him, though the intensity dropped from an occasional seven or eight to a low-thrumming two, as easy to ignore as outside traffic, until another abandonment dream raised the volume.

The recurring dreams continued, though much less frequently, and even the tone of these night visits changed over time. Now when he turned up nocturnally, I was less anguished than chagrined; he'd returned so many, many times that seeing his face no longer shook me to the core. We were in familiar territory. Some nights, we could even talk about the years he'd missed, what I'd been doing since he left me in the dark, and how I'd moved on. Though I still longed for a different outcome—and an explanation for why he'd left—I no longer woke up flattened to the bed with despair.

I can live with my memories. Snatches of songs and movies can still bring him back, and writing these pages has surfaced more dreams. But I'm growing up in those dreams, moving from passive victim to active participant, gradually rewriting the script, and maybe, by the time I'm 89, the dreams will vanish for good. Or maybe not. I think of old lady Rose, ready to cross over and still dreaming of melting into Jack on a perfect, unsinkable *Titanic*.

The fantasy life. The one that was never meant to be.

I KNOW YOU BY HEART

Henry and I moved again, by choice, to the sunny Okanagan Valley, five hours east of Coquitlam. He was hired by another small, independent congregation, and life changed dramatically. We went from a full house of boarders, family, and hangers-on to our first empty nest. (From the start of our marriage, we've almost always had at least one other person—and often many—sharing our home.) Unlike many mothers hitting this transition, I didn't mourn. I was ready for a new kind of empty.

After prepping the Coquitlam house for sale *again*, we moved eastward, and I threw myself into six weeks of round-the-clock painting to perk up our newly purchased, 54-year-old bungalow in Kelowna. Task completed— every wall, ceiling, door, window frame, railing, and baseboard painted in soothing colors— I found myself unable (or unwilling) to wet another paintbrush for the rest of my life. I took a long break before looking for work. It was a luxury to wake up every morning and not be hustling anyone off to school, and a gift to have entire days to spend as I wished. I'd been blogging a lot before leaving Coquitlam, chronicling the

disintegration of the London church, and now I was feeling around for my next writing project.

Our humble home sits on a quiet street, close to a library, six thrift stores, a quick-hike-to-the-summit mountain, and miles of orchard roads. It's blessedly peaceful. I write in an ethereal pink room, far from the distractions and drama of our former household. Some days I feel as if God sent us on an overdue retreat, the sabbatical we never had. To make ends meet, I clean houses, and the immediate gratification of vacuuming, dusting, and mopping other people's homes into gleaming order is a satisfying balance with sitting at my computer, putting my own life in order as I sweep the past.

After years of trauma, my relationship with God needed shoring up. I could finally pray without weeping and read the Bible without triggering flashbacks, and I was very, very grateful for the fresh start we'd been granted. The Coquitlam years had been essential to my spiritual growth, but brutal, and represented a long chapter I was eager to close. God knew exactly what I needed next, which was this: a simple home, a renewed marriage, and new friends in our little church. A lot less responsibility for others; a lot more sunshine and much less rain. Gratitude for these gifts came easily, but I still felt spiritually depleted.

Several women and I started a prayer and study group, which I was happy to lead. Looking for creative ways to study the Bible, I came up with a new, possibly gimmicky approach that ended up yielding great fruit. We called it The First Chapter Club and devoted ourselves to studying the first chapters of the New Testament epistles (letters), books like Romans, Galatians, and Philippians. The goal was to do an in-depth, verse-by-verse study, looking for themes that carry through the rest of each epistle, as well as practical insights and talking points. I wanted us to dig deep, get

personal, and let the Spirit lead us into whatever needed exploring. There'd be no time constraints; we'd take our time dissecting each first chapter and if we camped on only one verse or concept for an hour, that was just fine.

As I prepared for each meeting, chewing on both familiar and overlooked phrases and licking out the marrow, the experience was so pleasurable I decided to go a step further: to memorize each chapter we were studying. I already knew many sections by heart but had never memorized entire chapters. The challenge excited me, and soon I'd memorized several first chapters and was ready for more. It was time to tackle whole books of the Bible.

I started with First Peter (five chapters, 105 verses long), and as my brain got better at memorizing, I fell in love with the words and the discipline. Intensive memory work reminded me of my running journey, begun in my late teens with painful, lung-searing jogs that nearly killed me, before transforming into a euphoric addiction as my stamina and mileage increased. Once my lungs and heart were roadworthy, I couldn't imagine how I'd lived without running every day. In the same way, my brain adapted to the memory workout and craved more and more practice. I lost track of time in my sessions, just as I did on long runs.

The practice of meditating on God's Word wasn't new—we were fond of Psalm One in the ICOC, and often quoted verse two "...but his delight is in the law of the Lord, and on his law he meditates day and night." In the early days, all of us memorized scores of verses in our churchwide classes. Later, I'd memorized several verses from each of the first 100 Psalms during our time in South Africa and used them as brain fuel while summitting Mount Kilimanjaro in the dark. Many of these passages were still etched on my heart.

But having entire chapters and books of the Bible committed to memory was even richer. I finished First Peter and tackled other books, culminating with the book of Hebrews (13 chapters, 299 complicated verses about high priests, angels, temple worship, covenants, and the supremacy of Jesus). Scripture flooded my life as I recited through my days, whether hiking, cleaning, driving, or lying awake in the middle of the night, waiting to fall back asleep. I remembered some of my guru-following friends, back when I was a New Ager, who chanted Sanskrit mantras in their quest for enlightenment, but this was so much better. These words addressed every aspect of God's nature and my spiritual inheritance, bringing great peace to my soul. Like an infusion of pure encouragement, the words of life filled me with renewed faith. I'd been sipping from the fount of living waters in Dixie cups; now it was coursing through my veins in torrents, flushing out anxieties that scrabbled in my brain.

Along with *The Grief Recovery Handbook*, I cannot recommend this practice enough. Immersing myself in Scripture from morning until night brought immeasurable joy and hope. God's promises and protection became more real than anything I faced or feared. I felt different, and still do, as if supported from within by indestructible scaffolding. The words of life *became* my life. Even when fresh—or repeated—trials come my way, as they always will, the scaffolding keeps me from caving in. In fact, most days it keeps me happily afloat.

■ ■ ■

I hasten to add that the years since moving to Kelowna have not been seamless. After a short but blissful break, life intruded with new challenges we had never imagined. The church has gone through tragedies I wouldn't wish on my worst enemy. Family troubles have torn at our hearts and our

peace. We are surviving on less income than I ever thought possible. Our future, as we head into retirement, looks as hazy as the wildfire smoke swallowing the Northwest this summer. But my refurbished faith, bolstered by grief recovery, prayer, and memorized scripture, has kept me standing. All of my psychosomatic symptoms have vanished, and my health has never been better.

I'm not a doctor, a priest, or a therapist. But I can testify that, at least for me, these practices truly work.

■ ■ ■

Appeased by the Handbook and fortified by the Word, I was ready to write my first memoir, the book I'd carried inside but never felt ready to write. After years of sidelined emotions, now released, I finally had a grasp on its heart. *Paradise Road*, which chronicles my childhood, my runaway teen years, my relationship with Jack, and the bicycle journeys which led to my conversion, was ready to be birthed. Over the course of a year, the words flew from my keyboard, tapped by my Mavis-Beacon-trained fingers, relating the story I longed to share. This venture, too, strengthened my faith. Looking back, I could see how God had watched over every foolish, desperate, or hopeful step I'd taken and had used it all—the good, the bad, and the devastating—to shape me and guide me home. As I wrote, I felt the pain recounted in every chapter, but only as remembered pain. The rawness and loneliness were gone, replaced by the presence of a loving Father, backlighting every page.

But I knew the greater and much harder story to tell would be this one, the tale of a committed Christian leader, engaged in the mission and certain of her calling, yet nearly destroyed by unresolved grief and unexhumed

layers of pain and despair. The story is mine, unique in the details, but I know the bare outlines must parallel others.'

"No temptation has seized you except what is common to man," Paul writes to the Corinthians, and surely this applies to our secret sorrows, too. Although my delayed, complicated, soul-destroying grief seems to rival any grief the world has ever known (except, possibly, Queen Victoria's), I know others harbor hidden devastations that war against their souls. And my hope is that my rocky journey and the answers I eventually found will bring a measure of healing to others who are floundering in their faith.

How can God let this happen to me? When will the anguish end? Why am I not comforted? Questions like these can weaken our faith when answers don't come, or when the makeshift answers we concoct only crumble as our trials, instead of lessening, grow visibly worse.

The answers I found took a long time to find. Either I'm a slow and stubborn learner, or God knew the long journey was necessary to reconstruct my heart and my relationship with God. Along the way, He reconstructed my relationship with myself. I love Young Marilyn now, no longer blaming her for the serpentine road she had to travel, and I love Middle Marilyn (possibly the saddest), and Who-I-am-Today Marilyn, even as she tumbles into seniordom. Loving myself makes it so much easier to love everyone and everything else.

Time *doesn't* heal all wounds. Not without effort. I'm convinced entrenched grief can only be eased by dealing with it head-on, when the time is right, or when the griever is forced to be ready. I wasn't ready or able to deal with my grief at age 22, and it was decades before *The Grief Recovery Handbook* entered my life and gave me the tools I needed. In the meantime, a continent of subsequent griefs fell into my ocean, pulling me under. I didn't understand grief, how it consumes and grows, gathering

force out of sight; how it feeds off every loss and leeches the soul like a silent tumor. I understand it now.

Of all the words Theo spoke to me, one sentence resonates. "The box must be empty." Viewed from this perch, twenty years on, his instructions take on new meaning.

Back then, his imperative seemed as misguided as the rest of his perplexing advice. What value was there in burying an empty box? I wanted to put everything I'd neglected to say into the box, all the regret and apology and affirmation I could muster. Theo's suggestion, the memorial-that-never-was, would never have worked, and I'm glad I wasn't talked into it. But now I see profound truth behind those simple words.

The box must be empty.

We cannot bury active grief and expect it to go away. It won't. The conscious mind may succeed at 'forgetting' for a time, but the heart will not. Only by confronting grief, by assessing its scope and processing the *emotional* components of our loss, can we be freed from its corrosive power. Only then can we 'bury' our griefs, laying them to rest in a corner of our hearts that will forever cherish the joys and remember the pain, but only as a storm endured. We teach our hearts to release the deepest pain, and they grow stronger in resilience. Or at least they stop inwardly bleeding, allowing us to re-enter the crazy stream of life and love again.

■ ■ ■

The *Grief Recovery Handbook* was part of a four-fold package that set me free. Finding my voice—through writing, in my case—was equally important. Sharing my pain through writing connected me with others after self-imposed isolation, and the response brought comfort to my hollowed heart. Finding your voice might come through a different avenue,

but sharing your heart with others is essential. Unresolved grief leads to depression, and depression blocks us from wanting to share our darkest thoughts with anyone. By sharing my shame and anguish, I learned how fears and regrets brought into the light of another's love lose their power to isolate and diminish.

The fourth step, memorizing huge chunks of the Bible, has been the most surprising part of my journey. Every day, I recite chapters to myself as I move through my activities, and the practice brings immediate joy and calm to my heart. I fell a bit in love with Paul as I memorized his letters, sensing the passionate heart behind his words, and much more deeply in love with Jesus and my Father in heaven. It takes discipline to develop this practice and strengthen our memory muscle, but it's time well spent and the benefits are immeasurable.

As Peter foretold, I still "have to suffer grief in all kinds of trials," and as much as I long for still waters, I'm not holding my breath. The peace and perfection I crave will come when God calls me home. I'm reminded again of Job, stricken and afflicted. As omniscient readers, we're told exactly why Job suffered such shattering losses—the death of his children, servants, and animals; the loss of his property, health, and friends—all of which fell on his head in two fell swoops. His 'punishment' had nothing to do with sin, as all Job's friends and neighbors presumed, but with righteousness. At Satan's challenge and with God's permission, Job was tested to see what he'd do when his earthly blessings vanished. God had boasted in Job's faithfulness, and ultimately Job came through, refusing to curse his Creator in the face of unspeakable tragedy.

But the story is heartbreaking. Poor Job, when he's not scraping his festering boils with potsherds, spends most of his energy searching for the secret sins that damn him, but he's off track. He never comes close to

guessing the real reasons behind his trials, and even when God speaks to him, man to man, in the howl of a storm, the secret is not divulged to him. Imagine his relief when he got to heaven and grasped the spiritual backstory! Not only was he judged righteous by the only court that matters, but his journey would serve as inspiration for countless generations of afflicted souls. In the end he's richly rewarded for his grief; God blesses him with new children, new animals, and new servants to replace everything he lost. But I have to wonder: did he ever stop mourning the children who died? How long did he grapple with being singled out for so much suffering?

I'm not claiming to be anything like Job, except for being human and loving God. My sins keep me humble, though not as humble as I ought to be, which humbles me further. I'll never be counted among the righteous few who grace this earth from time to time—Daniel, Noah, Enoch, or the nameless widow who gave her last penny to the poor. I'm with the rest of us. But I take comfort from Job's story, knowing that perfect, divine reasons lie behind whatever I've suffered, and that in the end—or rather, the *beginning,* when our life beyond this earth unfolds—everything will make perfect, loving sense. Sometimes I think Satan went after me extra hard, seeing how fervently I loved to share my faith. Perhaps he got permission to go for my jugular, too: What would happen if he stripped away everything I trusted in? Could he make me let go?

Almost, but not quite.

If I've come close to guessing the truth, I won't know until the curtains are pulled and my own backstory is revealed. Like Job, I hope it will be a huge relief to see the big picture and to grasp what larger story lies behind my turbulent journey. One thing is clear: while I held on by the tiniest of threads, God held me tight in a mighty net of unbreakable love. I just couldn't see it.

As for my position on the ICOC, I'm still on the fence and maybe always will be. I cannot diminish or deny the blessings that came through our involvement. Nor can I forget the harm and hurt—but I can forgive those who harmed and even laugh about some of our most cringe-worthy moments.

Most of my dearest friends are, or were, ICOC members, and many of them are thriving. In the years following Henry's letter, every member was compelled to re-examine the movement and their own beliefs and allegiance. Some chose to leave, others to stay; some left and later returned. Many sit with me on the fence. While many practices were cultish, the foundational teachings are biblical, and those who embrace them are, to my understanding, true Christians. I have yet to find another group that rivals the ICOC in fostering deep, committed relationships that transcend worldly barriers.

Many readers will wonder how Henry deals with this painful and public state of affairs: a wife consumed by a previous love she couldn't shake, now writing about it in great detail. Their sympathies will lie with him, as they should. Truly, my delayed and prolonged grief journey was something no faithful spouse should have to endure. But by God's grace, our love has grown stronger, and we are closer than ever. Our wedding vows—the vows we made before God, in absolute faith and sincerity—have kept us together through the lowest valleys so we could witness the miracle of renewal.

Henry has bravely read these pages—not without anguish—wanting to know what lay deep in my heart at every stage of my strange, unpredictable journey. He prays my story will reach and encourage as many as possible, confirming a glorious truth: God truly does bring life—and joy—to dry, dead bones. Even the most traumatized marriage can be healed if we

refuse to give up. And even the most disheartened believer, broken by sin and disillusionment, can be revived.

God is able, if only we hold on.

■ ■ ■

So this is my story. Years ago, back in our street ministry days, Henry and I met a man who spent years holed up in his tiny apartment, writing a massive, sprawling, nearly illegible novel about a turtle. When Henry asked him why he wrote, his answer was simple. "I've never read a book I liked, so I decided to write my own."

This book is a little like that—not that I don't like many, many books. But the kind of memoir I needed, back when I was searching for a fellow belated mourner, hadn't been written, so I decided to write my own. The process of remembering and examining and sharing it with others brings another measure of peace and healing. It's not a pretty story, but it's all true, and there's a happy ending.

I hope your story has a happy ending, too.

"And the God of all grace, who calls you to his eternal glory in Christ, after you have suffered a little while, will himself restore you and make you strong, firm, and steadfast. To him be the power forever. Amen." (1 Peter 5:10-11)

■ ■ ■

Postscript

Many friends have heard my story and asked about Theo. Where is he now? What happened to my dear, overwhelmed therapist and friend?

After my sessions ended, I saw him only once, during a brief trip to the States to sort through our stored belongings. This was about two years after my sessions with him ended. Theo had been to rehab and was back home, fighting for his sobriety and still on leave from work. But he was troubled and confessed to me his deepest yearning: to run away from life and disappear on the streets of New York City. I never heard if he acted on this impulse, or if he persevered and found healing. I thought of him often, but for years my contact with mutual friends was almost non-existent.

As I began writing this memoir, I looked him up and found an obituary from 2016. He lived longer than I imagined he would and passed away just two years before my search. I wish I'd tried sooner. Despite our convoluted therapeutic journey, he remains dear to my heart, and I often picture his warm, mischievous smile and the cozy office where I wept, and he listened.

ACKNOWLEDGEMENTS

Writing a memoir summons ghosts and living people from the past. Once again, I want to thank the 'characters' who helped shape the journey depicted in these pages. From passing comments to life-changing conversations to years of selfless friendship: your impact has been indelible. Most of all, gratitude to my husband for loving me through the worst days—and years—of my grief. If readers marvel at his unbelievable patience, they absolutely should!

As for the writing-and-publishing part of this book's journey, here are my heroes:

Echo Montgomery Garrett, my publisher/editor/friend/cheerleader. Your support is an author's dream. Thank you for the love, attention, and determination you've poured into our shared vision. I hope to be collaborating long into our golden years!

For Troy King, for his creative book cover design—you captured the hollows of grief so well.

For Brette Sember, my second editor. Your astute comments, bolstered by your unbiased enthusiasm (you didn't know me from Adam), made this a better book.

My early readers:

June, the first to listen to each book I've written, from the shared comfort of my cozy home office. I'll always cherish those special hours of reading and discussion. Every writer needs an ardent friend like you!

Dan and Gwen, once again among the first to read this manuscript and affirm its value. Your friendship is an enduring jewel in my life, even as we continue to live too far apart.

To those who not only read the early draft, but completed my lengthy questionnaire: Dan and Mary, Wendy, Janet, Helene, Lynn, Dave, Declan: Thank you. And to all the other early readers I've forgotten: Thank you.

For my present and future readers: Thank you for helping this book find its place in the world. And for sharing it with anyone you think might benefit from its message. If even one sentence or confession helps another soul, I'm grateful.

ABOUT THE AUTHOR

MARILYN KRIETE

Marilyn Kriete is the author of the multiple award-winning, debut memoir, *"PARADISE ROAD,"* the story of her adventurous early life and the loss that resurfaces two decades later in *"THE BOX MUST BE EMPTY."* Her poetry and essays have been published in anthologies and by *Longreads.com, The Lyric, Storyteller, The Eastern Iowa Review, The English Bay Review,* and *Brevity Blog.* She's been the happy winner of several writing contests. *"PARADISE ROAD"* was named the winner in the non-fiction adventure category of the 2022 Book Excellence Awards. The 15th Annual National Indie Excellence Awards named her memoir the winner in the Young Adult Non-Fiction category and a finalist for New Adult Non-Fiction. It was also a finalist for Book Cover Design-Nonfiction. Born in Edmonton, Canada, Marilyn's service as a ministry leader took her and her husband Henry to four continents and sixteen cities. She currently lives in British Columbia, Canada, where she writes and hikes and tries to imagine the next twist in her unpredictable journey. A third memoir awaits publication. You can follow her writing journey on MarilynKriete.com.

INDEX

Made in United States
North Haven, CT
27 July 2023

39604035R00153